CREATIVE
freedom

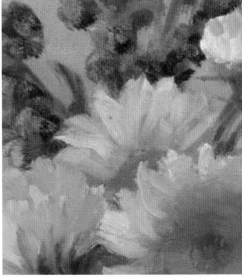

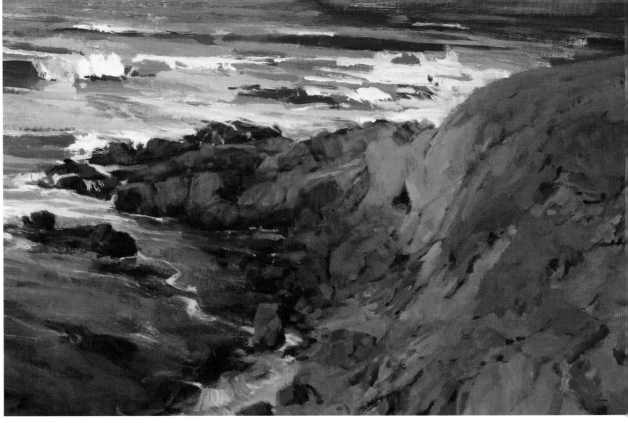

CREATIVE
freedom

52 art ideas, projects
and exercises to overcome
your creativity block

MAGGIE PRICE

NORTH LIGHT BOOKS
artistsnetwork.com

Contents

Landscapes are my primary subject. Until recently I rarely painted struc-
tures, still lifes or people. To break out of my landscape rut I have experi-
mented with a variety of subjects, including interiors and still-life subjects.
Exploring how outdoor light can illuminate an interior has expanded my
understanding of the ways light describes forms, both indoors and out.

IL REFUGIO | **Maggie Price**
Pastel on Richeson Premium Pastel Surface
24" × 18" (61cm × 46cm)

Breaking Out of Your Block to Move Forward

When we talk about breaking your artist's block, it can apply to far more than that "stuck" place when you don't quite know how to start. I've been painting for most of my life, but like all other artists, I experience the classic block. It's a vague feeling of unease, a not-knowing how to start or what to paint. It's what drives us to find innumerable errands or tasks to keep us out of the studio and as far away from the easel as possible.

But there are other kinds of blocks as well. One kind is the "same old, same old" syndrome. I recognize it when my paintings all start to look alike. I'm not talking about the artist's style—that's something else entirely—but that feeling of repetition, of boring redundancy, that leaves me tired of every subject I look at and, once again, keeps me from painting.

A more subtle block is that of failure to progress. When I'm producing acceptable paintings, but not what I consider to be great paintings, that's a "progress block." It doesn't mean there's anything wrong with what I'm doing, but the work I'm producing is simply a matter of repeating previous successes and not advancing to a higher level.

Over the past few years, I've experimented with various ways to break through these blocks. I've tried new mediums, painted different subjects and developed exercises to help me move through the block. I've also noticed other artists experimenting with different techniques to achieve that goal. Since it appears to be a fairly common problem, it seemed a good idea to pull a lot of these ideas together and share them.

This book covers techniques in a number of mediums. Some of the concepts are specific to the medium, but many can be adapted to work with other mediums as well. Here are a few things to keep in mind as you explore these ideas:

- Consider these as exercises and not necessarily steps to finished work. If you expect to produce a finished, perfect painting, you will worry too much about the outcome. Fear of failure creates another kind of block.

- Experiment with converting exercises shown here in one medium to another medium. See what happens if, for instance, you follow an exercise in watercolor but use pastel.

- Keep a sense of play. Have fun with the exercises and don't hesitate to head off in a different direction if you see possibilities outside the steps.

- Keep track of what works for you. If a particular exercise really motivates you, flag it to repeat again in the future.

One of the great things about being an artist is that there's always something new to learn and endless potential for growth. So when you find yourself facing any kind of block, try something new and break through it to move forward.

Tools & Materials

The creativity exercises within cover a variety of mediums, including pastel, oil, acrylic and mixed media. The materials are referenced within each demonstration as general guides for you to understand the artist's specific processes. If a paint color or tool sounds unfamiliar to you and you would like to know more about it, a quick Google search will usually yield the tool, its brand and where you can purchase it.

When purchasing art supplies, a good rule of thumb is to buy the best supplies you can afford. Use what you like and are comfortable with, but always be willing to experiment with unfamiliar supplies to inspire new ideas and energize your work.

PASTEL AND PAINT COLORS

Most artists develop their own palettes over time. You'll find you gravitate naturally toward specific colors and may shy away from others. For example, some artists might find a way to use purple hues in nearly every painting, while others never touch the color unless the subject is purple—and even then, they might find a way to make it blue instead! Whatever your medium, try a variety of colors and brands, and determine over time what speaks to you.

PASTELS

There is a wide variety of soft pastels available, ranging from very soft to medium-soft to harder pastel sticks, though they all are referred to as "soft" pastels. Every time you prepare to make a mark on your surface, you must first select a pastel stick by considering its value, temperature and hue. Many artists like to have a value range of a specific hue in variations of texture, so they might, for example, have a range of blues in hard pastels, medium-hard and very soft. Pastels are generally applied beginning with darker values and working up to highlights, so the lightest highlight colors tend to be very soft pastels that will adhere easily to colors already layered onto the surface.

PASTEL SUPPORTS

Pastel surfaces vary in the amount of tooth, or surface texture, that holds the pastel pigment. Some examples used in this book include various brands of sanded pastel papers, pastel boards and other prepared surfaces made specifically for pastel, and hot-pressed watercolor paper.

OTHER TOOLS FOR PASTEL

- 2-inch (51mm) flat foam brush
- ½-inch (13mm) flat bristle brush
- paper towels
- vine charcoal for quick layout
- pastel ground
- acrylics for tinting ground
- spray fixative (some artists use it, some never do)
- pH-neutral black masking tape
- solvents for dissolving pastel for underpaintings, such as Turpenoid, water, rubbing alcohol or denatured alcohol
- clear gesso
- palette knives
- old watercolor brushes

OILS

Oil is the primary medium of the Old Masters, and often the medium of the classical painter. You may work with just a few tubes of paint, mixing your own colors, enjoying the harmony of color created by this limited-palette

approach, or you may prefer using a wide variety of pre-mixed colors. Every artist will develop a preference as to type of brushes used, whether rounded, flat or the tapered filbert, and will select these shapes from a variety of hairs, from bristle to synthetic to sable. Palette knives are also a matter of personal choice—you'll find the shape that feels right to your hand. When you work in oils, you'll notice they can take quite a long time to dry, and traditionally you will begin with thin layers of paint, working up to "fat" and heavier applications, which allows for even drying of the paint. You may also choose to use a drying agent or any of a number of mediums for thinning or thickening the paint. There are lots of possibilities to explore when you begin painting in oils.

OIL SUPPORTS

Just as you will find the colors, brushes and knives that suit you best, you'll learn which surfaces are most comfortable for you. Some common surfaces for oil used include Masonite, canvas, linen and primed boards. Some people like the springiness and "bounce" of stretched canvas; others prefer a rigid surface, such as linen applied to a wood panel. Different surfaces will also have different absorbency rates; the way the pigment absorbs into a stretched cotton canvas will be markedly different than how it reacts on a smooth gessoed board.

PAINT BRUSHES AND KNIVES

Like paint colors and pastel sticks, the types of brushes you can select for painting vary widely. Some examples used for oil, watercolor and acrylic include bristles, flats, filberts, riggers, sables, rounds and bright brushes from very small and fine-pointed for small details to much larger for large washes or blocking in backgrounds.

OTHER TOOLS FOR OIL

• palette knives (flat, angled or trowel-shaped)

• odorless mineral spirits

• linseed oil

• walnut oil

• alkyd medium

• paper towels (Viva is a popular brand among artists for its high absorbency)

WATERCOLOR

Watercolor can be used in a variety of ways, from casual sketches in a travel journal to finished paintings. The paints come in tubes, useful for larger works, or in small blocks that can be reconstituted with water. Watercolorists generally work from light to dark values, taking care to preserve the lightest values, sometimes by coating with frisket. Watercolor pigments range from transparent to opaque, allowing a lovely interplay between the two in a finished painting.

SUPPORTS FOR WATERCOLOR

Watercolor papers are made specific to the medium, ranging from hot-pressed (smooth) to cold-pressed (medium-smooth) and not-pressed (rough). Rag paper is high-quality paper for watercolors made of fiber and usually acid-free or pH neutral.

OTHER TOOLS FOR WATERCOLOR

• acrylic matte medium

• drawing gum (liquid frisket)

• masking fluid

• palette tray

• cotton swabs

• plastic palette knife

• plastic picnic knife with end cut off

ACRYLIC

The medium of acrylic is a relative newcomer, having been invented in the late 1940s. It is popular with artists who want the look and feel of oil paints, but without the use of solvents. Pigments are suspended in an acrylic polymer emulsion to create the paints. One of the advantages of acrylic paints is its rapid drying time, though it may sometimes dry too quickly, requiring the use of a "retarder" medium to slow down the drying time and allow the artist to work wet-into-wet. Gels and pastes may be used to either make transparent layers or for heavy impasto techniques. Once dry, an acrylic work may look much like an oil painting or a watercolor, depending upon the techniques used.

ACRYLIC SUPPORTS

Some common surfaces for acrylics include canvas panels, portrait linen mounted on foam board and gesso-primed panels.

MISCELLANEOUS TOOLS

• black masking tape

• packing foam wedge/sponge

• hair dryer

• rags made of good cotton toweling

• tea towels, T-shirts or shop towels

• paint box

• bulldog clips

• sketchbooks

• pencils and erasers

• fine- and medium-tip pens

• ruler or straightedge

• razor blades

• sponges

• pen knife or credit card for scraping

• stiff toothbrush

1 Apply Color Intuitively With a Paper Towel

I've been a watercolorist for most of my painting career, but lately I've been experimenting with acrylics and gouache, and the results are pretty exciting! Photorealism is never my goal, as I no longer work from photographs, which is very freeing. I may have a general concept in mind, as I do for this painting, but I don't have a firm preconceived plan—I let the color guide me.

I never know exactly what the painting is going to be when I start. My goal in each painting is the use of light and color to project a powerful mood. I think of color combinations first, squeeze the paint out onto the canvas panel and go from there.

Unlike most painters, I don't use a brush. I use a paper towel to spread the paint around, and at times I use my fingers. I just kind of stumbled into this technique and kept pursuing it.

This piece is similar in style and theme to some of my other watercolor landscapes and seascapes. My paintings are statements about nature and my place in it. I strive for my paintings to combine elements of realism, Impressionism, minimalism and tonalism.

1 Beginning
The general concept for this painting is a bright yellow sky with reflections of the sky in the wetlands below in the grass. Turn the 6" × 8" (15cm × 20cm) canvas panel upside down so you can begin to work on the sky without initially affecting what will be the lower portion of the composition. Squeeze blobs of Yellow Ochre, white and Cadmium Yellow acrylics onto the canvas panel.

2 Rub In the Colors
Using a paper towel, start rubbing the colors together, using a horizontal movement to spread the colors over the surface.

3 Cover the Surface
Continue to rub the colors all over the canvas so the entire panel is covered in yellows. This will make sure you'll be able to catch the yellow from the sky in the reflection of the water in a later stage.

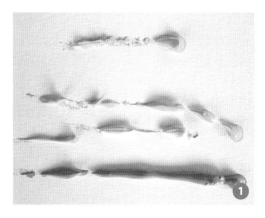

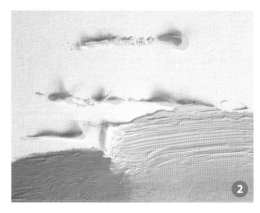

5 Develop the Land Mass
While the greens are still wet, add a little sepia for texture in the grass, and rub the greens and sepia together. Leave an area of yellow showing for the water, being careful not to rub greens over it.

6 Final Details
Squeeze out green acrylic at the horizon line for the trees and gently rub again with a paper towel until you get the shapes you want for the trees. Add more green at the horizon line, and gently blot this color in different directions to form the trees, working until you achieve the desired shapes and being careful to keep the edges loose and lacy. Then add a tiny bit more sepia in the foreground to create more texture and to finish the painting.

4 Place the Grass Colors
Now turn the canvas so it is right side up. Squeeze lines of yellow-green and moss green for the land formation, and rub in the grass area with a horizontal movement.

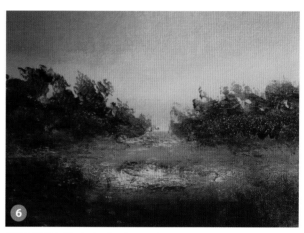

ONE FINE DAY | Catherine Anderson
Acrylic on canvas panel; 5" × 8" (13cm × 20cm)

Catherine Anderson | catherineanderson.net

A painter for over 40 years, Catherine was born in Chicago and attended the Chicago Academy of Fine Arts, University of Cincinnati and Academy of Art University in San Francisco. She is a signature member of the American Watercolor Society, National Watercolor Society, California Watercolor Association, Knickerbocker Artists, Rocky Mountain National Watermedia Society, Transparent Watercolor Society of America and Watercolor West. Catherine was recently selected for the honor of a two-year Directorship of the American Watercolor Society.

Catherine is the author of the *Basic Watercolor Answer Book* published by North Light Books and the column "Water Rescue," which appeared in *Watercolor Magic* from 1995 to 2003. Recently she produced the DVD *Creating Multiple Glazes in Your Watercolors.*

Her paintings are found in corporate collections and in the private collections of Will and Margaret Hearst, Patti and Gavin MacLeod, and Steven Spielberg. Catherine's paintings have been exhibited in museums throughout the U.S. and China. She has received numerous awards from major art organizations in the United States and teaches one-week retreats in her Top of the World Studios on the coast of Maine.

2 Experiment With Unfamiliar Colors

Like most artists, I tend toward a specific color palette, and even though I like to paint intuitively rather than from photographic reference, I probably pick up the same colors again and again.

To get out of this routine, I decided to pick some different color combinations and see what happened.

I envisioned a sunset and added two new colors—Luminous Rose and Opera—to my palette, as I wanted the sunset to be really glowing at the horizon line.

Exploring the interaction between colors is a never-ending process and can do wonders for getting you out of a rut.

1 Work From the Bottom Up
On a 6" × 8" (15cm × 20m) canvas panel, squeeze out blobs of paint: Ultramarine Blue Light, Cadmium Orange, Cadmium Yellow Light, Luminous Rose and Opera. Squeeze the paint out in long strings, rather than larger blobs close together. While it's not yet apparent, the blue at the bottom will end up being sky, so you're working upside down.

2 Blend the Blue and Orange
Using a good quality paper towel, prepare by tearing one sheet into quarters. Smaller pieces of paper towel are easier to handle when painting this way. Begin rubbing the blue and orange paint together with the paper towel section using horizontal strokes, removing any excess paint if needed. Keep blending until you have it the way you want it. Concentrate just on the orange and blue—you're not touching the yellow or pinks yet.

3 Blend the Next Section
Begin blending in the yellow and pinks with another piece of paper towel, continuing to use horizontal strokes. You can rub in a circular motion a little bit if you wish, but keep the movement mostly horizontal. If necessary, remove any excess paint. Blend all these colors together until you're satisfied with the result, keeping in mind where the horizon line is going to be.

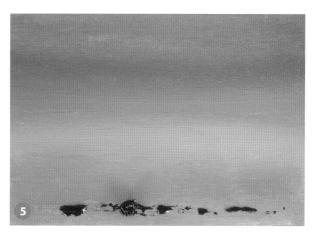

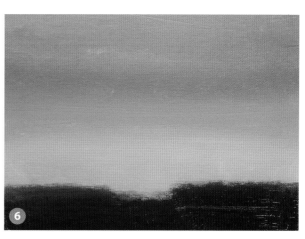

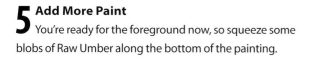

4 Turn the Canvas Right Side Up

Flip the panel so the painting is right side up, and do a final blending of the bottom of the painting with a paper towel section until it is smooth.

5 Add More Paint

You're ready for the foreground now, so squeeze some blobs of Raw Umber along the bottom of the painting.

6 Rub In the Umber

Take another piece of paper towel and rub the Raw Umber along the bottom to create some land masses, being very careful not to wipe up and over the Luminous Rose color that you rubbed in earlier. You want to keep that lovely color right at the horizon line so it will glow.

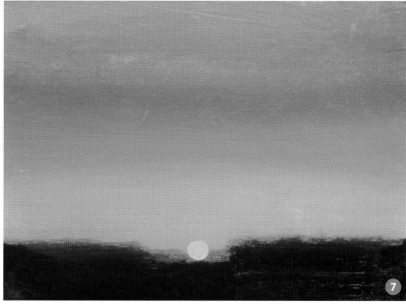

7 Create a Sun Spot

Pick up some paint from the top of the Cadmium Yellow Light tube with your finger and carefully blot in the sun. Keep the shape clean and don't let the edges smudge.

DAYDREAMS | **Catherine Anderson**
Acrylic on canvas panel; 6" × 8" (15cm × 20cm)

3 Paint Quick Sketches for Fresh Ideas

When I find myself struggling to settle down in the studio to get started, or when I don't have a specific idea in mind to paint, I often walk around the outside of my studio and simply look around.

Sometimes my eye is caught by potted flowers or the landscape around my house or the lemons on my Meyer lemon trees. Something about the freshness of the color of the lemons and the dark green around them always excites me. I look for a leaf formation and lemons that I think will make an interesting study and then I begin. My goal is simply to have fun and enjoy the process.

It's not always easy to decide how to begin, so I often do quick preliminary color sketches. These can be just a few strokes or a treatment of a possible composition. These color studies set the stage for the more involved painting that follows.

One of the reasons this helps break the block is it's simply so much fun to work loosely. There's nothing tight about these sketches. It's simply the joy of the strokes, knowing I can make a mess and get out of it if I need to. After I've worked through a few sketches, I find the direction I want to go for the final painting.

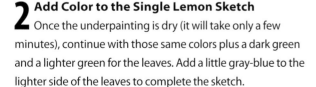

1 The Initial Sketch
Look for something simple to start with such as this single lemon. Working on 5" × 7" (13cm × 18cm) white sanded pastel paper mounted on foamcore board, sketch the subject loosely and block in darks and lights with Yellow Ochre and a dark purple, along with a little Burnt Sienna on the leaves. Brush over the shapes with rubbing alcohol to set the sketch.

2 Add Color to the Single Lemon Sketch
Once the underpainting is dry (it will take only a few minutes), continue with those same colors plus a dark green and a lighter green for the leaves. Add a little gray-blue to the lighter side of the leaves to complete the sketch.

While this is a simple way to get started, the resulting composition is awkward because the lemon is in the middle of the leaves and the leaves are evenly balanced on each side of it. It would be more pleasing to have the lemon off center with an odd number of leaves.

3 Try Another Sketch
Using the same process and materials, try another sketch, this time grouping several lemons. It's better, but the space between the 3 lemons is almost the same, making it less interesting to look at. It also has a feeling of being centered again.

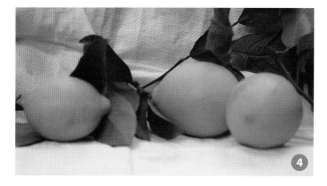

4 Improve the Composition

Set up a new grouping of lemons. Take a reference photo to preserve the lighting in case it changes while you're working.

5 Begin Again

Beginning on a new piece of sanded pastel paper, sketch the composition. Block in the basic colors of the underpainting and brush the shapes with alcohol. Because these are young lemons, the skin has a greenish cast, so use a light green and gently layer it on the lemon shapes. Next add a very pale Yellow Ochre to bring some of the background light into the painting. Add a dark green to the leaves to start to give them depth.

6 Develop the Shadows

Keep the strokes loose and keep having fun. As you work, consider where you want distinct, crisp edges and where you want them to be softer or lost. Look more closely at the shadows and background for color. The lemons are obvious as to being in the yellow family, but the background is much more subtle. Ask yourself how you can bring color into the whites. It often works to pick up color from some of the other colors in the painting. For example, there is a lot of reflection on the white cloth from the lemons and leaves, so you can use Yellow Ochre, greens, blues and purples in a lighter value in the cloth.

Add a soft warm green to the areas around the leaves in the background as part of the leaf color reflection in the background. Note there is a little Ultramarine Blue in the shadows, so add it. Also, add purple in the leaves for contrast and a lighter shade in the background. Use a very light stroke to layer the pastel, and don't blend the pastels other than through layering.

7 Final Details

Start to become more specific, looking for details such as highlights. Use the dark green and Burnt Sienna soft pastels to deepen the shadows. Squint at the subject often to simplify the values. Paint the highlights on the lemons with a cooler, lighter lemon yellow color. Step back to see if there is anything you've missed. When you cannot see anything else to do that would make it any better, the painting is finished.

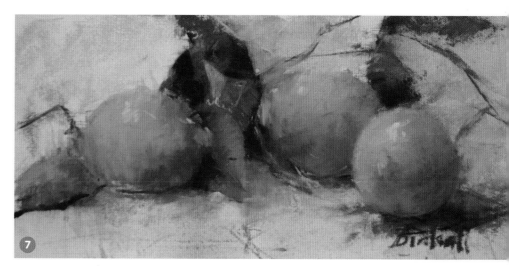

FRESH LEMONS | **Stephanie Birdsall**
Pastel on Wallis sanded pastel paper; 5" × 9" (13cm × 23cm)

15

4 Explore Color in a Series of Paintings

One of my approaches to being stuck is to break out and do something completely different, something opposite my norm, in some creative way.

I tend to pick a color theme and follow it for a year at a time or longer. I paint it until I no longer see the object associated with the color, and the color simply becomes a shape. I once started with yellow pansies growing in a pot in my garden and became enchanted with yellow. I painted a series of yellow pansies and then went on to paint the yellow lemons from my lemon trees.

Recently I found myself painted out of yellow and experiencing a bit of a block. Because I like to paint in color sequences (same-colored objects), I challenged myself by trying a new and exciting color: purple. I didn't have expectations about the outcome, just the idea of exploring the color and subject.

Painting a new color series involves trying out new color combinations. Based on my new experiment with purple, I'd like to now do a painting that incorporates my yellow experience with my purple one. I guess the block is broken. I'm thinking ahead!

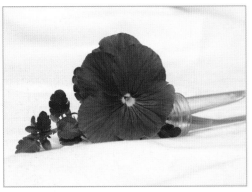

REFERENCE PHOTO

1 Sketch the Subject
Begin with a 5" × 7" (13cm × 18cm) Pastelbord. Lightly tone the board with a Light Ochre soft pastel so you have a background and value to work with. I prefer densely pigmented pastel that won't fill the tooth of the paper as quickly as soft pastels.

2 Lay In the Darks and Wash With Alcohol
Using a light touch, put in some of the darks with a brownish green pastel. It's often easier to begin an underpainting with harder pastels, rather than the super-soft ones, so if you have that color in a harder pastel, use it. If you use a softer pastel, apply it with a light touch.

Next, put down more dark colors in purple and blue-purple. Using a hake soft-bristle brush and alcohol, wash each color area, keeping them clean and separate. This will create a base of color to work on top of in subsequent steps.

3 Lay In the Flower Colors

For the next layer, use a magenta pastel to start laying in the darks of the flower. Use a dark green for the leaves. Then lay a royal blue over the magenta to start to make the pansy purple color. Lighten the edges with a lighter purple. Study the flower to try to discern what colors of blue and purple make it this specific color. When you're not familiar with a particular color combination, you have to work slowly and think hard about what colors to use.

Add the yellow center to see how it interacts with the purples. This completes the first step of breaking the color block and starting a new sequence. It gives you an idea of where to go with the next painting and how to work with this color.

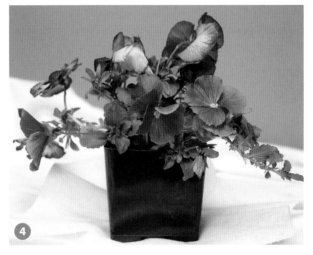

4 Begin Again With a New Photo

Now that you've explored the ways to interpret the colors of the pansies, move on to a more complex arrangement. The pansies in this pot are the same colors as the previous step, but there are more of them, and the shapes are very different as some of them turn away from the viewer.

5 Block In

Start with a new surface, 9" × 12" (23cm × 30cm) sanded pastel paper mounted on Gator board. Scumble a mix of green-brown, ochre and green over the surface. This will set up a background so you can put the pansies in front. In the underpainting, suggest the darks and some of the plant structure.

6 Find the Darkest Values

Now determine what are the darkest shapes and put them in with a dark brown soft pastel. Look for the gesture of the arrangement and try to find its movement and rhythm.

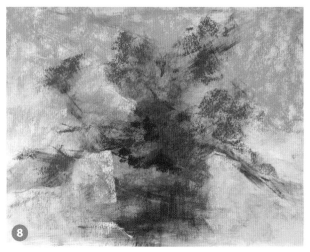

7 Wash With Alcohol
Wash the pastel in with rubbing alcohol, which will evaporate quickly so you can continue. When it's dry, lay in some of the green for the back leaf shapes and purple for the pansy shapes. Wash those colors with alcohol.

8 Move Toward Brighter Colors
Once the alcohol has dried (it will take only a few minutes), it's time to put in some of the brighter pastel colors. Keep the shapes loose so you can still work on the composition.

Because the background is a soft khaki green, find 2 colors that are similar and lay them in, looking for the largest shapes that you can identify. Do the same thing with a cream color for the cloth, creating big shapes.

9 Lay In the Blues
Start to place the individual blossoms and indicate the shape of the pot. Use a mid-value blue for the pansies and dark greens for the pot.

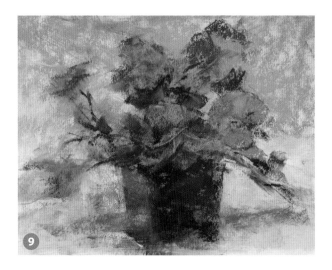

10 Continue to Refine the Shapes
Refine the shapes and create more specific edges with the magenta, light blue and a rich blue-purple. Try to make every shape as accurate as possible so you don't have to go back over it and repaint it. You can use a harder pastel over the soft ones to blend the colors lightly.

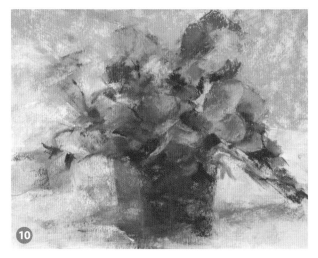

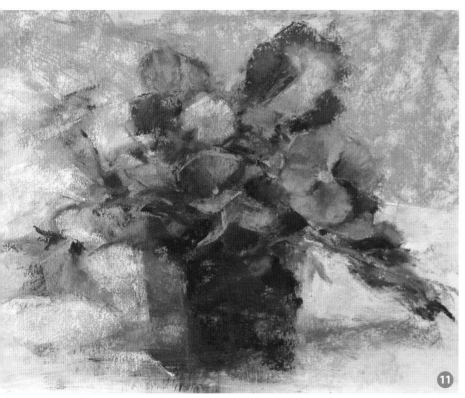

11 Study the Composition and Finish

Step back and study the painting to determine whether you've achieved accurate purples through layering. Add Light Ochre to darken the lighter petals.

Go over the darks, add yellow to the centers and touch a few leaves with a light green-blue to indicate that they are catching the light. Darken the value of the pot as needed to give it a little more feeling of substance. Touch up the light values on a few of the leaves. Consider which edges can be lost and soft, and which need to be harder; refine the left side of the large pansy on the right to give it a crisp edge.

PURPLE PASSION | **Stephanie Birdsall**
Pastel on Wallis sanded pastel paper; 9" × 12" (23cm × 30cm)

Stephanie Birdsall | stephaniebirdsall.com

Stephanie received her formal training at the City and Guilds of London Art School in England. She has exhibited at the Royal Academy in London, England, in Bargemon, France, and in both the Salmagundi and National Arts Clubs in New York. Her work has garnered recognition and over 40 awards in national and international juried exhibitions and is among the permanent collections of five museums. She was honored with a successful one-woman show at the Museum of Florida Art and Culture in 2006.

She is a signature member of the Pastel Society of America, a member of Oil Painters of America and the Rocky Mountain Plein Air Painters, and a member of the Master Circle of the International Association of Pastel Societies. Her work has been featured in numerous books and magazines, and PBS has featured her as part of the *Expressions* television series.

Stephanie has a passion for painting from life, whether in the studio or plein air. She spends as much time as possible in Putney, Vermont, painting with a group known as The Putney Painters led by Richard Schmid and Nancy Guzik.

5 Skip the Planning Process

Artists are sometimes hesitant to begin because the planning process can be so intimidating. Using acrylics allows me to set down rapid impressions without worrying about where I'm going. There's no need to work out a composition ahead of time, no need to make a lot of thumbnail sketches or to make a drawing first. The acrylic medium is utterly forgiving and allows restructuring all or part of the composition every time I change direction.

Rather than establishing a formula or routine, working in acrylic means each painting becomes a unique process of discovery and invention. Because acrylic dries very fast and is quite opaque, and because each layer is impervious to lifting once it's dry, you can set down every brilliant color impression, every intense dark, every bright point of light—in any order—assessing how well the painting is working by stepping back and looking critically every few minutes.

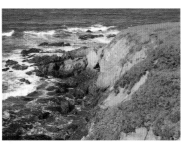
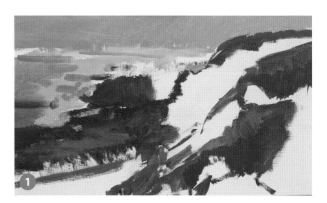
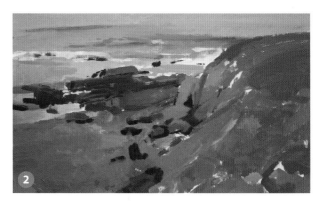

REFERENCE PHOTOS
On my first day of painting, the sky was quite overcast. My painting subject, Otter Point in Cambria, California, was sunlit on the second day.

1 Getting Started
Using an 18" × 30" (46cm × 76cm) canvas and a no. 16 brush, set down gestural lines and patches of color using only water and acrylic paint mixed on the palette. This helps ensure that the composition fits onto the canvas and that the elements relate to each other in an exciting way. Fool around with whatever color you first choose, then add complements or other colors. For the ocean color, use Phthalo Blue and Titanium White modified with Cobalt Blue, Permanent Green, Dioxazine Purple or Violet Oxide as needed. For the cliff, choose bright colors like Permanent Green and Cadmium Orange modified with their complements. Cut into the line of the cliff by using the color of the ocean to create a notch. Add white with caution as it can kill the brilliance of the colors.

2 Begin Painting the Water
Observe the waves and rocks carefully and block in the shapes. Modify the colors and the shapes as you observe changes in each area. Trust yourself to see the color and put it down as you see it. If it looks slightly purple, paint it that way.

Paint the smaller waves and rocks with as large a brush as you can. Use white to depict waves over rocks in the distance, as well as a gray mixture of white, Permanent Green and Dioxazine Purple. In the foreground water, a mixture of a bit of Phthalo Blue, Dioxazine Purple, Cobalt Blue and Violet Oxide with a bit of white will give the impression of looking through the water to the dark rocks below.

3 Make Adjustments to Accommodate the Changing Scene

When your subject changes, if you like what's happened, you can make those changes on the canvas. The tide has been coming in and has raised the water level and covered some of the rocks. There is more surf in the background and the bottom foreground. Capture the foam breaking along the rocks and rolling waves using the same colors in different combinations and keeping your brushes large. To paint foam or breaking waves, be aware that they are not usually pure white, so modify Titanium White with Cobalt Blue, Chromium Oxide Green or hints of any other color you see. Begin to define some of the darks in the cliff area using a no. 10 brush, Violet Oxide, Dioxazine Purple, Hooker's Green and Cadmium Orange to approximate the shadows cast by the vegetation. By painting over what was already done, you have sacrificed some aspects to achieve improvement in other elements.

4 The Second Day

On the second day the sun lit the scene with brilliant colors. Keep the composition more or less as it began, but add in the sunshine. As you work over the first or second layer of paint with nos. 10 or 8 brushes, dry your brush on a rag after mixing the new color and drag it over the color already there to give subtlety and richness to the surface. The further you go in your painting, the more you can rely on this technique.

As the tide ebbed, the scene returned to the very low tide I began with the first day. Add back all the rocks previously covered over, retaining some huge waves breaking over the farthest rocks. Cut down the roundness of the cliff top, letting the pale gold cliff and the foam in the water blend into a single light value. Avoid thinking of details; instead resolve the painting so you are happy with the way each area tells the story of the scene and works with all the other areas.

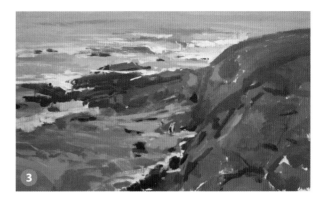

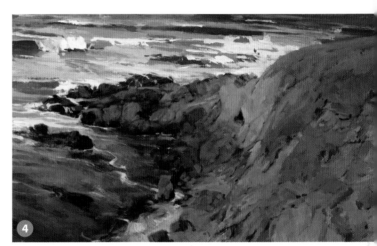

OTTER POINT | Marcia Burtt
Acrylic on canvas; 18" × 30" (46cm × 76cm)

Marcia Burtt | marciaburtt.com

Marcia Burtt is drawn to qualities of color and light and how they form changing patterns throughout the day. She focuses with intensity on every subtlety of light in the landscapes she paints. "Making a painting, for me, is a process of studying a subject over a period of hours or days. Eliciting meaning from a random collection of natural objects requires receptively seeing in a sensual way, while at the same time imposing structure. This dance between perception and intellect to create an object that holds a unique communication is the great joy of being a painter."

Burtt graduated from UC Berkeley with majors in pre-med, psychology and art, and earned a master's degree in art from the University of Montana. For over 25 years she has worked with fellow painters to protect California's agricultural and wilderness lands. Her paintings have been included in a number of exhibitions in regional museums, and large commissioned paintings hang in major healing centers, including MD Anderson in Houston and Cedars-Sinai Outpatient Cancer Center in Los Angeles. Her work frequently appears in art publications.

6 Paint Without Stopping to Critique

When my husband took up fiction writing, he read a lot of books about how to become a writer, and I read them too. Several of these books offered one piece of essential advice: figure out a way to let the whole story flow out before you edit or critique what you've written. Do not stop to reread, edit or pick at your pages until the first draft is completely finished.

Transferring this idea to painting wasn't easy, but I wanted to find a way to help my students cover the canvas boldly. Simply asking them to do this didn't work. Gradually I noticed that my most rigid and fearful students liked to work with very small canvases. Think-

ing backward from effect to cause, I wondered if the fact that they could see the entire work at once without stepping back allowed them to critique their work continuously. I believed that constant self-criticism made them afraid to work freely, and therefore their work was stilted and tight.

Even though I wanted to work outdoors, I decided that in order to free up, I would use a very large canvas and a large brush. My goal was to cover the canvas completely before stepping back to critique. This allowed me to be in the canvas and to let my work flow.

REFERENCE PHOTO
East Beach, Santa Barbara, California. The subject, artist and unblemished canvas in bright sunshine about 2 o'clock in the afternoon. As the sun began to set, the colors changed. When this happens, you have to decide what you will incorporate into the painting and what you will leave as it was earlier.

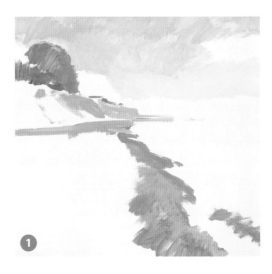

1 Lay Down Large Shapes
Working on a 40" × 40" (102cm × 102cm) canvas, set a deadline and allow yourself at least 3 hours to set up and paint. It's best to use a roughly square rather than panoramic canvas for this technique as you won't be able to see around your canvas if it's too wide.

Begin with a no. 16 brush and set down large patches of color using only water and acrylic paint mixed on your palette to quickly establish the shape of the sky, the trees and the line of wet sand on the beach.

2 Continue Finding Shapes
Still using a large brush, observe the waves and sand in the undertow and roughly indicate the distant points of land. Sticking with the large brush will keep you from focusing on details and helps you see the larger forms. Keep your paints readily available in a fishing tackle box and occasionally mist them with water from an ordinary spray bottle.

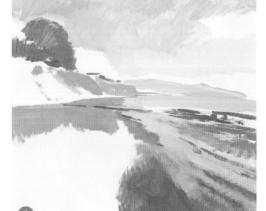

3 Paint the Sand

As you look at each area of sand, mix the color you see and apply it rapidly. If it looks wrong when you brush it on the canvas, continue adding bits of color—Cadmium Orange, Permanent Green, Dioxazine Purple, Violet Oxide, white—on the palette until you're happy with what you've got. Then look at the next part of the sand, modifying the pool of color you just made by adding whatever colors you need to get it right. It might take 10 or 20 tiny bits of color, added serially, until you are satisfied each time. Don't worry if the patches don't quite fit or blend into one another. Sometimes this can add excitement to your painting, but you can decide later whether to modify or blend. Now your job is to see and put it down as accurately but as swiftly as you can. Paint the cliff and trees with the same approach. Use Permanent Green and Cadmium Orange in the trees and Cadmium Orange and white in the cliffs, modifying both mixtures as needed with touches of any color in your box.

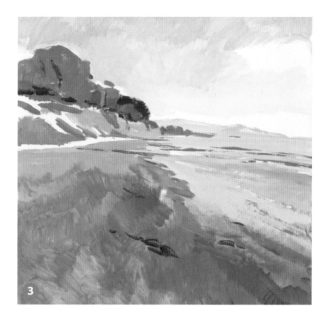

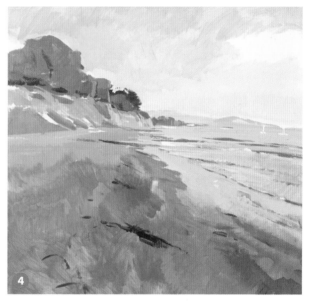

4 Adjust to Changing Light

The sun is slowly getting lower in the sky. Still working rapidly with a very large brush and standing within arm's distance of your canvas, continue observing the ocean and sand, repainting with abandon. The foam is slightly pink, so without fear paint what you see. As you observe the sky, you can see a faint haze appearing near the horizon, and this is slightly pink too.

As the sun lowers in the sky, you will see more gold in the cliffs, so repaint those areas to maximize the drama of the moment. The sand will appear much darker, and you can either leave it as it was earlier or darken it, or just darken it nearest the water. Add faint shadows and golden lights into the distant mountains.

5 Finish in the Studio

Back in the studio, use photographs to modify your composition, check values and refine small shapes and details, but don't get so carried away that you lose the energy and freshness you put into the painting's first draft. Turn the canvas upside down to get a better sense of the abstract qualities of your painting and to analyze your composition and make adjustments. In this case I heightened the trees on the far left and repainted the distant point to improve its shape.

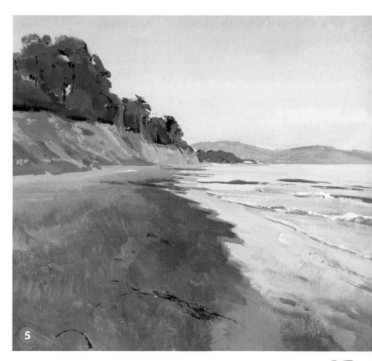

LATE SUN, EAST BEACH | **Marcia Burtt**
Acrylic on canvas panel; 40" × 40" (102cm × 102cm)

7 Paint With the Other Hand

To get out of a rut, you have to do something different. I wondered what would happen if I painted with the other hand. In my case, being left-handed, that would mean using my right hand. Although doing something the hard way can be satisfying in a weird way, I wondered what else I could accomplish? Perhaps a less detailed, more painterly effect would emerge because detail would be difficult.

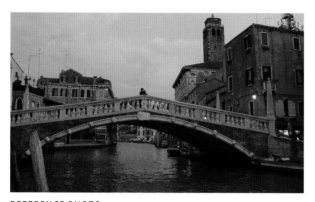

REFERENCE PHOTO
This photo was taken just before sunset in Venice during a visit there a few years ago. It had a strong focal point, a very interesting sky and a lot of detail. The goal of minimizing detail and simplifying made it a perfect subject.

I have to admit that I am somewhat ambidextrous. I write and paint with my left hand and use it for anything requiring steadiness and precision. But I use my right to eat, handle tools and for anything requiring a strong grip. To make sure I didn't absentmindedly cheat with my left hand, I turned my easel around so my right hand was closest to the pastel boxes and trays, providing a constant reminder.

Considering my objective of reducing detail, I chose a subject in Venice, where every square foot is packed with detail. I did the initial outline drawing with my left hand, as usual, because this was an experiment with painting, not drawing.

Being forced to simplify reminded me that I didn't have to paint every window or all the details shown in the photo. Completion of this piece took about twice as long as it would have normally, but I am pleased with it, and I proved that I can paint with either hand. Give it a try— you may think it's going to be difficult, but on the other hand, you may be pleasantly surprised at the results.

1 Draw on a Tinted Surface
Start your sketch on 11" × 14" (28cm × 36cm) tinted pastel paper with a coarse tooth. The background tint adds to the color harmony and works with the dusk theme. Use vine charcoal to outline the basic shapes for a simple drawing. You can erase the charcoal with a clean kneaded eraser if you need to correct the drawing.

2 Concentrate on the Sky and Water
Paint the sky with soft pastels in light to medium values of Ultramarine Blue, a light purple, a medium magenta and a medium pink. Lay in the pattern of clouds and sky, and blend to fill the surface. Using a surface that has a coarse tooth means it will resist most blending techniques. A paper towel folded to create a point will work much better than your finger or many other common blending tools.

Using the same colors, create the reflective portion of the water under the bridge, making it slightly darker than the sky. Then, using a very dark purple, block in an underpainting for the rest of the water.

3 Block in the Structures

Fill in all of the buildings above the bridge using hard pastels in medium and dark brown, reddish brown, light and dark blue, black, dark red and orange. Use a medium-hard dark purple to add texture and neutrality to some of the buildings. Finally, to add interest to textures and colors, lightly skim over some of these areas with a soft reddish brown stick. Use darker-value pastels, held on the side, to skim over some of the buildings to add dimension and depth.

4 Rough In the Bridge and Finish the Water

Moving from background to foreground, render the bridge with light- and medium-value blue, blue-gray and black, all hard pastels preferably sharpened to points. At this stage you will realize that fine lines are impossible on this paper's very coarse tooth. Much of the detail in the bridge is eliminated, but the basic shapes are needed for this "look at me" focal point.

Finish the water using a light warm yellow-green, a very dark green and an olive green soft pastel. Use the 2 pinks used in the sky in the lighter reflection areas. Create ripple effects with a light skimming of soft olive green pastel and some very light blending with a finger. Indicate detail under and behind the bridge with a hard black, 2 blue-gray soft pastels in medium and dark values, and the hard dark red used in step 3.

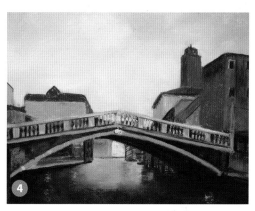

5 Paint Windows and Any Corrections

Being very careful not to smudge the sky, install the windows using a hard black pastel sharpened on one end and squared off on the other. The squared end makes nice block marks. Finish the bridge with more detail and make any necessary drawing corrections.

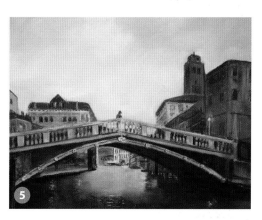

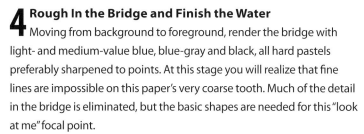

6 Final Details

It's usually a good idea to set a painting aside for a day or two before you decide it's finished. In this case, the dotted line under the red roof at the left side practically screams "cut here." Remove it, make any other adjustments you find necessary and it's done.

The reference photo had a figure standing on the bridge. If you've ever been to Venice, you'll know this scene shouldn't be totally devoid of people, so add in this figure, using a dark hard pastel and keeping it simple.

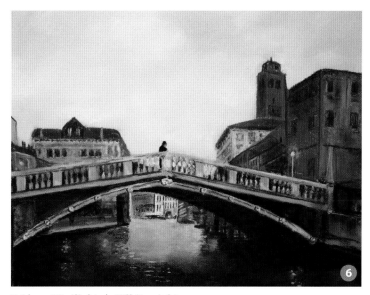

Bridge at Twilight | **Bill Canright**
Pastel on Richeson Premium Pastel Surface; 11" × 14" (28cm × 36cm)

25

8 Tackle a Difficult Subject

Recently while thinking about what I might do to improve my work, it occurred to me that I should quit procrastinating and attempt one of the subjects that most intimidated me. For example, scenes that involve close-ups of the human figure have always been intimidating. Although I like doing buildings and street scenes, I have generally avoided human figures in the foreground because I can't stand a drawing that is not quite right. If you make many corrections working in pastel, you lose the freshness and often create a messy muddle. When I included people, they were very small and required nothing but simple shapes.

Sometimes you can tell an interesting story with just one or two people doing ordinary things. This photo of a little boy fascinated by something in the water was a good example. It had some very strong light and shadow effects but would have been less interesting without the boy. So I accepted the challenge and got busy with it. Actually, it was not as hard as I thought. I not only ended up with a nice sense of achievement, I also have a new level of confidence and can envision a lot of new possibilities. Instead of trying to paint people out, I may just paint them in.

REFERENCE PHOTO
During several workshops in Spain, we painted in a plaza in the village of Ronda that features an interesting fountain. This youngster also seemed to find it interesting, and his figure added a lot to a potential painting composition.

1 Start With a Black Surface

When a subject is mostly dark or in shadow, it works well to use a black surface. Working with pastels on the black pastel surface allows quick handling of dark areas. You can also work on a piece of sanded pastel paper that's been toned with a black pastel and washed with Turpenoid or alcohol, but that approach allows some mingling or muddying of subsequent layers of color.

Begin by drawing with a light gray pastel pencil to establish the outline of the major shapes. The boy's figure will probably present some drawing difficulties. One disadvantage with using the black surface is you will merely make smudges

if you try to erase or brush off the pencil marks. To avoid this, tape a piece of tracing paper over the board and render the figure with a pencil, erasing as often as necessary. Then rub a soft pastel all over the back of the tracing paper and transfer the main features to the board with a ballpoint pen or ordinary medium-hard pencil.

2 Block In Around the Figure

Using hard pastels when working close to the figure, fill in the surrounding area. Then using hard and soft pastels, roughly fill in the balance of the panel to establish the basic value and color structure. Use a brown, a white and a gold pastel close to the figure. For the rest of the panel, you will need soft pastels with three values in the orange/brown range, a very dark green, a mid-value yellowish green, white and light blue. Use wide strokes with a light touch allowing some of the black surface to show through. This also avoids filling the tooth too much. Also add a few details with a sharpened black hard pastel and some blending with a medium blue-gray hard or semi-hard stick.

3 Finalize Around the Figure

Take the area close to the figure to completion. This way you won't be in danger of hitting the sharp, critical edges of the figure. Continue with the greens, grays and browns used in step 2. Add soft pastels in a dark reddish brown, very dark brown and very dark purple. For the water, use a medium-hard olive drab green and a soft light yellow-green. Skim the yellow-green over the darker color to create the moving water effects. Smooth out the darker water areas with a finger or other blending tool. When blending on the very coarse surface, you may find a paper towel folded to a point to be the best tool for the smooth blending usually needed for sky and water areas. Bits of the paper towel may rub off on the surface, but they can be removed easily.

4 Paint the Background

Create the background using the black, dark green, medium green and dark brown soft pastels already selected. Some touch-ups on the fountain surround and pedestal can be done at this time. The sun spots are created with the corner edge of the light yellow-green soft pastel—preferably one with a square shape. Some simplification of the sidewalk lines will clarify the confusion of lines in the photo. Letting some of the original black surface show will make the tree trunks and rock more visible. Use your darkest purple for the trees.

5 Begin the Figure

Begin rendering details in the figure using three values of gray, consisting of the two lighter soft pastels already selected and a hard, slightly darker stick. Also use several hard pastels—2 yellows (1 bright light and 1 medium), a red, an orange, a skin-tone orange and a black. All hard pastels will be easier to control if sharpened to a point. An artist's mechanical pencil sharpener or small handheld sharpener works well for this.

6 Finalize the Figure

Finish the details on the figure. Brighten the yellows in the shirt with a soft pastel. Use an orange pastel pencil to blend skin tones. Use a hard pastel with a flat end to make straight, uniform marks for the red slats along the front of the fountain base. Brighten up the pedestal in the center using soft, square-shaped pastels. Notice how a light touch with broad strokes creates an interesting pebble-like texture as a result of the rough surface. Make any drawing corrections needed on the pedestal.

Now that the painting is virtually finished, set it aside overnight and take a fresh look the next morning. You may be surprised by something that you didn't see before, and you'll have a chance to fix it.

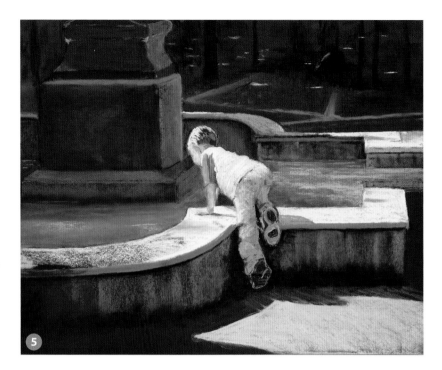

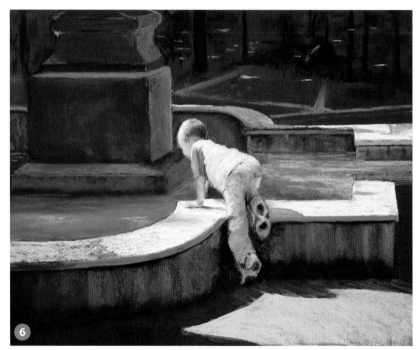

7 Final Details
With a fresh look in the morning, I fixed the blotch in the middle ground, the top edge of the stonework, a problem in the boy's left pant leg and the distracting, overly bright, red slats in the foreground.

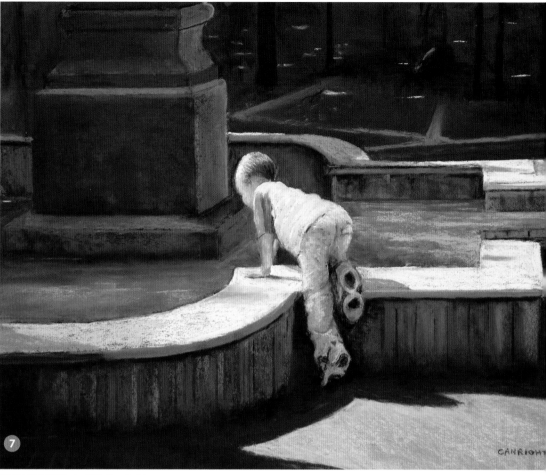

FASCINATION | **Bill Canright**
Pastel on black Richeson Premium Pastel Surface; 16" × 20" (41cm × 51cm)

Bill Canright | billcanright.com

Bill Canright was born in Royal Oak, Michigan. He grew up in a number of locations in Minnesota, Ohio, New Jersey, Michigan and Oklahoma. At age fourteen, he started his art career as a self-taught painter in oils. By the time he was old enough to consider art school, the focus in schools was on non-representational art, which did not interest him. He turned to product illustration, art direction, writing and creative direction in advertising. About twelve years ago, he left the advertising and commercial art world and returned to painting full time in pastel and acrylic.

He is a signature member of the Pastel Society of America and the Pastel Society of New Mexico and a member of the International Association of Pastel Societies' Master Circle. His work has been shown, often winning awards, in 27 national pastel exhibitions since 2005.

Bill and his wife, Maggie Price, combine their love of travel with teaching foreign and domestic workshops. On these trips, they enjoy plein air painting with their workshop students and on their own in locations including Scotland, Spain, Italy, France, Greece, Australia and other interesting places yet to be discovered.

9 Use a Limited Palette

Any single hue used throughout a painting, or in mixtures of color within a painting, usually helps the painting read as harmonious. Yet overmixing can lead to dull colors. Premixed colors contain the primaries—and sometimes even secondaries and tertiaries—in their mixtures. Mixing with these colors can lead to a loss of color harmony and a muddy or garish painting.

Limiting the palette, using only 3 or 4 pigments (plus white), gives you the freedom to make colorful works that remain harmonized. In a limited palette, few colors are mixed and used in the painting without including and mixing in some of the other colors even in small amounts. All the colors work together, creating a strong sense of harmony.

Color in nature is not inharmonious or garish and rarely requires bright, pure pigment. We all recognize a pleasing painting that represents nature. The advantage of the limited palette is that it teaches you the nuances of every color you can mix, and the painting is unified because all the color is related. In theory, the primary colors (blue, red and yellow) can be used to mix all colors. A limited palette is not limiting!

1 Arrange Your Limited Palette
Arrange your palette with a generous amount (thick 2-inch (5cm) strip or about a tablespoonful) of 5 colors—from left to right, Ultramarine Blue, Alizarin Crimson Permanent, Cadmium Red Light, Cadmium Yellow Light and Titanium White. Using your palette knife, play with different color mixtures before you begin.

2 Begin the Drawing
With a 1½-inch (4cm) palette knife, lift a bit of Cadmium Red Light, Alizarin Crimson Permanent and Cadmium Yellow Light and mix together. Dip a no. 8 filbert into mineral spirits and use your brush to mix a wet, thin rosy mixture. Apply to your 11" × 14" (28cm × 36cm) canvas, spreading it around loosely until you have an even layer of thin transparent paint on the canvas. Using a paper towel folded around your finger, lift out the light spots of the painting. This serves as a drawing as well as a guide to the lightest values in the painting.

3 Begin With the Darks
Mix equal amounts of Ultramarine Blue and Cadmium Yellow Light to make a green. Add Alizarin Crimson Permanent until the mixture is a dark reddish-purple-umber color, and apply with no. 6 filbert to the areas of darkest values in your painting. Connect the darks into a silhouette, working all over the painting where darks are found. Use a paper towel to blot or lift out areas, soften edges and lighten some of the darks if necessary.

4 Add the Midtones

Add Cadmium Red Light to the darks mixture and indicate leaves in the tree in the foreground. Indicate leaves, tall grass and foliage in the foreground.

Mix a mid-value green and break up the dark areas. Paint around the house and within the trees to establish a mid-value green within the darks in the distant trees, bushes, foliage and tree in the foreground.

5 Paint the Grass, Sky and House

Mix a light greenish color for the grass. Apply this to the lawn as well as the few leaves on the tree that catch the light from the sky. Add more blue to this mixture to make it darker in areas where the grass is thicker and in the rough grass in the foreground, using the knife as well as the brush. Paint the sky with a toned warm color.

Begin the house with a very light blue. Use the palette knife to pull in a small amount of yellow and red to warm the mixture. To warm up the house-color mixture, create a light white color that is more yellow than blue. Paint over the bluish whites already laid down, keeping some of the blue tint showing in some places.

6 Final Details

Mix a dull reddish gray with the remaining house paint color and paint the light poles, pulling the paint from the side of the brush. Lighten the mix with white to create a sense of light on the right side of each pole.

Use the edge of the palette knife blade dabbed in white to place the cable wires. Add the bush growing up the wire using the medium green mixture for the foliage. Loosely paint the white flowers with white paint warmed slightly with red and yellow. Use your palette knife to smear the mix from the flowers downward to indicate the stems and textured grass.

HOMEPLACE | **Dot Courson**
Oil on canvas
11" × 14" (28cm × 36cm)

Dot Courson | dotcourson.com

Dot Courson is a full-time professional artist whose work is in corporate, public and private collections all over the United States and abroad. From her Hidden Creek Studio in Pontotoc, Mississippi, she paints and hosts workshops for artists. Her oil paintings have been exhibited in and won awards in several national shows, as well as numerous solo shows, galleries, colleges and art museums.

Dot is best known for large landscape paintings and has traveled the United States painting and photographing the scenery from coast to coast, but she primarily paints the beauty of the Southern landscape. A large triptych of the Natchez Trace Parkway is in the collection of Haley Barbour, governor of Mississippi. Her work has been featured in *Mississippi Magazine*, *Delta Magazine* and *Mississippi Farm Country* magazine and in numerous newspapers and other publications in the Southeastern United States.

Dot is a member of the Mississippi Painters Society, the Mississippi Oil Painters Association, Oil Painters of America, Landscape Artists International and the American Impressionists Society. She is a signature member and serves on the board of Women Painters of the Southeast.

10 One Reference Photo for Many Paintings

If a picture is worth a thousand words, as the old saying goes, then it's probably worth at least two good paintings!

Sometimes artists feel paralyzed by trying to decide what to paint next. This indecision stalls artists and saps their energy. As right-brained, creative individuals, we can dream up ideas extremely well, but sometimes lack organization and direction.

If you have already painted from a particular photograph and the painting was successful, you probably have another potential painting at your fingertips. Why not just recrop it to make a new and different painting? Or change the elements around in the painting. Or both. It may give you a level of comfort that gets you back to painting your best!

Choose a good photo from your files that you've used before and crop it to see if you can find a new painting and renewed inspiration. Push the colors in it to cool it down or warm it up. Rearrange elements if needed. You may find new inspiration and enhanced creativity by approaching your work from a totally new angle.

JEKYLL ISLAND | **Dot Courson**
Oil on canvas; 30" × 30" (76cm × 76cm)

VERSION 1

Jekyll Island is a painting that I did earlier from a favorite photo. Some time later, on a winter evening, while mired in angst and indecision about what to paint, I stumbled upon the original photo and saw more possibilities for other paintings.

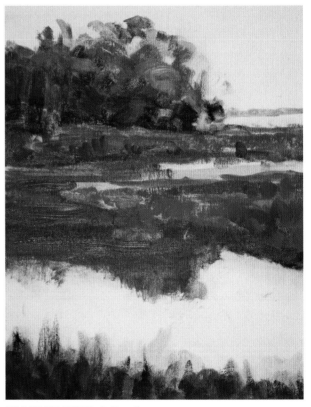

ISLAND MARSHES | **Dot Courson**
Oil on canvas; 14" × 11" (36cm × 28cm)

VERSION 2

Island Marshes is a cooler color variation of the flipped reference photo and a more intimate view of this landscape than *Jekyll Island*. A new look at older reference material can often bring renewed inspiration and new ideas.

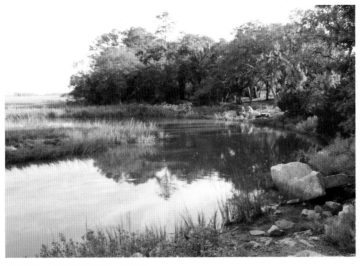

ORIGINAL REFERENCE PHOTO
When you have a really good photograph, there could be 2, 4 or more possibilities for a painting.

ZOOM IN ON THE FIGURES
The first new painting possibility is the figures sitting on the bank, backlit by sunlight with the wonderful reflections in the water. This could even be cropped closer to focus on the figures alone.

CREATE A STRONG HORIZONTAL
Another possibility is a long horizontal of the marsh, emphasizing the light in the trees, which floods across the water and the grasses. A horizontal landscape panorama is generally attractive as a painting.

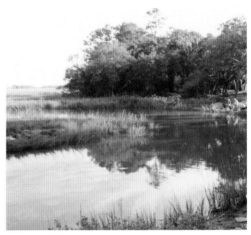

SQUARE THE COMPOSITION FOR SOLIDITY
Cropping to an almost square format and then zooming in on the trees creates another pleasing possibility. This image is the basis for Jekyll Island, *though the colors were warmed up in that painting.*

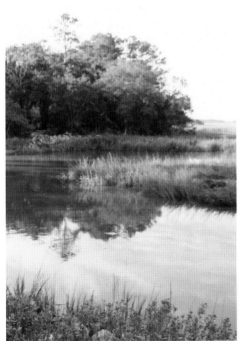

FLIP THE PHOTO
Flipping the cropped scene on the computer screen to vertical reveals this composition that features the tree masses with the water and horizon all coming together in this one area in the upper-left third of the painting. I also liked the left-to-right light flow, so I chose it for this painting. To balance the scene, I decided to move the tall pine tree from the center of the photo over to the left when I painted Island Marshes.

Feel free to move or eliminate elements (trees, buildings or objects) in your own photos to help you see a stronger composition.

11 Working Backward

I consider myself a pastelist, but every now and then I feel the need to get out of that old pastel artists' rut. You know, darks first, thinly applied, then midtones, edges, highlights, etc. I find it refreshing to switch to watercolors, where you do just the opposite—paint the lights first and the darks last. To me, this is working backward! And whenever you do something opposite what you normally do, it helps get you out of the rut of your normal procedures.

Watercolor demands a lot more planning and a lot more care when painting than pastel does. One of the main reasons is that it is so much more difficult to make changes. For example, if I put in a yellow sky and I don't like it, I cannot simply wipe it out or paint over it as you can in pastels or even in oils.

Planning is the secret of watercolor painting. Value sketches are invaluable for many reasons. That process lets you consider more than one composition, and it makes you really concentrate on values. I always try to do my sketches using only three values: dark, medium and light. I like to call the result my "road map" because it tells me which route to follow.

REFERENCE PHOTO
This is a photo of old ranch barns on the high road to Taos, New Mexico. The barns are old and abandoned but so full of nostalgia that I have painted them dozens of times. I use cardboard Ls to isolate interesting items and to create pleasing compositions.

1 Create a Value Sketch
Create a simple drawing from the reference photo using a chisel-point soft carpenter's pencil. Concentrate on making a tonal value sketch, not a line drawing. It's often helpful to do several versions of the scene, then select the strongest one. Quite often you will find yourself working from the sketch rather than the photo, particularly in the early stages.

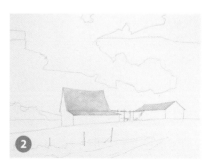

2 Sketch the Drawing and Preserve the Roofs
On a sheet of stretched cold-pressed watercolor paper, lightly sketch in a simple line drawing with an HB pencil. Ignore details and concentrate on establishing large masses.

To preserve the light areas of the roofs, posts and fences, apply a masking agent—in this case, Pebeo Drawing Gum—with an old brush. Now you are free to paint in the background with long, sweeping strokes without worrying about painting around small details.

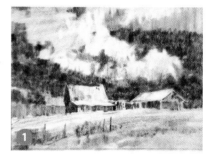

3 Apply the First Wash
Dampen the entire sheet, then apply the initial wash with a 2-inch (51mm) brush using Ultramarine Blue with just a tad of Burnt Umber to soften the blue. Cover the entire sheet with this wash to establish the cloud color and at the same time develop an overall tonality to the painting. Make sure to vary the color and value from top to bottom. It is important to get this wash just right as it is the foundation of the whole painting.

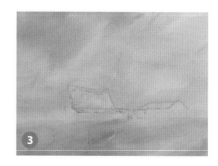

4 Block in the Foreground

Using the same 2-inch (51mm) brush and a mix of Burnt Umber, Raw Sienna and Ultramarine Blue, darken the foreground as needed. For good texture, make sure the first wash has a variety of color and value. Once that layer is completely dry, apply more texture using various dry-brush, stippling and splashing techniques.

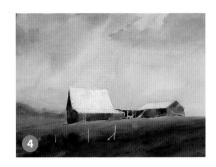

5 Paint the Clouds and Mountain

Create the cloud shapes by painting the blue sky and mountains around them, careful to retain the correct shape of the clouds. Use a wet sponge to lightly dampen the whole background. Use a 1-inch (25mm) flat to paint the sky with Ultramarine Blue toned down with a touch of Burnt Sienna. While the paper is still wet, put in the mountains with a mix of Olive Green, Cobalt Blue and Burnt Sienna. If some of your cloud edges dry with a hard edge, soften them with a brush dipped in clean water. Your underpainting has now become your clouds.

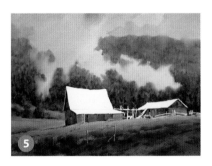

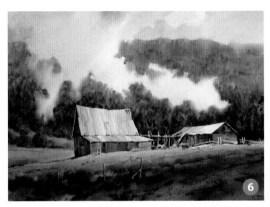

HIGH ROAD TO TAOS | **Charles "Bud" Edmondson**
Watercolor on 300-lb. (640gsm) cold-pressed Arches
20" × 28" (51cm × 71cm)

6 Paint the Barn and Add Final Details

Remove the drawing gum and block in the barns using a mix of Burnt Sienna and Cobalt Blue, keeping the roofs light in value. Make sure that some areas are cool and others are warm, keeping the values of the barns in proper relationship with everything else. Because this is a dull day, the values are fairly close together. For the details of the barn, use a no. 7 brush with a chiseled point to create impressions of barn siding.

Now for the fun part! Add dark accent strokes to enhance details like holes in the roof, windows, fences or anything else that will give the painting character and mood. Be thoughtful at this finishing stage because more paintings are ruined by overpainting than anything else. Lastly, tidy up by erasing obvious pencil lines and making sure your value relationships are just right.

Charles "Bud" Edmondson | budedmondson.com

Bud's entire working career has been art related. He worked as a commercial illustrator for 35 years. He owned his own studio and worked with clients such as World Book Encyclopedia, Motorola and Sunbeam. Even while working as an illustrator, Bud was active in the fine arts, showing his paintings in several Chicago and Wisconsin galleries and teaching night classes at Northeastern University.

Nearly 20 years ago, he decided to devote himself to painting full time and moved to Albuquerque, New Mexico. He paints and teaches classes and several workshops a year. He works primarily in pastel and watercolor, which he says allow him to combine draftsmanship with spontaneity. He is a firm believer in painting on location so he can "get the real feel of a place." Most of his larger works, while conceived on location, are finished in the studio.

He holds Signature membership in both the New Mexico Watercolor Society and the Pastel Society of New Mexico and has won numerous awards in a variety of juried exhibitions. His work has been featured in *American Artist* magazine, *The Pastel Journal* and *Focus Santa Fe*.

12 Pick Four Photos, Create One Painting

"Pick Four" is not a lottery game; it's just a little trick I use to inspire myself. As artists, we all have those moments when confronted with a blank sheet of paper and not a single idea about what to draw on it. As we all often do, I end up wasting hours of time perusing and discarding every research photo I own. Nothing is ever quite right and that perfect composition doesn't seem to exist.

So to get started, I go to my photo file and randomly, without looking, select four photos. Why four? It just seems like a nice number. From these four photos, I do numerous value and compositional sketches. It's amazing what you will discover if you really analyze each picture. I have found that many of my best works have come from ordinary sources.

Shown here are the four photos I picked at random from my photo file. When I think about the composition, I never just look at the photo; I always use my homemade cardboard Ls to isolate parts and create different sizes, shapes and compositions. I first look for the obvious—is there a lead-in, is there a good center of interest, is there good value range in the center of interest and, of course, is there a mood to the piece?

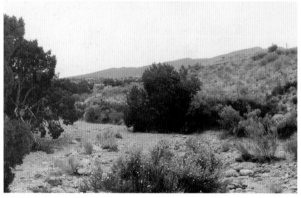

PHOTO 1: THE OPEN SPACE
This photo was taken at one of Albuquerque's open-space areas. The picture has all the elements I look for.

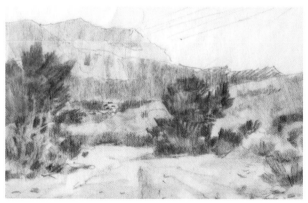

SKETCH 1
I zoomed in on the subject to make the center of interest larger. The leftward slanting mountains didn't work for me, so I added a larger mountain. I also added a bit more of a pathway to lead the eye into the composition.

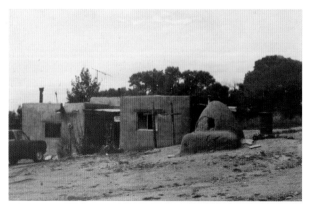

PHOTO 2: THE PUEBLO
A photo of a pueblo in New Mexico.

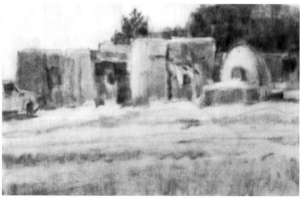

SKETCH 2
I decided to eliminate a lot of sky and some of the trees on the right side to force attention to the center of interest, which is the building.

PHOTO 3: THE RIVER
A section of a river gorge in northern New Mexico. Notice how the center of interest is dead middle. I decided to crop to relocate this point.

SKETCH 3
You will often find that your photos contain too much information and you can improve your composition by just zooming in.

PHOTO 4: THE RANCH
This old abandoned ranch house is now gone, but I still have my photo.

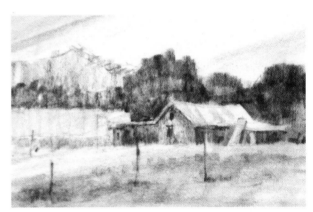

SKETCH 4
I liked the mood of the photo, but the center of interest was in the middle, so I relocated the house in the picture frame. I also relocated the large tree in front of the house, made the fence less intrusive and made the distant mountain a more important part of the sketch. This sketch was used as the basis for the final painting.

Pick a Sketch and Paint

Using my Pick Four method, I've got 4 sketches that would make acceptable paintings. For today, I like the old ranch best as a painting subject.

For the final painting, I sketched the subject, masked out the lightest areas with frisket and washed in the sky. From there I painted loose with as little detail as possible. Near the final step, I removed the frisket and painted the roof, added a few accents and checked to see which edges needed to be softened or emphasized.

Keep in mind the message, the mood, the emotion or that intangible something that every good painting should have. A painting without emotion is simply an arrangement of shapes and colors.

This old ranch house may have gone to pieces, but it made a great subject selected from my Pick Four exercise.

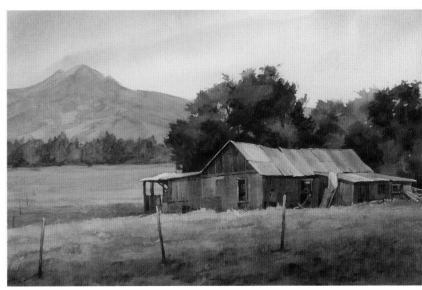

GOING TO PIECES | **Charles "Bud" Edmondson**
Watercolor; 17" × 28" (43cm × 71cm)

13 Painting From Memory

Whenever I'm struggling with my art or feeling adrift, I try to look for simple shapes and relationships that I can use in a composition. Usually these efforts are more impressionistic and slightly abstract, but they can lead to some very serious work down the road. For these exercises, I work from memory and resist the use of photographs. I rely on my own stored experiences, which I believe we all can get to if we just begin to access our personal mental databases.

I work out several sketches with the emphasis on big shapes and the feel of the remembered scene. I focus on composition, center of interest, and movement and energy, remembering that everything must support the center of interest. The more I am comfortable with this part of the process and feel engaged and challenged by the sketch, the more free and expressive I can be with the painting.

When you try this, spend some time visualizing the place, the weather, the time of day, even the sounds of the place. It is amazing how this amount of non-painting visualizing can inspire a big jump forward. When you start to paint, move outside your comfort zone and let the painting happen. Begin with both brushwork and expressive colors, get into the scene and don't get bogged down with the little details—they are not important. Try hard to not let the "critical you" interrupt the painting process, but rather look to be creative instead of perfect. If the colors are too strong and unusual for your normal style, that is good; let the excitement and boldness take control. You are trying to remove the artistic block, not add to it. Just paint.

1 Recall and Sketch the Subject

For this demonstration, I recall a windy, big surf day at Pemaquid Point, Maine, and have interpreted the landscape features from memory, adjusting the subject matter for the purpose of compositional needs. I want the big surf and rocks to starkly contrast against the landmass and beach area at the right of the painting. I remember the power of the surf as it crashed against the rocks. I will push the colors and contrast beyond the normal because I want to get into a more expressive and creative mind-set.

Using a 6B pencil and working on 15" × 22" (38cm × 56cm) cold-pressed paper, draw a strong contour drawing. Cover the whole paper and make an expressive drawing of the scene, focusing only on the big shapes: rocks, surf and the landmass behind the surf and rocks. Try not to get lost in details. Keep your pencil on the paper and draw strong, evocative lines.

2 Wash In Some Color

Using a 1½-inch (38mm) flat brush, put down a wash of Cobalt Blue and Cobalt Violet for the sky, loosely cutting around the tops of the surf and preserving as much white paper as possible. Clean up the edge at the top of the surf with a damp paper towel. Then lay in a very strong passage of New Gamboge for the tree-covered hill in the background and brush in Cobalt Blue just above the middle surf to get the strong contrast. Remember this is surf, so it has to have movement in a diagonal direction.

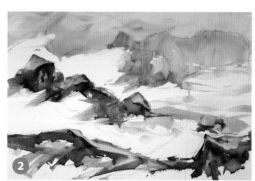

3 Indicate the Water Movement

Using a no. 12 round black sable, paint curvilinear marks in Cobalt Blue between the rock shapes to get the water moving in a current pattern. Continue using this brush with a mixture of Raw Sienna and New Gamboge to paint the beach and shoreline. Mix a nice green color with Cerulean Blue and Hansa Yellow, and paint tree patterns into the hill in the background and then darken this mixture with a little Burnt Sienna; pull this color over the blue shape behind the surf. This creates an extra plane and more detail of what is on the landmass.

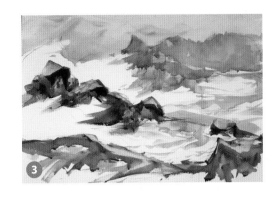

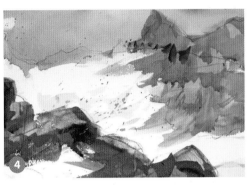

4 Paint the Rocks

Change to a 1-inch (25mm) flat brush with a beveled handle to paint in the rocks. Use a rich pigment combination of Alizarin Crimson, Burnt Sienna and Ultramarine Blue, and apply the paint with a flat, angular mark. Try to get a different top angle and size for each rock. Focus on varying colors slightly each time you touch the paper. Leave the bottom edge white, but cut into it with a variety of edges to evoke the feeling of water splashing and running in front of the rocks. Add a flat plane of Raw Sienna between the little rock on the right and the major shape. This gives a feeling of water carrying some seaweed.

5 Final Details

Using a no. 12 brush, put some darker green shapes in the background to add detail to the trees. Load a clean brush with yellow and splash into the wave pattern. Use a warm color near the foreground to indicate that the waves are strong and picking up seaweed when they hit the shoreline. To finish the painting, splatter a few bits of texture into the lower water and add a few more pieces of trees on the distant hill.

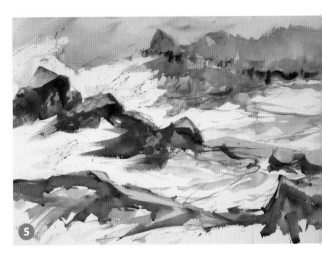

AHEAD OF ISABELLE | **Steve Fleming**
Watercolor on 140-lb. (300gsm) cold-pressed Arches
15" × 22" (38cm × 56cm)

Steve Fleming | steveflemingartiststudio.com

Steve Fleming studied at the Maryland College of Art and Design and with Millard Sheets, Rex Brandt and Robert Wood. He is a member of the Baltimore Watercolor Society and of Studio Gallery in Washington, DC.

Steve has been painting for about 40 years in water-based mediums. He spent 23 years as a commercial and residential lighting designer. For about 15 years he has been teaching watercolor, design and drawing, and painting the figure, both privately and for The Art League in Alexandria, Virginia. He has conducted workshops in Maine, Texas, California, France, Spain and Ireland, and has juried a number of local and regional exhibitions. His work has been featured in *American Artist* magazine, and his paintings are held in many private collections. His paintings have been included in solo and juried exhibitions around the United States.

14 Work From Line to Design

A great way to come up with inspiration when the creative well seems dry is to begin with the abstract. I like to draw without a specific place or subject in mind. I draw lines on the paper, letting the feeling of the pencil dictate the direction and shapes. I try to overlap lines and use all of the paper. My goal is to experiment with a freedom of line and get the creative juices flowing. I want to get involved in a creative activity and to forget about all of those excuses that keep me from picking up a brush and painting.

When you do this, it forces you to look beyond photographs and inward to those favorite shapes and relationships that are sitting around waiting for you and your muse to take out and turn loose. I also like that I am working without color references, so I have to use my own palette, which is very freeing.

I have found that on one piece of paper I can find many great ideas for work without having to resort to my photograph library. This exercise is a nice, organic way to break out from a stagnant period in your artistic journey. You're working totally from your own imagination—the shapes, colors and compositions will be uniquely yours. Soon you will find making up your own subject matter to be easy and extremely fulfilling.

1 Draw Freely
On an 18" × 24" (46cm × 61cm) drawing paper, using a 6B pencil or graphite stick, draw a continuous line from top to bottom and side to side, overlapping the lines many times to create lots of interesting shapes and sizes of shapes. Try not to think about subject matter, and look at the paper only occasionally—this will help to keep the drawing free and loose. When you are satisfied with the page, do another one. Keep creating pages until the lines are flowing and not forced.

2 Find Interesting Shapes and Relationships of Lines
Look critically at your pages for shapes in relationships that could make dynamic or evocative compositions for paintings. To isolate them, make a rectangle shape from two detached L-corners from a used mat. Move the rectangle all over the drawing looking for exciting compositions. When you find a section that you like, hold the rectangle on the paper and outline the rectangle onto the pattern of lines. You can usually find multiple sections of interesting possibilities.

3 Select a Grouping and Sketch Your Painting Surface
Select the grouping that appeals to you the most. It may evoke a feeling or suggest a composition, but look for a good design of line and shape.

On a 15" × 22" (38cm × 56cm) piece of rough watercolor paper, sketch the lines and shapes. The lines and shapes selected here suggest rocks and landmass. Try to stimulate your memory and create a painting that means something to you.

4 Paint the Sky

Using a no. 16 round, wet the sky shape. Fill the brush with a light mixture of Cobalt Violet and brush up into the sky from bottom to top covering about one-half of the sky. Load the brush with Cobalt Blue and float in the sky. Lay the paint down softly without rubbing the surface of the paper, letting the colors merge. Use a light cool green over the upper portion of the sky. Let the paint create colors and accidents; it will make the painting more exciting.

5 Mass In the Land Shape

Load a no. 16 round with a mixture of New Gamboge and Hansa Yellow and start at the top of the landmass to paint the hills. Work quickly and move down to the bottom of the shape. While it is still wet, apply green along the top edge of the hill and brush it into the side of the hill. Then clean your brush and make a strong mixture of New Gamboge and Burnt Sienna and apply it along the top edge of the shape. Add some Cobalt Violet to the mix and drag it into the lower portion of the landmass.

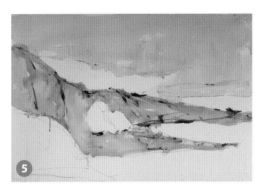

6 Paint the Rocks and Foliage

Using a 1-inch (25mm) sable brush, mix some Burnt Sienna, Ultramarine Blue and a small amount of Alizarin Crimson to paint the rocks. While the paint is still damp, use the beveled edge of the brush to scrape marks on the rocks to indicate light. Use a no. 12 round loaded with a mid-value green to place hints of trees and foliage along the top of the hill and on the lower edge of the rocks. Create a dark green and apply it to the foliage. Mix some Cobalt Violet with a hint of Cobalt Blue and make a few quick passes across the bottom of the painting for the water. While the area is still damp, use a color similar to the hill and quickly overlay it on the water to create a few areas of reflection.

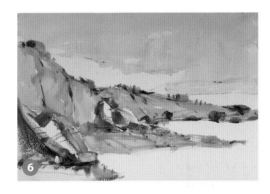

7 Final Details

Add some details to the hillside using your no. 12 round brush with the green color you mixed previously. Vary the sizes, shapes and color, and put in just enough to create interest without being overly repetitive. Then clean the brush and mix some Cobalt Violet and Cobalt Blue and brush in a few little watermarks in the water. This should pretty much finish the painting.

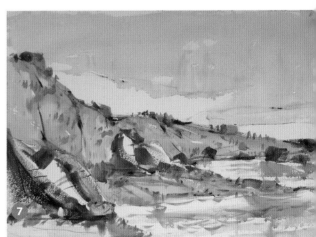

MEDOCINO LAKE | **Steve Fleming**
Watercolor on 140-lb. (300gsm) rough Arches
15" × 22" (38cm × 56cm)

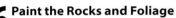

15 Get Up Close

As a painter of landscapes, my usual compositions depict vistas with fields, mountains and sky, images that allow the viewer to experience a large portion of the landscape. This is my painting comfort zone, so it's a challenge for me to do the reverse by zooming in on a very small area of a landscape and painting what I see there.

To paint *Cedar Creek Currents*, I cropped a portion of a photograph of a nearby stream, then turned it on its side. My intention was to paint the flow of water with sparkling highlights in a palette of rich autumn colors, but to let the painting evolve.

The resulting painting became very abstract, something quite different from my usual landscapes.

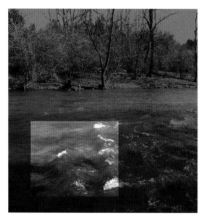

REFERENCE PHOTO
I was intrigued by the movement of the water in this photo.

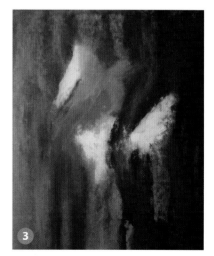

1 Crop the Reference Photo
I cropped a small area of the larger photo, then turned it sideways. By manipulating the color on my computer, I created an interesting composition with deep rich colors, as shown in the cropped photo.

2 Begin Applying Color
Working from left to right, begin applying color in long swaths with the flat side of the larger pastels. Use deep brown, maroon, blue-violet, dark Yellow Ochre, dark green and medium green. Add Titanium White to the area you want to keep highlighted, following the color plan suggested by the cropped photograph.

3 Blend and Add Another Layer
Blend the colors lightly using downward strokes with your fingers, then add more colors—yellow-green, medium orange, bright green—in a vertical pattern. After the first application of colors, apply a light misting of workable fixative here and there throughout the painting wherever you don't want the colors to blend together. This helps give a feeling of depth.

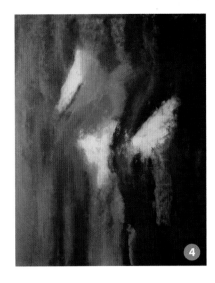

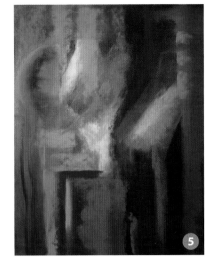

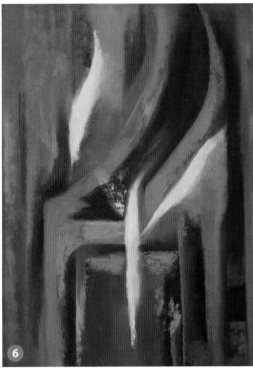

4 Develop Abstraction
Continue to work in the colors and form suggested by the photo. The painting is becoming quite abstract—allow it to develop on its own.

5 Add Color
Add more of the colors from the reference photo—Deep Cerulean Blue, turquoise, blue-green, dark red, medium red-orange, deep purple—continually keeping in mind the highlighted focal area. Use the same technique throughout, holding the pastel sideways to use the flat side in mostly downward strokes. Use the fixative spray between some of the pastel layers and do not blend the colors.

6 Final Details
Continue to develop the abstract lines. Add and subtract shapes, keeping in mind color, form and balance, until you are satisfied with the composition.

CEDAR CREEK CURRENTS | Diane Artz Furlong
Pastel on UArt sanded paper; 14" × 11" (36cm × 28cm)

Diane Artz Furlong | dartzfineart.com

Diane Artz Furlong is well acquainted with the landscape of the northern Shenandoah Valley of Virginia. A lifelong resident, she draws on the landscape surrounding her home in Oranda for inspiration, giving voice to the trees, fields, creeks and mountain ranges she loves. Her paintings are reminiscent of the French Impressionist painters, but she is influenced more by the idea of Impressionism rather than a specific artist. She explains her work as "expressions of her impressions." A self-taught artist, Diane has worked the last few years exclusively with soft pastel, focusing on mastering the medium. Primarily a studio artist, she makes frequent forays to the woods and fields and along the country roads near her home to take digital images of the views, which she then uses as reference material for her landscape paintings.

Diane is a founding member of the Pastel Society of Virginia and an artist member of the Maryland Pastel Society. She exhibits her work locally and regionally.

16 Paint From Your Imagination

I live in a particularly beautiful area where the landscape abounds with fields, woods, mountains, rivers and streams. I prefer working in the studio, so I take many drives through the countryside to photograph scenes that strike a responsive chord in me, frequently taking pictures of the same scene at different times of the day and different seasons of the year. As a result, I have literally hundreds—maybe thousands—of reference photos.

I tend to paint whatever season of the year we happen to be in, and I try to keep all those digital images sorted in albums on my computer with titles like "new painting list summer 2011," "possible paintings" and "must paint, late fall 2010." When I am ready to start a new painting, I scroll through my photos, looking for an image that will recall for me a certain mood or feeling. Sometimes I find just the right one.

When I am overwhelmed with the sheer volume of pictures and frustrated with my inability to choose one, I turn to my imaginary folders—the ones filed away in my artist's brain—that contain composites of thousands of images. These are the ones that, more often than not, contain a joyful spark. My familiarity with the landscape around my home allows me to paint meaningful landscapes that express exactly what I want to say, relying only on my memory and imagination.

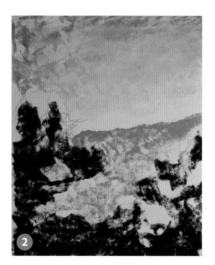
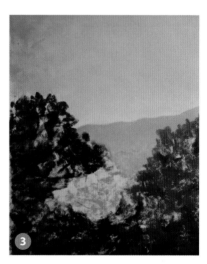

1 Sketch the Subject
Begin by doing a rough sketch on a sheet of 11" × 14" (28cm × 36cm) sanded pastel paper. Before starting, mount the surface to the acid-free side of a piece of mat board cut to 16" × 20" (41cm × 51cm) using an automatic tape gun and acid-free tape. Select your palette for painting—a combination of hard, medium and soft pastels.

2 Lay In Basic Colors
Begin adding basic color in bold strokes, starting with the sky area and moving down and around the paper clockwise, finishing with the swath of color on the mountain and the pathway. Use the darkest blue shade at the top of the sky, moving toward a lighter value blue nearest the mountain.

Since the majority of the painting image will be fall foliage in rich, warm colors, use dark cool values in green, blue and purple for the first layer of color.

3 Blend the Sky and Paint the Clouds
Lightly blend the sky with your fingers, moving top to bottom, then begin placing cloud shapes with a warm peachy-pink pastel. Continue clockwise, adding autumn foliage using the flat sides of soft pastels in red-violet, blue-violet, deep green and purple. Finalize the mountain with cool lavender and blue pastels, and paint the highlighted distant hillside area with blue, yellow, orange and green hard pastels using the same color values to create luminosity.

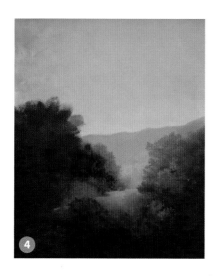

4 Let Your Imagination Lead You

Now the fun starts, when you let your imagination flow with the tree, foliage and bush shapes and all the glorious colors of fall. Continue adding and removing color, refining the composition with shadowed and highlighted areas. Using softer pastels, create richness by lightly adding new layers of color, including medium and light yellow-orange over deep red-orange, spring green and pink over the darker greens, and red-violet and magenta over dark green and dark purple, allowing some of the underneath color to show through.

5 Paint the Tall Trees

Add the tall vertical trees and tree limbs on the left using the edges of a violet and a purple. Always start at the bottom and draw your lines upward to form trees and branches. Add foliage shapes with the flat sides of the square pastels, using a deep blue and deep green over the violet undercolor, gradually lightening the colors used until the tops of the trees are a soft orange and yellow.

6 Strengthen the Clouds

Refine the cloud shapes by lightly dragging the flat side of purple over the clouds. Use a dark Cerulean Blue at the top of the sky, a medium Cerulean mid-sky, and end with pale lavender. Lightly blend these colors using your fingertips. By lightly dragging the pastel over the cloud shapes, new shapes are formed. Add extra definition but keep the shapes soft with the flat side of a peachy-pink soft pastel.

7 Final Details

The painting is nearly finished. Add rich highlights on the treetops on both sides of the landscape to indicate the illumination from the morning sun, using your softest pastels in bright orange and yellow.

AN AUTUMN WALK | **Diane Artz Furlong**
Pastel on sanded paper; 14" × 11" (36cm × 28cm)

45

17 Sketch your Surroundings

Looking at a blank piece of paper can be overwhelming when you're not inspired. Rather than just sit around cleaning my palette or sharpening pencils, I'm much better off going outside with a sketchbook rather than a camera. I frequently use a sketchbook to record places I visit while traveling, but it works close to home as well.

I've wanted to paint our city hall for a long time but never could get exactly the right view. Although it faces a street, it's not easy to set up an easel in the middle of the road in midafternoon when the shadows are best, and photographs taken from the sidewalk are distorted and cluttered with signs and autos. With a sketch, I can incorporate what I want and look around obstructions for hidden information.

I use a sketchbook with bound pages so I'm not tempted to rip them out in search of the perfect drawing. Rather, my goal is a quick impression of the place, ignoring or redrawing crooked or nonparallel lines. I use fine micro-tip pens (0.5mm) and add watercolor or watercolor pencils for local color because the ink won't run.

REFERENCE PHOTO

In January in Bath, Maine, it's not easy to paint or sketch outside. The days are short, so there's the need to move quickly before the light changes. I park my car near a good vantage point. I can sit with the heater on and sketch, but first I stand outside to snap a photo. I want to be able to see my whole subject.

There are situations where you can't take a good photo of your subject, but by moving around and eliminating distracting elements, you can get a good reference sketch, which can later become the basis for a painting.

1 Begin the Sketch
Take a moment to get the proportions correct. The schooner wind vane at the top reflects Bath's history as a shipbuilding town. It's important to have the vane and entrance in the sketch, so find the midpoint between the two and mark it, then sketch the basic shape of the building.

Decide what to omit, such as the signs, wires and cars, which would distract the foreground. Focus on the subject and suggest a building on the left and one car to give the subject its setting. Simplify the bow windows on the left and homogenize the features of the car. A person passing by gives a reference for scale.

2 Finish the Drawing
Put the windows in quickly by drawing the left side of all the windows. This way, they're all above each other. Then add their tops, following an imaginary curving line for the curved part of the building and then extending the lines straight out to both sides for the side windows. Complete the bottoms and other sides, and suggest lightly where the wreaths are hung. This step is completed with a bit of shading, applied only where it's very dark.

3 Block In the First Color

Using watercolor pencils, block clouds with layered colors—blue-gray, Imperial Purple, Iris Blue and Brown Ochre. Give the rest of the paper a light covering with either a blue or ochre pencil, using the sides of the point and leaving only the whites: the flag, some of the clouds and the top of the cupola.

4 Add More Color

Use the same ochre to bring out the features of the building, add an overlay of blue for the street, add Leaf Green for the wreaths and tree, and add Poppy Red for the bows and flag stripes. Simplify the number of stripes. Put in a few spots of blue to create the feeling of a field of stars. Correct the drawing of the building's left windows with more lines. That helps pull the eye to the point of interest.

5 Back to the Studio

Work on balancing the picture into something that could be the reference for a future painting or a good memory of the place. Go over the shadow areas of the building with Mustard, emphasize some shadows crossing the street and run some water over the colors, working from light to dark.

6 Corrections and Final Details

Make necessary corrections and add details. Place a line of Shiraz color on the underside of the vane. The building on the left gets the hint of brickwork with overlays of Shiraz and then Baked Earth; the cupola is warmed with Baked Earth. To some of the windows add a blue-gray glaze with some violet and brown panes. Wash with water, which pulls the small marks together. The Leaf Green swags get hung on the railings, and the yellow stripe goes down the street, the same Mustard used in the building. Leave the flag and the wreaths untouched by water to preserve their crispness.

BATH CITY HALL | **Livy Glaubitz**
Watercolor on paper; 11" × 8½" (22cm × 28cm)

18 Splash and Dash

Here's something to do to get away from the same-old, same-old. I call it "splash and dash."

I start by stretching four to six pieces of watercolor paper on separate pieces of luan board and staple them with a desk stapler after they've soaked in water for ten minutes. After they drip for a few minutes, I lay them flat to dry. Then comes the fun part, dropping and splashing on color. I find I get better paintings if I limit myself to two colors. Sometimes I use warm complements, sometimes cool, and I try to remember to leave a few places where the pure white of the paper can add sparkle later on.

1 Drip, Spray and Splatter
Start by propping up the board with the stretched paper. Then, using a big fat brush, such as a no. 14 round, put Cerulean at one end of the paper and add water until it drips. Then spray it with water from a mister. Splatter on some ochre by tapping the same color-charged brush against your hand so the paint splatters onto the surface. Work quickly and try to keep part of the paper dry as you add more of each color.

2 Add More Color and Let Dry
Watercolor always dries lighter, so try to be bold with the colors. When you are happy with the splashes and splatters, let the paper dry.

3 Choose a Reference Photo
Look for a photo that would work in either a landscape or portrait format. This is a photo of a bait hauler, taken at Five Islands Lobster's dock in Maine, which would work well in a vertical format. I picked this so the splashed-on ochre could be left untouched to tie the figure into the splattered underwash.

4 Sketch in the Composition
Turn the paper to a vertical format. Using a no. 2 pencil, sketch in the main parts of the image: the figure, the opposite shoreline, the long pole with the boom and part of the dock. Use a light touch so the lines don't dig into the paper. It's often helpful to lay in some local color right away so you don't get lost when you start to paint.

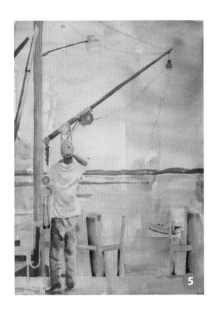

5 Develop the Composition

Begin painting with a no. 10 round brush using Cerulean and ochre. The dock and the two-by-fours between the pilings are painted in ochre. The green for the tall post and dock pilings is mixed with Cerulean, ochre and a small bit of Hooker's Green. Use the same three colors with more Cerulean to define the far shore of the Sheepscot River, and add Burnt Sienna for the hint of exposed rocks behind the figure.

6 Final Details

Paint the water with a glaze of Cerulean, leaving the space for the boat. Continue with the no. 10 round brush, and paint the boom with Burnt Sienna and ochre and the shadow side of the pants with Cerulean and some of the green from the tall post.

Use Raw Umber and Ultramarine for the shadows in the tall post and the dock pilings to help define the separation of the two-by-fours. Switch to a smaller no. 4 round with Burnt Sienna and ochre for the skin tones, shoes and shadows under the figure, then add details on the boat.

Leave the sky untouched as the white of the paper. Eliminating some boats will allow the viewer to focus on the subject of the painting.

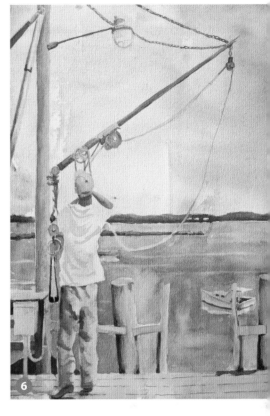

FIVE ISLANDS BAIT HAULER | **Livy Glaubitz**
Watercolor on 140-lb. (300gsm) cold-pressed paper
15" × 11" (38cm × 28cm)

Livy Glaubitz | livyglaubitzart.com

Bath, Maine, artist Livy Glaubitz started drawing with her father while watching Jon Nagy on television when she was 5 years old. She continued to be inspired by her dad, who painted after work and devoted himself to watercolors and cooking when he retired. He also used to accompany her on outdoor painting expeditions.

Livy specializes in watercolor, pastels and pen-and-ink drawings. Her watercolors and drawings reflect her travels and interest in the outdoors. After living in New Jersey most of her life, Livy moved to Maine where she continues to enjoy painting local architecture and scenes, and maintains a studio/gallery. In the warmer months, she paints plein air with 3 different groups weekly, exposing her to new vistas. She has studied with many artists including Betty Lou Schlemm, Judi Wagner, Frank Webb, Marge Chavooshian, Maggie Price and Terry Ludwig. She has received first-place awards in the Garden State Watercolor Society's and the Arts Council of Princeton's juried shows.

19 Give It a Bath

When dealing with a block, I like to challenge myself by utilizing a familiar technique in a new way. I discovered many years ago that it did not harm a watercolor painting to soak it in the tub, and if I scratched the surface with anything from a soft brush to my fingernails, the damage to the surface, when repainted, could look like rain, cobwebs or wrinkles on a face. I had never used this technique on such a detailed and difficult subject, but I decided to give it a try.

The watercolor method I use is called glazing. You start with the lights and build the darks by slowly layering in the colors, drying between layers with a hair dryer. You will never get "mud" using this technique.

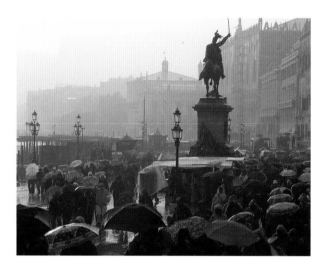

REFERENCE PHOTO
I chose this scene because I am always on the lookout for unusual lighting and weather situations, and this sudden cloudburst in Venice, while the sun still shone, fit the bill. I also like a humorous twist to my work, and I love the way the statue seems to be herding the tourists along.

1 Draw the Composition
Draw the scene on paper using a no. 2 pencil, and use a ruler for the buildings and a circle template for the sun. Mask out the lightest areas with removable masking fluid mixed with white soap and hot water, using an old no. 2 round brush. Make any improvements you wish on the composition at this point. For example, add more figures with umbrellas and leave out a confusing detail on the base of the statue.

2 Lay In a Wash
When the paper is dry, using a 1-inch (25mm) flat sable brush, lay a flat wash over the whole scene using a mix of Quinacridone Gold and Quinacridone Rose grayed with a little Sap Green. While it's wet, drop in pure Quinacridone Gold around the sun and a darker mixture of the 3 colors to indicate a break in the clouds. Blot around the sun with tissue paper to soften the edges.

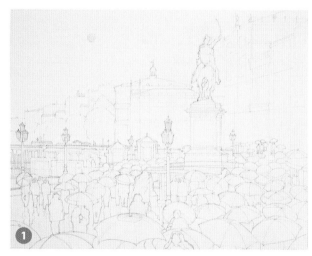

3 Build Some Darker Shapes

Using the same 3-color mix, start to build in the darker shapes with a no. 12 round brush. You will need to adjust the ratio of the 3 colors in different areas—more Quinacridone Gold in the fronts of the buildings, more Quinacridone Rose on the sides and more Sap Green in the trees.

4 Work on the Buildings

Draw in the rest of the detail on the buildings and start painting them using a no. 12 brush for broad areas and nos. 2 and no. 4 rounds for details, introducing Cadmium Red Light, Yellow Ochre and Ultramarine Blue. Use more Yellow Ochre in the fronts of the buildings that face the sun, more Cadmium Red Light and Ultramarine Blue on the sides and a mixture of all 3 for the windows and balconies.

When dealing with rain or fog, remember to keep more contrast and detail in the foreground, letting the background recede by using lighter values. Add a layer of Sap Green to the horseman and the Quinacridone Rose. Add the Quinacridone Gold mixture to the statue base to bring it forward so the value contrast will make the distant buildings fall back.

5 Remove the Masking Fluid

Remove the masking fluid and develop more detail in the foreground, adding color and detail to the umbrellas and detail to the figures, using all of the colors listed above. With a 1-inch (25mm) flat brush, lay in a strong wash of Quinacridone Gold, Quinacridone Rose and Ultramarine Blue over the buildings in the foreground to soften and flatten them. Let it dry or dry with a hair dryer.

Bathtub Technique FAQs

Q: Why don't I rough up the paper with a toothbrush when I first soak it to stretch it?

A: There are several reasons not to do this: 1) You want to draw the image on an undamaged surface. 2) You want the initial washes to go on smoothly. 3) You need to have control over your toothbrush strokes, making them more noticeable in the foreground and less in the sky.

Q: Why don't the darks lift off and contaminate the light areas?

A: If you use the glazing technique, even the darkest darks are thin and transparent. If you have thick paint on your paper, your darks will lift and contaminate your lights.

6 Move to the Bathtub

At this point, the painting is ready to go into the bathtub. Submerge it in about 2 inches (5cm) of warm water and brush in diagonal strokes with a stiff toothbrush, bearing down quite hard. The brush will rough up the surface of the painting, and when you paint back in all the detail, the scratches will look like heavy rain. This step should take 1 minute at the most. The painting will come out with a light imprint of what was there to guide you when painting it in again.

Note: This technique doesn't work well on all papers. Arches rough works best. A soft toothbrush or oil painter's bristle brush works well for softening edges or cleaning out an area you don't like.

7 Dry and Repaint

Clamp the painting onto Masonite, blow it dry and start building the colors back in. Using nos. 8 and no. 12 rounds, begin with the dark areas in the foreground to see how well your scratching worked. If the rain isn't showing up enough, you can help it out by keeping your strokes and washes on the diagonal. You should be more concerned with creating the atmosphere than with the details. Let the figures blur. To cool down the sky, add a wash of Cerulean Blue and drop more Quinacridone Gold and Quinacridone Rose around the sun using the 1-inch (25mm) flat brush.

8 Add More Washes

Add several more washes in the sky and background using the 1-inch (25mm) flat brush and Quinacridone Gold, Quinacridone Rose and Cerulean Blue until the sun shines. Add the light and shadow back onto the umbrellas using a no. 12 brush and keeping a pleasing pattern of colors and values. If the umbrellas look too bright, gray them using their opposite colors and wash over the shadowed edges on a diagonal to blur them. Keep the closest umbrellas fairly dark. Your goal at this point is to capture the murky atmosphere and strange quality of the light.

Replace the confusing plastic-covered cart to the left of the statue base with a figure and umbrella. Draw in the figure with umbrella, then patch in the dark areas around it using a no. 4 brush. Paint in the figure with Cerulean Blue and the umbrella with Burnt Sienna, then wash over the area several times to soften the edges and blend the figure into the scene.

Contrary to popular belief, all mistakes can be fixed in watercolor. There are several ways to fix mistakes. Paint can be lifted by washing the area with clean water and then blotting with tissue paper. For more desperate situations, soak the

painting in the tub and lift the area with a stiff brush while it's underwater. For the most desperate situations, you can cut a hole in your painting and patch in a new piece of paper. This technique works best on hard-edged areas like a sign.

CLOUDBURST, VENICE | **Becky Haletky**
Watercolor on paper; 20" × 25" (51cm × 64cm)

9 Study the Painting

Let the painting sit for a few days and then look at it again critically. You will be surprised at how many areas need tweaking. Darken some of the darkest areas under the umbrellas in the foreground using your nos. 8 and no. 12 brushes. Add Quinacridone Rose and Quinacridone Gold to the glass on the street lamps. Some of the umbrellas on the right side behind the statue are too large compared to those on the left side. With your Ultramarine Blue, Cadmium Red Light and Yellow Ochre mixture and a no. 2 brush, make a few of them smaller by patching in darks around them.

The final step is to submerge the piece one more time in the tub. Leave it submerged until you see the paper relax; it usually takes only a few seconds. Remove it, and to flatten it, clamp it on the Masonite and blow it dry. Let it sit for at least 24 hours before removing the clamps.

Becky Haletky | artbecko.com

Becky Haletky has been painting in watercolor for over 30 years and teaching for over 20 years. She holds a BFA in photography from Massachusetts College of Art and uses her photography background as a tool in her painting. Her realistic, atmospheric watercolors have won hundreds of awards in regional and national exhibits. Her focus is finding an unusual subject, photographing it in unique light and then emphasizing the light when painting it. Her paintings are in corporate, municipal and private collections in Boston, New York and London.

Becky has served on the board of directors of the prestigious New England Watercolor Society since 1994 and recently served a two-year term as president. She teaches watercolor workshops in Venice, Italy; County Mayo, Ireland; and on the island of Santorini, Greece.

20 Paint a Subject That's New to You

Usually I have so many projects in my head that I am thinking about the next one halfway through the one I am working on. But occasionally I get into a slump of "I want to paint but I don't know what." Worse yet, sometimes I paint several exciting subjects in a row that just don't come out very good.

The only way out of a slump is to challenge myself. I chose this scene of these three glasses in Eugene's Pub in Ennistymon, County Clare, Ireland, because I had never done anything remotely like this. Frankly, I found it terrifying!

In spite of my apprehension, in the end I really enjoyed this painting. I do a lot of night and evening architectural landscapes, and if you look at this scene in terms of structural shapes, color and light, it's really not so different. I have already started a new one looking down on a coffee cup on the same table.

REFERENCE PHOTO
I look forward to visiting and photographing Eugene's Pub every time I go to Ireland. With unusual nooks and wild architectural details lit by stained glass windows, everywhere you look is a subject for a painting. I have been photographing our drinks on this table for years; I just never had the courage to actually paint one until now.

1 Prepare the Surface

Crop your surface—140-lb. (300gsm) rough watercolor paper, soaked and stretched on gessoed Masonite, using bull clamps and blown dry with a hair dryer—from 30" × 22" (76cm × 56cm) to 20" × 15" (51cm × 38cm) so that 1" (3cm) of the photo equals 2½" (6cm) of the paper.

Sketch your drawing with a pencil, masking out the lightest areas with removable masking fluid, using an old no. 2 brush, very hot water and white soap. Be as neat as you can with the masking fluid. The success of this still life depends on crisp edges and bright, deep colors.

2 Begin With Darks

With a mixture of Burnt Sienna and Payne's Gray, begin establishing the warm darks with a 1-inch (25mm) flat brush. While the paint is wet, drop Cadmium Yellow Light, Perinone Orange and Sap Green with a no. 12 round brush into the desired areas. Let the colors run together within the defined areas of the drawing. Pay close attention to the subtle shifts of color and value. Blow-dry when you're happy with it.

3 Deepen the Background

Layer Burnt Sienna and Payne's Gray in the background with a no. 12 round and a 1-inch (25mm) flat brush and blow it dry. Keep strokes vertical to indicate wood walls even though it will be very dark in the end. Use Burnt Sienna to establish the first layer of color on the wood parts of the table, and Phthalo Blue and Cobalt Blue to establish the blue reflection on the table. Use Cadmium Yellow Light, Yellow Ochre, Sap Green and Cadmium Red Light to layer the table's painted stripes. At this point, remove the masking fluid from the table but not the glasses. Continue building depth and detail in the tabletop. Deepen the beer bottle on the right side, leaving little detail showing.

PUB
Becky Haletky
Watercolor on 140-lb.
(300gsm) rough paper
20" × 15"
(38cm × 51cm)

4 Finish the Table

The glass of tea on the left is a hot drink, which causes a lot of condensation on the glass above the liquid. Using your no. 8 round, start with Burnt Sienna and drop in the mixture of Phthalo Blue and Cobalt Blue while still wet, then salt it. Add one more layer of Burnt Sienna and Payne's Gray to the background with the 1-inch (25mm) flat. Use very wet horizontal strokes to soften it. Continue adding color to the top of the other glasses. When the salt on the tea glass is fully dry, remove it. Continue building the colors on the tabletop and stripes using unmixed colors to help brighten and deepen them.

5 Begin the Glasses

The tabletop is almost done, so move to the glasses. Use your no. 12 round to add a wash of Burnt Sienna mixed with Sap Green to the tea. Drop a little Cadmium Orange in the tea bags for a highlight. Keep darkening the center glass and add color to the glass on the right, making sure the edges in the drink are soft.

6 Final Details

Remove the masking fluid on the glasses and carefully redraw the details. Clean up any areas where the mask was sloppy on the rims and edges of the glasses by patching in the color beside it with a no. 2 round, then finish the detail in the glasses. Use unmixed Cobalt Blue, Phthalo Blue, Cadmium Yellow Light and Quinacridone Rose in the highlights of the glasses. Leave some white highlights and blot freely with tissue to soften some edges. The tea glass is a little flat, so to add life, wash out a bit of steam rising from it using clean water and a no. 12 round, wiping with tissue. Add more layers of color to the table.

Put the painting away for a week and don't look at it. When you take it out again, tweak any areas that bother you.

21 Change Your Tools

I've always been told to use the absolute best materials to paint with that I could afford, and I have, sometimes sacrificing to be able to afford the best. You can't go wrong if you purchase and use supplies that are designed for the art trade. However, recently I have become interested in breaking out of the rut of repeating the same kind of technical strokes that very well-tailored brushes make. I've experimented to find tools that produce less than accurate strokes, and while I can learn to control them, using these brushes means that I won't always know exactly what the resulting application of paint will be.

In this exercise, we'll use brushes available at any hardware or home improvement store. They're the inexpensive little "chip" brushes with natural bristles that sell for around one dollar. There is nothing premium about these brushes, and you'll note the bristles often fall out. Making a stroke with one is an exercise in taking an educated guess as to what the brush will do, resulting in strokes that aren't the norm and that are only semicontrollable.

CHIP BRUSHES AND PALETTE KNIVES
Purchase these chip brushes in a couple of sizes from your local hardware store. Select 3 or more palette knives of various sizes to use on the painting as well. They can be used for fine line drawing, as in this painting; for scraping part of a layer out, which leaves interesting passages of thin color; or for applying paint to large passages where brushstrokes aren't wanted. It can surprise you, which also helps get you out of a rut.

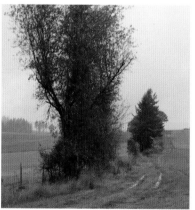

REFERENCE PHOTO
For this exercise, we'll paint from a photograph of a relatively simple scene shot on an overcast day. The concept for this painting is the misty, obscured neutral background contrasting with the intensity and warmth of the foreground and how they transition from one to the other.

1 Tone the Surface

Working on a canvas panel of linen on board, 16" × 16" (41cm × 41cm), begin with a thin wash of Transparent Red Oxide and Ultramarine Blue Deep to knock down the value of the white surface. Using the 1-inch (25mm) chip brush and odorless mineral spirits, mix these two paint colors together until you have a good, strong gray/neutral mixture, and then brush it on from top to bottom, letting it run with a wet edge. The wash sets into the oil primer on this linen board fairly quickly. After a few minutes of letting it set in, use a cotton rag to wipe it down, leaving a light gray tone on the surface.

2 Block In Transparent Color

Continue with Transparent Oxide Red and Ultramarine Blue Deep. Using the larger of the 2 chip brushes, thin the Transparent Red Oxide with mineral spirits until it's not quite runny. You don't need to use any white pigment yet. Draw and scrub color on with this mixture, working from the larger masses down to some of the directional lines of the composition and the details of the tree trunks. For darker values, add more Transparent Red Oxide and/or Ultramarine Blue Deep. The color in the foreground is warmer, so mix more Ultramarine Blue Deep into the mixture as you work toward the distance in the composition.

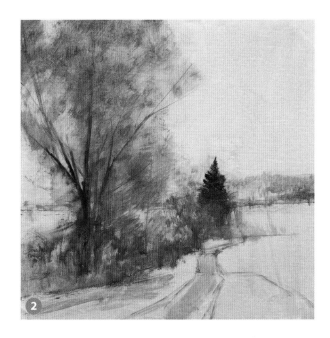

3 Add More Color

With the basic layout of the composition down on the panel, it's time to commit and bring the painting together. Apply paint in the sky area using a mixture of Titanium White, Ultramarine Blue Deep, Yellow Ochre, Venetian Red and Cadmium Red Light with larger palette knives. Paint up to the edges of the tree and landmasses and then paint in those masses with the palette knives and chip brushes, working the edges back and forth to create soft or hard edges as needed.

For the warmer foliage areas, create mixtures using Cadmium Orange, Yellow Ochre, Burnt Sienna, Cadmium Red Light, Ultramarine Blue Deep and some Viridian. These mixtures will vary slightly; for instance, the foliage of the small oak on the lower left is very red, so that mixture has more Cadmium Red Light and Venetian Red in it than the upper tree foliage. Lay in the trunks of the trees with a 1-inch (25mm) palette knife using Ultramarine Blue Deep and Transparent Oxide Red. Instead of drawing in with a brush, sculpt the trunks in with the knife. The result is a more angled, harder shape, more like how the strong wood of the trunk actually is.

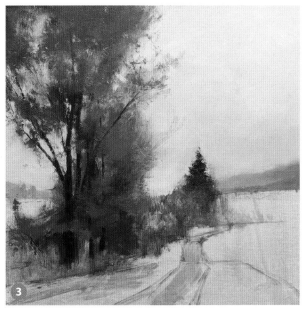

4 Continue Working Over the Surface

Continue to work the rest of the painting, laying in broad areas of color. You might like to use a drying medium, such as linseed oil. Using the medium will give you the option to glaze, to work the paint as it starts to set and get tacky, which can be great for building paint textures and impasto. Using the chip brushes and palette knife, paint the grassy area with a mixture of Ultramarine Blue Deep, Cadmium Yellow Deep, Yellow Ochre and some Viridian in the most intense passages. Apply the paint in more intense colors than reality at this stage in order to have a base for subsequent glazing and scumbling, which will be used to tone down the intensity but also add depth and contrast.

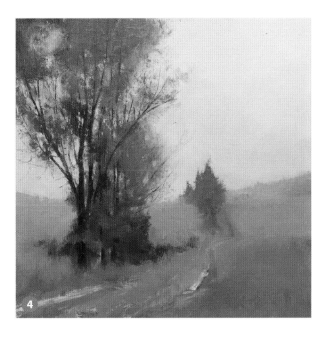

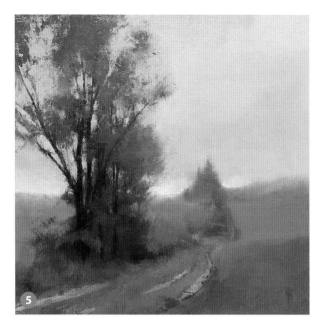

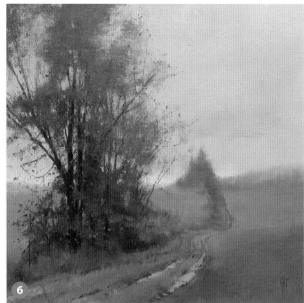

5 Warm Up the Sky

It's always a good idea to take a break and come back to the painting the next day. If the paint from the previous session is dry, use some of the drying linseed oil to "oil out" the entire painting surface by brushing it on with a 2-inch (51mm) nylon flat brush, then using a clean cotton rag to wipe off nearly all of the oil so there is only a very thin veil of oil left on the surface. This allows fresh wet paint to be applied to a dry surface like it's being applied to a wet paint layer. You can control edges much easier this way.

With a fresh look at the painting, it's time to change the sky to warm it up and add some break in the overcast in the distance. Remix the sky color, making it slightly warmer than before by using more Yellow Ochre and Venetian Red in the mixture. Using the 1-inch (25mm) chip brush, apply large passages of the color already mixed on the palette and varying it as you work from top to bottom, from darker to lighter, and from warmer to cooler.

At the horizon, apply a very light-value mixture of Titanium White and Yellow Ochre using a small palette knife. Apply it fairly heavy and then scrape, brush and even use your fingers to manipulate it until you create soft edges and transitions.

Using a small palette knife, paint the negative shapes in and around the foliage area, tree trunks and branches. Throughout the process you can redesign shapes and their edges as need be. Paint the wet area on the road with the palette knives also. Build up the structure in the weedy fence line using Burnt Sienna, Yellow Ochre, Transparent Oxide Red and Viridian, and apply Ultramarine Blue Deep to gray it.

6 Refine the Foliage

Continue to work into the foliage area of the trees, adding the details along the road as it wanders into the distance, and to refine the quality of light as it rolls across the landscape. Scumble a mixture of Cadmium Orange, Burnt Sienna and Ultramarine Blue Deep with some Titanium White added to the upper area of the foliage in the near tree. On top of that add more intense warm notes representing individual leaves. Working back and forth between sky, foliage and branches, a combination of wet-on-dry paint, palette knives and brushes will help create a natural look to the foliage.

The chip brushes are a little bit wild in nature, and they lend themselves perfectly to painting the wildness in nature. You may wish to use an egbert (extra-long bristled filbert) brush to draw some of the branches. You can load this brush up and use it on edge to draw pretty fine lines.

Using some glazes and scumbling with Cobalt Blue, Yellow Ochre and white, begin to increase the recession and atmosphere in the painting, brushing it on and wiping it off with a clean cotton rag. Then apply more and wipe it off.

In this step you will complete the drawing of most of the branches and leaves. However, another change needs to be made to improve the composition—the area on the lower right that was a little bit of a ridge needs to be flattened out. You can begin to do that by showing more of the road as it winds back into the distance

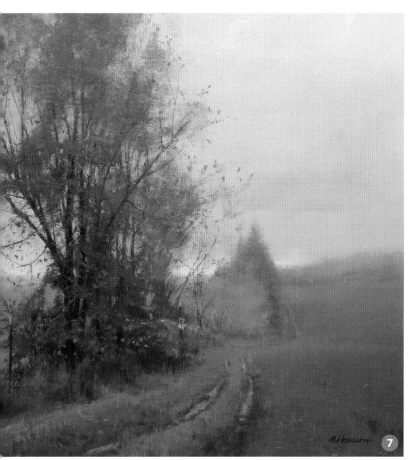

7 Final Details

To further improve the painting, change the perspective of the ruts and bring them out more toward the viewer. Soften the land even more with layers of scumbled paint mixed with some drying linseed oil and applied with the ½-inch (13mm) chip brush. This will allow you to work over the surface with fresh wet paint every few hours as the drying linseed oil sets up.

Alter the road with heavily applied paint mixtures using the palette knives, and then work into those layers with the brushes. Add some color going up the fence line foliage with a no. 3 bristle flat, and touch up the colorful leaves and grass in the foreground road, fence line and field using various combinations of Yellow Ochre, Burnt Sienna, Cadmium Orange and Titanium White. For the leaves at the base of the trees, use some pure Cadmium Orange and Cadmium Red Light picked off the pile with a little no. 3 flat bristle brush or the same size filbert. Fine little touches of pure color there and along the weedy edges complete the painting.

OREGON MIST | **Marc Hanson**
Oil on linen; 16" × 16" (41cm × 41cm)

Marc Hanson | marchansonart.com

Having grown up in a military family, Marc's youth was spent on the move. He lived in California, Alaska, Florida, Arkansas, Nebraska, South Dakota and Norway. He studied at the Art Center College of Design in Pasadena, California, majoring in illustration. After a brief stint as a staff illustrator in Sacramento, California, Marc moved to Minnesota where he resided for more than 30 years. He recently relocated to Longmont, Colorado.

"I have pursued a career as a painter for many years now. Along the way, my methods, materials and focus have evolved. A naturalist at heart, the landscape is the perfect vehicle for expressing the joy I have for the world that surrounds me. My real interest and challenge as a painter is how to best manipulate the core principles of painting into effective visual statements. I'm most successful when I'm able to communicate that joy to the viewers of my paintings."

Marc has shown his work in galleries and museums nationally and internationally since the early 1980s and has garnered a number of national awards, including placing 4 times in *Pastel Journal*'s Pastel 100 competition and winning an Award of Excellence at the Oil Painters of America National Exhibit 5 times. He is a signature member of the Oil Painters of America. Marc teaches landscape painting workshops in many locations nationally.

22 Paint Outdoors at Night

For a landscape painter, there's no better way to alter your comfort zone than to haul your gear outside on a cold winter night, stand in the snow and paint a nocturne. If that doesn't shake you out of your rut, I don't know what will. Once out there, everything calms down, the sounds of life are muffled by the blanket of soft snow, and without a wind and with a bright moon, it's always a paradise waiting to be put down on canvas. The difficulties, beyond staying warm and not losing your supplies in the depth of the dark and the snow, begin with being able to see your painting surface, paints and the subject matter that you're painting.

While working, I alternate between having the lights on and observing or painting with them off so I can see the subject as it is naturally without the blindness the lights cause. Stay organized and take as few supplies as possible out on location, and carry an additional flashlight for getting supplies out and seeing what's around you. Also, if you can, put your paints onto the palette before you go out. Lastly, be safe. At night, alone and lit by a bright light, you're a visual target for people and critters that have less than healthy intentions.

THE SET-UP
Use a battery-powered LED book light to light your panel and palette. To block the bright lights to view your subject in the distance, clamp a small piece of wood molding about 3 feet long (91cm) onto the panel holder with 2 small spring clamps. Clamp the book light onto the piece of wood high enough to be out of your direct line of sight so you don't look into the light, but low enough to still broadcast good beam coverage across the palette and painting surface. If it's a moonlit night in the winter, you will find you can do a lot of the preliminary work without even having to turn the light on.

1 Block In the Simple Shapes

At night, color, value, shape and the edges of the forms are all muted and simplified, sometimes difficult to see at all. You must not try to figure out what you're looking at beyond its shape, value, color and how the shapes all integrate with each other.

Using a mix of Ultramarine Deep, Transparent Oxide Red and Alizarin Crimson, block in the tree mass onto the untoned panel using a worn no. 8 flat and plenty of thinner to make the paint workable in the cold air temperatures. No white is used in this mixture as it's important in a nocturne to keep the darks transparent for as long as possible. Mix the sky value with Ultramarine Deep, Chromatic Black, Alizarin Crimson and a bit of Titanium White, and paint it against the tree mass. Sculpt the trees and carefully work the edge between the sky and trees. Mix a bit of Cadmium Red Light and white into the sky color and paint a slightly warmer area near the horizon.

REFERENCE PHOTO
The scene before starting to paint. The moonlight illuminated the subject.

2 Refine the Shapes

Mix and apply a grayer version of the sky color. Where the softer edges of the tree mass seem to almost become lost into the sky, scrape paint off with the knife and smear it back into and out of the mass, mixing it until the edge and the color are correct. Mix a slightly heavier mixture of the Ultramarine Deep, Viridian, Alizarin Crimson and Transparent Oxide Red, and paint into the masses of the trees using a ½-inch (13mm) mop brush. Breaks in the tree line showing sky, as well as the trunks of some of the trees and branches, are all painted with mixtures similar to what has been already used, with the small- and middle-sized palette knives.

3 Create a Secondary Point of Interest and Paint Some Details

Sometimes it's necessary to invent a secondary point of interest. Turn the little unlit gazebo into a small inhabited building with a light on inside to create interest. Carefully indicate the snow on top of the roof of the building, branches, piles of wood, etc. To paint tracks in the snow, use the end of the no. 5 filbert loaded with a mix of white, some of the snow gray and a little Cadmium Yellow Deep.

Now finish the details in the trees, the dark shape under the trees and the inhabited area. Mix a warmer gray using more Cadmium Red Light and the already-mixed sky color, and complete the tree trunks and branches, adding the snow that is lying on them at the same time using the small palette knife and the no. 5 filbert.

Using Titanium White, Cadmium Yellow Deep and Cadmium Red Light, mix a very light but slightly warm color for the stars. The stars aren't all the same color; some are warmer and some are a cooler, slightly greenish blue.

4 Final Details

The major area of concentration in this step is the development of light on the snowy areas around the building. Using Titanium White, Cadmium Yellow Deep and a touch of Cadmium Red Light, mix a very light warm white that represents the reflection of the artificial light from the building onto the surface of the snow. The little building seems too isolated, so create another roof of what could be another building on the property on the right side.

Sign the painting by scratching your name into the snow area with the sharp end of a brush handle, then go inside and warm up.

JANUARY MOONLIGHT | **Marc Hanson**
Oil on linen on board; 9" × 12" (23cm × 30cm)

23 Paint in a New Location

Daily life can get to be a rut sometimes, and it's not always easy to climb out and start painting again. One way to get out of the rut is to make a painting journey to a new place. It can be a long trip to a distant place or just a short trip across town. Either can give you a new perspective and help you find fresh, exciting painting subjects.

Over the years I have found a few ways to get the most from such a getaway. The most important thing is to let yourself be as free as possible. You may have a destination in mind, but you may find something you like on the way and paint there instead.

I recommend going with just one painter friend. When I plan travel on my own, it is too easy to cancel the trip if something important comes up. Two painters traveling together can encourage each other, help each other find painting subjects and talk about the scene and how to approach it ahead of time.

And turn off that phone. In fact, leave it somewhere else—you can check your messages when you're done painting. Just let the scene pour into you, and it will flow back out through your fingertips. Once you've broken the block this way, it won't be hard to pick up the thread back in your studio.

REFERENCE PHOTO

Nature served up an overcast day with drizzly rain. The way the sweeping, changing clouds spilled over the mountain and floated down the side was fascinating. The valley was lush with an air of tidy prosperity; the road was a shimmering ribbon reflecting the sky brightly as it went over a small ridge. It all seemed peaceful and romantic under the soft rain.

1 Start With a Quick Sketch

On a 12" × 24" (30cm × 61cm) piece of gray Pastelbord, use a stick of vine charcoal to sketch in the mountain ridge, the yellow field and the roadway on the right. While it's usually a good idea to do a couple thumbnails and a value study before starting, with the clouds changing quickly, it's best to just jump right in. Block in the clouds using very light soft pastel blues, grays and lavenders, plus a mid- to deep-range violet-blue. A quick block of dark blue soft pastel, almost a Prussian Blue, establishes the top of the mountain.

2 Block In Big Shapes of Color

Establish some colors in the rest of the panel. Lay in a bit of a dark warm green for the pine trees on the ridge, some reddish brown for the bare trees in the clump on the left side and dark yellows for the fields in the foreground and middle distance, all with medium-soft to soft pastels. To get some aerial perspective into the mountains where that cloud comes down, skim some of the lighter-value blues and violets from the sky over that area. The feeling of soft, wet weather and the drama of the clouds are important to this painting. Add the highlight of the wet highway in the lower right.

3 Tone Down the Contrasts

Tone down the contrast between lights and darks in the sky a bit by lightening the darks. It is always difficult to get the close values of a rainy day correct—too dark and gray and you have gloom rather than poetry, but too much contrast creates the wrong mood. Paint the rest of the mountainside with that same intense, dark Prussian Blue, and then go over it with a veil of warmer gray. Add touches of pale brown-gray to the yellow field and above the road.

4 Refine the Mountain

Some lavender, blue-gray and a touch of medium warm brown lightly pulled over the mountain will help lighten and neutralize it.

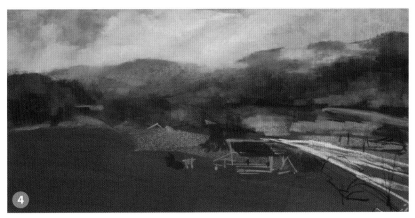

5 Foreground and Middle Ground

With a dark bluish gray pastel, draw the line of the closest ridge, and put in the dark fir trees with a warm dark green soft pastel. Lightening the value of the clump of trees on the left, and putting the warm green in front of them, helps move them back a bit and establish a middle ground that is consistent in value.

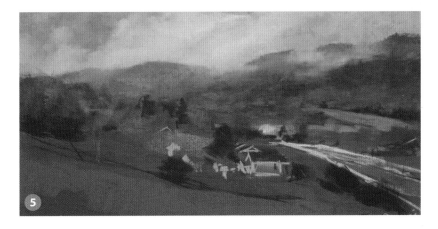

6 Break Up the Mountain's Edge

The mountain ridge makes a tangent with that clump of trees, so make them a bit taller so they break that line and go up into the sky more. A bit of cool blue-green on the grassy area will help it recede. Adding the barn on the foreground ridge really helps set it apart from the middle distance. Use the same light blue soft pastel for the barn roof as used in the sky. A few touches of Burnt Orange indicating autumnal leaves are scattered about.

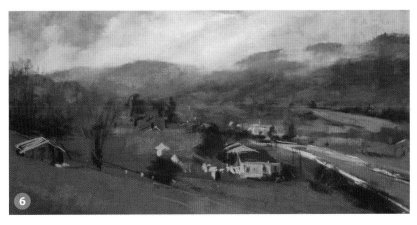

7 Adjust the Values

Mute the value where the road goes over the hill. Add lavender, gray and brown into the middle section with a soft pastel to indicate bare trees among the pines. Touch the edges with a fingertip to soften them. Layer some of that same color over the closer ridges of the mountain with the lightest touch. Add a brighter orange in the right corner to bring that area forward. Using a blue-gray pastel, refine the tree near the barn.

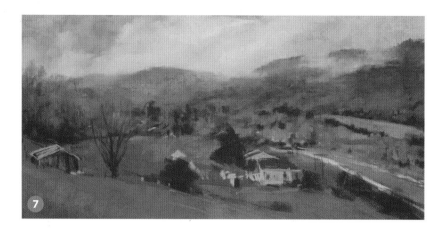

8 Adjust the Color Intensity

Continue working on the buildings in the middle ground, then make a few other adjustments in saturation of color. The actual color of the green grassy field should be more saturated or intense in color, so adjust that. Mute the intensity and brightness of the yellow field in the distance, which will also help it recede. Add a few darker values in the lower right, and introduce some dark red and brown tones there as well as in the middle trees.

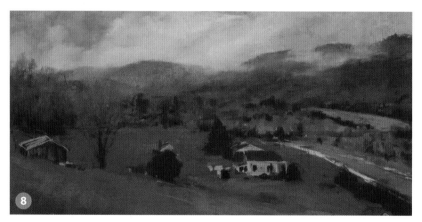

9 Work on the Middle Ground and Foreground

Consider adding a few more details in the middle ground. More trees and some poles along the road will help slow the viewer's eye as it travels back into the painting. Use a blue-violet and a dark green. Add some lighter areas to the 2 big fir trees with cool greens to help give them form, and work on edges of the trees in the foreground.

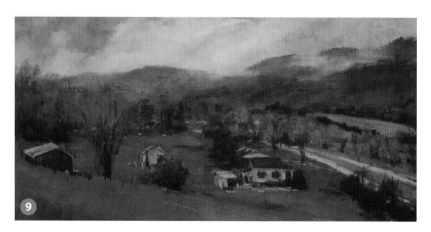

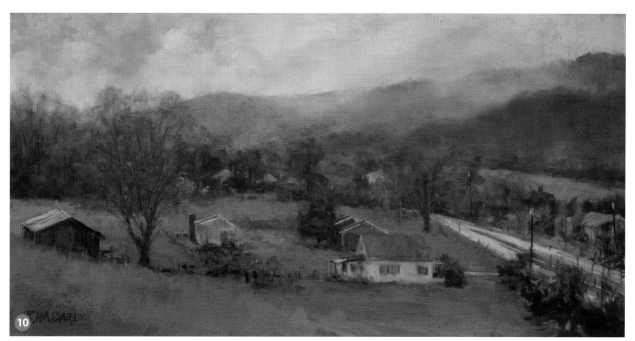

SOFT RAIN IN THE VALLEY | **Ray Hassard**
Pastel on Ampersand Pastelbord
12" × 24" (30cm × 61cm)

10 Final Details

The clouds and mountain intervals are too even, so adjust the pattern to be more interesting and more natural looking. Soften and lower the value a bit in the area of clouds in front of the mountainside, making them appear gauzier and more transparent. Enlarge the main house a bit so it will hold its space better and at the same time decrease the clutter around it. Finally, enlarge the tree near the barn and bring it up into the sky, connecting the top and bottom areas of the painting.

Ray Hassard | rayhassard.com

Ray Hassard was born in Freeport, New York, in 1949. He grew up in the New York City area and studied at Pratt Institute in Brooklyn. He moved to Buffalo, New York, in 1977, where urban landscapes became his primary artistic theme. Ray won several commissions, most notably one to create and install a large wall piece for the subway the city was building. In 1987, after moving to Cincinnati, he became co-owner, publisher and art director of *American Record Guide*, a bimonthly magazine reviewing classical music CDs.

Ray is a signature member of the Pastel Society of America and the Cincinnati Art Club and a master pastelist with the MidAmerica Pastel Society. His work is in numerous corporate, museum and private collections. In addition to painting, Ray loves to travel. He returned to India for the sixth time in 2009 to paint en plein air and painted in Spain, Italy, France and Croatia in 2010.

Ray teaches pastels at Baker Hunt Art & Cultural Center in Covington, Kentucky, and the Woman's Art Club in Mariemont, Ohio. He leads workshops around the country and occasionally judges exhibitions.

24 Use a Plein Air Painting for a Studio Piece

Do you have a box or shelf where you store failed paintings? I have a couple of them, and though I always plan to go through them someday and throw most of them out, I never seem to get to it. And maybe that's good—sometimes those unsuccessful paintings can lead to a way out of a block. To do that, I find a plein air piece in that box and paint it again—better, I hope—in my studio.

In 2010, I stayed with a painter friend in Germany, about an hour south of Munich at the edge of the Alps. During my visit, the weather was unseasonably cold and rainy, so we visited some local churches one day, including St. Wolfram's, a very small, old country church. I was struck by the plainness of most of the architecture and the way it contrasted with the massive, ornate Baroque altar. We made inquiries at the parsonage and were allowed to set up and paint inside.

I was especially taken with a silhouetted statue of St. Wolfram's son on the side of the altar. By the end of an hour or so of painting, I stepped back and realized I had been seduced by details. Baroque carving in all its exuberant craziness had distracted me entirely, and the painting eventually ended up in a box. But using it as reference for a new painting was a great way to push myself out of a block and get going again.

REFERENCE: THE PLEIN AIR PAINTING
St. Wolfram's, 12" × 9" (30cm × 23cm) pastel. I still had a vivid memory of what I wanted to paint in that church and where I went wrong the first time, so I had a good, clear way to get into the picture again. I decided a larger, square format would work better, and I remembered the light in the church on that rainy day filtering through the frosted glass, so adding more to the window on the left side would work.

1 Cover the Surface
Begin with a 24" × 24" (61cm × 61cm) piece of white Richeson Premium Pastel Surface on foamcore board. Cover the surface with several washes of Ultramarine Blue watercolor and a final touch of Prussian Blue. This will set the tone for the light values, even though most of it will be covered up eventually. Once it is dry, sketch the shapes, drawing with vine charcoal.

2 Distinguish Light and Shadow
Use a light blue soft pastel in the window and on the side wall of its alcove as well as a few touches for highlights on the side statue. Skim a very light pale green hard pastel over the window section as well. Using hard pastels in the darkest warm grays, browns and a purple-blue, block in the darks of the altar area.

Use rubbing alcohol and a brush to wash the darks so they melt together into a big sludgy mass. This will help you avoid focusing on the details too much. Leaving the light area untouched by the alcohol will preserve its texture.

3 Begin Adding Color

Re-establish the drawing in the altar area, and begin laying in colors. That small Wolfram has some gold trim on his dark blue robe. A few quick touches of Olive Green and a very dark yellow go in there with some accents of a very dark brown. Lay in the red horseshoe shape of the niche with red-violet and a very dark red. Block in a lighter brown on the front of the tabernacle in the lower section of the altar.

4 Refine Shapes and Colors

Skim over the window with some dark lavender-grays for the window frame and shadows, and add a lavender cast to the wall. Using one of your lightest light soft pastels, increase the light in the window area.

The red and gold frames of the niche might seem too intense and too distinct, so go over them with washes of your darkest blues and crosshatching of black. Putting a few gleams of gold on Wolfram's gold skirt helps to subdue those darks also by contrast. Using a deep black, continue to define the large Wolfram in the niche. Touches of dark yellow and green make up the frame of the niche as well as parts of the gilding on the statue.

5 Final Details

Go back to little Wolfram on the side, and define him better and draw him more accurately. A strong black, slightly harder pastel is very handy here as well as below him and at the top of the column. Define the column itself with a dark bottle green added to the top and blue to the bottom. Highlights on the column are the light blue you originally used in the window.

Now on to the tabernacle. Because it comes forward from the niche, it should be brighter. Lighten with some lighter browns, and touch up the gold trim with some of the lighter yellows you used previously. Paint the candles with a cream-colored hard pastel lightly washed with the light blue from the window.

It's a good idea to set the painting aside and come back to it the next day. Once again it appears the details got a bit out of hand. Judicious wiping with a paper towel and your little finger helps to remove some of them. Working in the big Wolfram statue, lighten some of the darks just a bit to bring the value closer to the others and lose more details. Finally, use a hard pastel as needed for blending and softening details while unifying with faint color.

IN A COUNTRY CHURCH, BAVARIA | **Ray Hassard**
Pastel on Richeson Premium Pastel Surface; 24" × 24" (61cm × 61cm)

67

25 Set Your Subject in Another Era

When I'm struggling to overcome a creative block, I return to painting the subject that I'm most passionate about—people. I'm always drawn to paintings of portraits and figures. Being able to bring the soul of the subject to life on canvas is a great joy to me.

If I find myself feeling uninspired, a live model may be what it takes to put me in a more creative mood. But sometimes I think the way people dress today can be a problem. I find the fashions of bygone eras more grace-ful and romantic. For many years, I've kept my eye open for clothing, hats, etc. at estate sales or antique stores, where they are inexpensive. Having complete creative control over selecting a model, costume, pose, props, settings and lighting is very inspiring.

When I see my subjects in the costumes and set-up that I've chosen, I become excited at the possibilities. Any creative block I might be facing is gone, and I'm ready to paint.

REFERENCE PHOTO
This photo was taken late in the afternoon. The sun had slipped behind the hills, so the light was subtle. I've dressed my daughter and her son in costumes that appear to be from the very early 1900s and took them to a local park for a photograph session. The "vintage" pull toy was made by my husband and was a great addition to the set-up.

1 Sketch the Subject

Sketch the figures on an 18" × 24" (46cm × 61cm) canvas with a pastel pencil. Don't worry about drawing too much detail as it will be covered as soon as you start painting. Aim for accuracy in the composition, keeping the figures from being too centered. Divide the canvas into approximately two-thirds sky and one-third grass.

2 Lay In the Darks, Paint the Sky and Begin the Skin Tones

Lay in the darkest darks—the hat ribbon—with nos. 2 and 4 filberts using Alizarin Crimson, Viridian and Ultramarine Blue Deep. For the darks of the hair, add Transparent Oxide Red and Raw Sienna to the ribbon mixture. Keep the paint thin—you'll work toward thicker paint as you progress.

Put down a color note for the lightest light—the baby's shirt next to his hand—with a mix of white with a touch of Permanent Red Medium and Cadmium Yellow.

Paint the sky with a variety of blues and violets with touches of Cadmium Yellow and Cadmium Orange here and there.

For the skin tones, mix orange and Cadmium Yellow and Yellow Ochre with white and cool it with a bit of Cobalt Blue. Warm and cool these base skin tones as needed with Alizarin Crimson and Viridian. Start with the average tone first, working toward changes in value and temperature as the painting progresses.

3 Finish Blocking In the Faces and Begin the Hair and Clothing

Finish painting the skin tones and mix Cadmium Orange, Transparent Oxide Red and a touch of Cobalt Blue for the darks of baby's hair. Mix a gray for the blouse behind the baby's head. Lay in the top of the hat with a no. 6 filbert and a mixture of Raw Sienna, Yellow Ochre and Cadmium Yellow Light. Darken and cool the underside of the hat. For the blues in the baby's shorts, mix Cobalt Blue, white and a bit of Cadmium Yellow Light; use that mix for the mother's skirt but move it toward a blue-violet. Begin the grasses with Viridian and Cadmium Yellow Pale.

4 Refine the Faces and Begin the Foreground

Mix a darker tone for the shadows on the faces, adding more Alizarin Crimson and Transparent Oxide Red with blue to cool and Viridian to gray it. Use warm darks, leaning heavily to Transparent Oxide Red and Alizarin Crimson. For these smaller areas of darks around the features, use a no. 2 filbert bristle brush.

On the mother's blouse, use a grayed-down purple tone made of white, Ultramarine Blue Deep, Alizarin Crimson and Yellow Ochre and a no. 4 filbert.

For warmer greens in the foreground and midground, mix Ultramarine Blue, Cadmium Yellow Medium and touches of reds and Yellow Ochre.

5 Final Details

Add dark accents where needed, such as in the sky. Check for any drawing corrections, and look for edges that need to be softened or sharpened. Keeping strong contrast, adding a sharp edge or two and using clean color and more detail help to ensure the baby's face will stay the center of the viewer's focus. Check your values, edges and temperature changes, and you're done.

THE BIRTHDAY GIFT | **Jean Hildebrant**
Oil on canvas; 18" × 24" (46cm × 61cm)

Jean Hildebrant | jeanhildebrant.com

Born and raised in a small town in Oregon, Jean Hildebrant found herself drawn to the beauty of art at the early age of 3. As her art education progressed and her style developed, she discovered that she especially enjoyed working in oil and pastel mediums.

Jean specializes in portraits and figurative works and paints realism with the purpose of leaving an indelible impression. She has exhibited and won numerous awards in local and national shows, including a first place in the portrait/figure category of *Pastel Journal*'s Pastel 100 competition and the Pastel Society of America's National Annual Exhibition.

She is a charter member of the Pastel Society of Oregon and a member of the Arizona Artists Guild, the Arizona Pastel Artists Association and the Fellowship of Christians in Portraiture. Her work is in private, public and corporate collections. She resides in Scottsdale, Arizona, with her husband.

26 Copy the Work of Another Artist

Sometimes when faced with a block or a feeling of difficulty in getting started, it can be helpful to study the work of others. Trips to museums and art galleries, and looking at work in books, magazines and online references all give the artist an opportunity to study how others have solved specific problems. To get even further into the techniques used by others, it can be helpful to copy their work. Copying the work of the Old Masters in museums is a time-honored method of learning. But copying the work of contemporary artists can be just as useful. (Of course, when you copy the work of another artist, you cannot exhibit or sell it, and if it's a living artist, it's best to ask permission.)

Finding a quality in someone else's work that we would like to see stronger in our own paintings can stimulate our creativity. Once a skill is studied and improved upon, we can begin to paint with greater confidence. Feeling confident can be a powerful tool in breaking through artist's block. I feel I gained confidence in the use of vivid color and looser brushwork by studying and copying this delightful pastel painting.

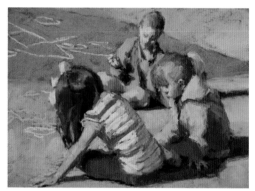

REFERENCE PAINTING
I paint in both pastel and oil, and find duplicating the rich saturation of color I can achieve with pastel to be a challenge when working in oils. Margaret Dyer's painting Chalk Artists *is done in pastel. I love the vibrant color and looseness that Margaret uses in her pastel paintings and wanted to see how I could employ those elements in oils.*

CHALK ARTISTS | **Margaret Dyer**
Pastel; 9" × 12" (23cm × 30cm)

1 Sketch
To begin, loosely sketch the children on the canvas with a pastel pencil. Pay special attention to the large shapes. Look for the angles of the torsos and arms and also the cast shadows. Once the drawing is done, sketch in the masses of the dark areas. Don't worry about a completely detailed drawing as the painting will cover it.

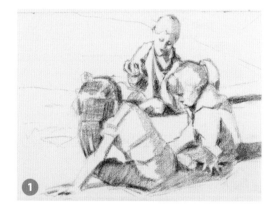

2 Lay In the Dark Colors
Start by massing in the dark areas with a no. 6 bristle filbert, switching to a no. 4 for smaller areas. For the large darker area behind the girls, mix Cobalt Blue and Viridian and gray it with a touch of Cadmium Red Light and white. Lay in the darkest accents under the figures with Ultramarine Blue Deep mixed with a small amount of Alizarin Crimson Permanent. Use this to establish the darkest parts of the hair. Add Transparent Oxide Red and orange for the lighter darks in the hair. Paint the darks of the pink fabrics with Alizarin Crimson Permanent and Cobalt Violet. The shadows of the white are a mixture of Cobalt Blue and violet with white.

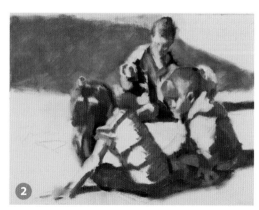

3 Develop the Background

At this stage, keep everything loosely stated and look for the temperature and value changes in all the colors. Add more color to the background blue with various lavenders, pinks and blue-greens of a similar value. Mix warmer colors for the hair using Yellow Ochre, Cadmium Yellow and Burnt Sienna. Mix Cobalt Blue and Raw Sienna for greener tones in the hair and for the pants on the figure on the right. For the jacket on the top figure, use Viridian, Cobalt Blue and white. Mix Raw Sienna, orange and white with a bit of violet to gray it for the foreground and touches in the hair. Lay in some skin tones with Alizarin, Yellow Ochre, white and a tiny touch of Cobalt Blue for cooler darks in the shadow side of the face and the hand in the foreground. For warmer skin colors, mix orange, Permanent Red Medium, white and the slightest touch of Cobalt Blue. Begin to indicate the stripes of the shirt.

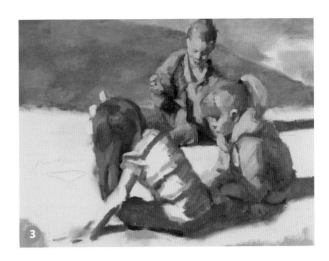

4 Cover the Canvas

Continue to lay in all areas broadly until the entire canvas is covered. Place a variety of colors of similar value wet-into-wet in the background and foreground. Add stripes to the shirt and add warm notes to the brown pants with Cadmium Orange. Paint the light areas of the skin tones loosely with small sable brushes.

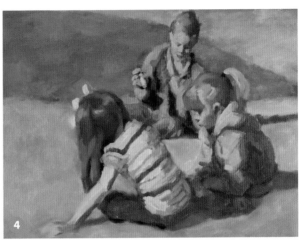

5 Final Details

Paint cooler colors of pink, lavender and aqua over the underpainting in the foreground. Restate the dark accents in the jacket and under the figures and refine the hand and arm of the girl on the left. Begin the chalk drawings in the background using a no. 2 bristle brush with cool white.

Study the painting as a whole to decide what needs further attention. Refine the face, hair and jacket of the focal figure—the girl at the top. She should have a bit more detail than the other girls.

Add the final details of the chalk drawings in the lower left side. With the no. 2 bristle, paint in the pink and bluish white lines. Assess the full painting to see what else is needed. Adjust the shape of the yellow bow and add a bit more detail to the profile figure's face and hair. Place final dark accents and highlights to finish the painting.

CHALK ARTISTS REVISITED
(AFTER MARGARET DYER) | **Jean Hildebrant**
Oil on canvas; 12" × 16" (30cm × 41cm)

27 Rework a Plein Air Painting With Layers

Who isn't excited about plein air painting? It gives the artist a chance to commune with and feel a part of our natural world.

From my earliest days, I remember sketching landscape subjects outdoors. My parents would always remind me to take along my drawing and watercolor supplies to journalize our family vacations. I was known as the artist in the family.

But as I learned more about design, composition, value, color and shapes, I found plein air painting getting harder and harder. I could get started, but then it was like I forgot everything I knew about art.

Over the years, I've stopped apologizing for not being able to always render a masterpiece on location, although I have had some successes. I've learned some tricks to get through the process, but most important, now I don't expect to always finish the painting on-site. Knowing I can rework a plein air piece back in the studio is one way to keep from being blocked when I start the painting on location.

REFERENCE PHOTO
The time is early November in a vineyard in southern Oregon. The grapes are ripe, the vines are in their best color and the grapes are being picked while we're painting. It's a beautiful day—clear, warm and perfect for painting.

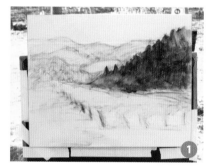

1 The Plein Air Sketch

After doing several preliminary thumbnails to determine the composition, lay in the sketch on a 12" × 16" (30cm × 41cm) white Pastelbord surface using a dark violet pastel pencil. Using the same pencil held on its side, add dark values, especially in the midground mountains.

Next cover the sketch with denatured alcohol, brushing it on with a no. 10 synthetic brush. Brush it gently on the dark areas first. Apply it lightly, using a paper towel to blot the brush—you don't want to lose the drawing at this point with any drips of dark color. The denatured alcohol will set and embed the drawing into the surface of the Pastelbord. Spread the alcohol over the whole painting. It will dry immediately, and the drawing is preserved.

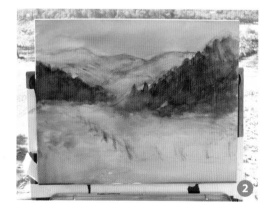

2 Apply a Watercolor Wash and a Layer of Gesso

Using Cretacolor watercolor blocks and a no. 10 flat bristle brush, apply a watercolor wash. To keep the temperature of the painting warm, use washes of red in the sky, yellow or Burnt Sienna in the foreground and violet for aerial perspective in the mountains. Let the colors flow together so there is an obvious relationship between the masses. You can add more washes if needed. When the watercolor is dry, apply a layer of clear gesso with a 1½-inch (38mm) flat brush over the surface. The clear gesso adds texture, so if one coat doesn't create enough texture to suit you, add another. You may want to let the gesso dry overnight before the next step, which will be back in the studio.

3 Add a Layer of Pastel

Lay in some dark values of violets and greens in the midground, and start to work on the vineyard and generally cover the board. Now that you're back indoors, take time to analyze the composition. If it doesn't seem to be working, go brush off all the pastel and add another coat of clear gesso. It may make everything rather dark, but that is no problem.

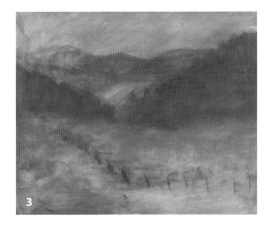

4 Add a New Layer of Pastel

Paint the sky with a selection of blues: very light turquoise, light blue-violet and a light-value Ultramarine Blue. Don't blend with your fingers in the sky area. Let those colors make the sky texture. Now consider compositional changes. Revise the foreground by removing the road on the left, improving the composition. Block in the mountains with blue-violet, and the midground hills with warm greens, violet and orange. Add a mixture of warmer greens, oranges, red-orange and rusty reds to the foreground.

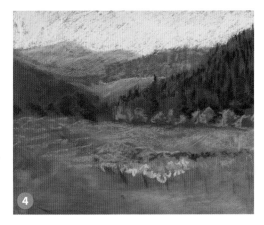

5 Refine the Composition

In the dead center of this scene is a denuded area of ground. You can try several things—lighten it, darken it, warm it or cool it—but it adds nothing to the painting, and it's visually disconcerting. So it's best to eliminate it. Cover that area with colors similar to those next to it, like warm greens and violets, to make it fit with the other background mountains.

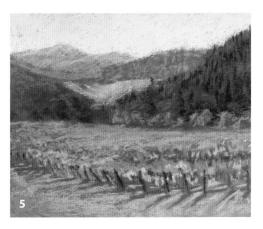

6 Adjust the Aerial Perspective and Make Final Adjustments

The background hills are too dark and need more aerial perspective. To make them recede, add a lighter blue-violet to the hills and the far reaches of the vineyard. Add bright yellows and oranges to the right foreground to catch the viewer's eye.

When you think a painting is about finished, it's a good idea to place it where you can observe it throughout the next day or days. After observation, the trees in the midground seem isolated, and the right foreground needs to be emphasized. Put a dark cap on the fence poles and a few darker shadows to guide the viewer's eye to start in the foreground and then wander over the vineyards into the depths of the distant mountains. Make the mountains recede by softening them with some pinkish hues, and add some light pink into the right side of the sky and a little yellow on the right.

HARVEST COLORS | Janie Hutchinson
Pastel on Pastelbord; 6" × 12" (15cm × 30cm)

28 Explore Color Variations of the Subject

During the winter months, plein air is pretty much out of the question in the Northwest where it's usually foggy, raining buckets or snowing. This is a good time to experiment with art in the studio, maybe loosen up a little and try something I ordinarily wouldn't think of doing.

I decided to pick a photo and morph it into something entirely new. I wanted something simple—one clear and single idea, one movement of light—something that could catch a viewer's eye in a gallery window.

In the finished painting, the light is ambiguous. Is it morning or evening light? I'll let the viewer decide.

REFERENCE PHOTO

In looking through my photographs, there was one of those sunsets so fleeting that no one could paint it on location— it was gone in a second. If I painted this scene as it was, I could never do justice to that one single moment in time, but I wondered if I could use some of the elements to make my own sunset or sunrise.

1 Color Studies and Planning

First I painted 3 variations of the subject in oil on 6" × 8" (15cm × 20cm) boards. The first version, like the photo, was in yellows and golds. Then I did one dominated by red and finally another dominated by blue. Still, I wanted something not quite so full of detail. It needed to be simpler with one strong light source that went across the painting—not dragging the viewer's eye out of the painting, but allowing it to start on the left behind the tree, then go to the right over the distance and down across the land. Or maybe it could be a river? If it were a river, there could be some reflections in the water. I wanted to dramatize the long shadow that followed the light streak diagonally across the scene.

2 Prepare the Surface

On Pastelbord, sketch your subject with a dark violet pastel pencil, then use a synthetic brush to gently brush

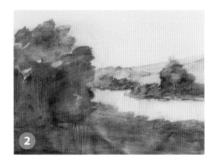

denatured alcohol over the marks. Use a no. 10 synthetic brush to go over the dark masses. Blot your brush on a paper towel and be gentle applying the alcohol. Don't scrub it into the surface. When dry, use a no. 10 brush to cover the whole board with alcohol. This gives you a value sketch that will be preserved for subsequent applications of medium.

Texture is lost when alcohol is brushed over Pastelbord, so once the alcohol has dried, take a 1½-inch (38mm) house painting brush and apply a coat of clear gesso. Use a hair dryer to dry the surface.

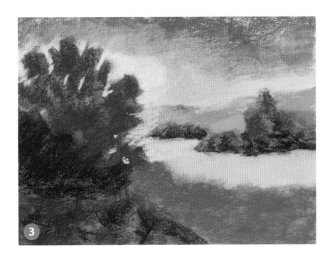

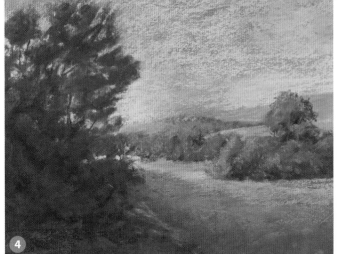

ONE SINGULAR SENSATION | Janie Hutchinson
Pastel on Pastelbord; 11" × 14" (28cm × 36cm)

3 Add the First Layer of Pastel

Use the sides of the pastel sticks with gentle, light strokes to apply many layers. Begin with the dark areas using a very dark green in the large trees, and let some of the violet show through. With a dark green and dark violet, lay in the shadows under the trees. Move to the midground trees on the right and add dark violet in the shadow areas. Paint the midground hills with a light warm brown on the sun side and a medium brown on the shade side.

Still using a light touch, use a medium blue-violet in the distant mountains. Now take the dark turquoise used in the sky to paint the long foreground shadow. Add light turquoise between the distant mountains and the dark sky.

Use a light yellow and cut into the edges of the right trees. Extend the yellow to near the center of the board. Take a light pink color and gently connect the yellow and turquoise of the sky. Add a very light brown to the sunny streak going across the painting.

4 Continue Layers and Add Final Details

Create a transition from dark to light or from cool to warm of the foreground shadow. Use a light orange on the light side of the shadow and a light violet on the edge of the shadow to mellow out the transition.

Use a variety of darker greens and violets in the trees to give more form, working back and forth with the light colors and the darker colors. Don't make the tree too light because you want it to stand out against that bright yellow sunlight.

Work in the right landmass under the trees. Make some strokes of dark violet in the shadows among the dark greens in the right foreground landmass to give it form and variety, generally keeping this area the darkest on the painting.

When you think you are at a finishing point, place the painting where you can observe it for several days and make final corrections before you decide it's done.

Janie Hutchinson | janiehutchinson.com

Janie was raised in the Midwest, became a registered nurse in St. Louis, Missouri, then moved to the western U.S. She lived in Portland, Oregon, and worked in health care for many years. Her work took her to the Middle East and eventually to New Mexico. Painting had always been an avocation, but became a passion when she retired. While in New Mexico, Janie and Maggie Price cofounded *Pastel Journal* in 1999, which is still thriving since its sale to North Light in 2003.

For Janie, painting is about capturing the beauty of the landscape. She had training in drawing the figure and occasionally paints a still life, but the landscape remains her main choice. She finds satisfaction in painting the mundane, everyday views of our surroundings as well as the awesome scenes of the seasons. An avid student of art history, she is especially inspired by paintings of the early California artists and the American Tonalists.

Now living in Jacksonville, Oregon, Janie works in pastel and oil. She belongs to The Wednesday Group, a long-standing association of local artists mentored by artist Richard McKinley. She is also a member of the Pastel Society of the West Coast and the Northwest Pastel Society.

29 Apply Watercolor With Unusual Tools

Applying paint with an unusual or new clunky tool—sponge, rag, squeegee, credit card, scraper or roller—helps break me out of the necessity of accurate drawing prior to painting. It's a way of breaking with the traditional tightness that is often the product of careful pencil renderings and the resulting requirement of painting inside the lines.

I like to find or make nontraditional tools to deliver the paint to the paper. Using a "clunky" tool enforces simplicity. When you paint a portrait, it's tough to paint eyelashes, veins and little nits with a large tool. I look for every sponge, squeegee, credit card, palette knife, feather or scraper I can find. Sometimes I even make a couple of tools. Not all of them work, but many will.

I often use this approach without any preliminary line drawing. The tools are cumbersome enough—forcing simplicity—so there is no fussing or refining. It makes you paint more directly by blocking in large shapes. The purpose is to break out of your current block—not necessarily to paint this way all the time. It's a way to do an end run around your critical mind-set and force you to be more kid-like and playful.

THE CLUNKY TOOLS
Collect an assortment of tools, such as these: left to right, 1-inch (25mm) flat wash brush, plastic picnic knife with end cut off and sanded smooth, cotton swabs, white eraser, Sofft mini applicator (or foam makeup applicator), packing foam (or sponge) wedge, Sofft sponge knife, plastic palette knife.

PHOTO OF THE MODEL
Working from a live model, arrange the set-up using a backdrop to eliminate distractions behind the model and positioning a light to one side.

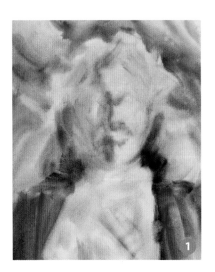

1 Block In the Colors
Create a simple line drawing on watercolor paper, then saturate the paper from both sides with a 1-inch (25mm) wash brush. Let the water soak in until the paper is slightly floppy. (This is the only use for the brush.) Mop up any extra surface water by rolling a paper towel across like a rolling pin. Once the paper is saturated, it will stick to your plastic backing board (waterproof surface).

With a sponge wedge or rag and a creamy consistency of paint, rough the colors of the background into the face in a light to medium value. Keep it loose and spread the paint around most of the surface. Fuzzy shapes are okay at this point. Adding additional water with the sponge will make the washes run and lighten if you get the paint on too thickly to mingle.

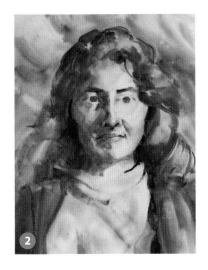

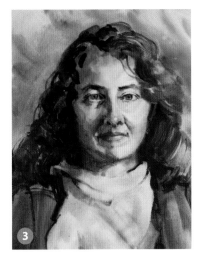

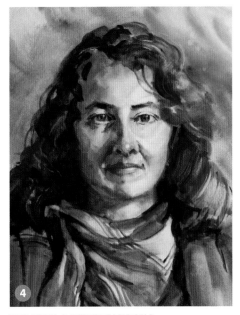

2 Work on the Face

Build more value contrast in the face on the left shadow side and create more darks on the neck with the small sponge wedge and creamy to pasty paint consistency. Add paint with the sponge knife to darken the eyebrows and hair to indicate curls. Further develop the lips with the mini applicator and palette knife. Create the eyes using a cotton swab with a few bits of green and orange for the beginning of the iris.

3 Using the Sponge Knife

If your paper is starting to dry out too quickly and curl, particularly at the corners, apply more clean water on the back side with the 1-inch (25mm) wash brush, lifting the paper up only halfway.

Create additional darks in the hair using the sponge knife to smear on paint in the direction of the curls. Create eye detail with the plastic palette knife and modified picnic knife. Lay in a small sliver of orange along the right side of the face to create an edge-softening mid-value step. Restate and darken the left side of the face, and scratch in some hair highlights using a fingernail or palette knife. Lift highlights on the lower left chin, the nose and upper right cheek with the mini applicator, and use the white eraser to create highlights on the bridge of the nose and above the eyelids.

DEB WITH A GREEN BANDANA
Jeanne Hyland
Watercolor on Arches 140-lb. (300gsm)
cold-pressed paper; 15" × 11" (38cm × 28cm)

4 Final Details

Create more darks and details in the scarf by smearing and drawing with the sponge knife. Add a little more Cerulean Blue as reflected color to the left underside of the chin in the shadow, and darken the lower left wave of hair. Add a few creamy white highlights on the nose, lower lip, chin and eye pupils with the mini applicator. Let the paper dry slowly, sandwiched between 2 plastic boards, until completely flat.

Jeanne Hyland | jeannehyland.com

Jeanne Hyland holds a BFA in figurative sculpture and drawing from the University of New Hampshire and also studied at the École des Beaux Arts in France. After 25 years in commercial graphic design, she returned to her fine-arts roots in bronze figurative work and later to watercolor as her medium of choice.

Jeanne's artwork combines her love of nature's beauty, energy and forms with an intense palette plus technical skill and experimentation. She teaches workshop around the U.S. and has served on the board of directors of the National Watercolor Society. She is a signature member of Women Artists of the West, and member of the National Watercolor Society, the American Watercolor Society, the Portrait Society of America and the New Mexico Watercolor Society.

Her paintings have been exhibited and won awards in numerous exhibitions and have been published in *ArtRageUs* and *How Did You Paint That? 100 Ways to Paint Still Life and Florals* (Volume 2).

30 Splatter Paint for an Intuitive Start

Sometimes I find it's hard to get started when facing a piece of blank white paper ... maybe even a fear of failure, of not being good enough or that I don't have the necessary skills. Sound familiar?

As overcompensation, I often find myself feeling compelled to stick too closely to reality, mimicking the reference photo or live set-up. I'm too tight, too controlled from the outset. So I look for a way to sidestep that negative head chatter and trick myself to jump in. Starting with a random pour-and-splatter process is a great way to jump-start the intuitive side of your brain with a playful approach. The ensuing patterns present myriad opportunities to challenge yourself with new thinking and techniques.

I often make a drawing on watercolor paper first, then pour and mingle light-valued multicolored washes with a rough idea of where the colors will be placed. For even more fun, I pour colors first, then impose my drawing over those washes, modifying the washes and shapes as needed to build and reveal an invented or altered image.

1 Draw and Splatter

After working out the large shapes or design on a sketch pad, with a red watercolor pencil draw from your reference. Tape the edges of your paper to a backing board.

Either outside or on the studio floor covered with plastic, create a pattern that picks up some aspect of your image (such as rhythm or directional shapes) with splattered masking fluid (Pebeo drawing gum) on dry paper by dipping your fingers into a small cup of masking fluid (coat your hands with barrier cream first). Using a drinking straw to control the direction of movement, blow on the splattered masking fluid. Wash your hands immediately with soap and water. Let the paper dry. Remove any masking that you don't want. Add more if needed and let it dry.

2 Apply Washes of Color

Next, wet your paper with clean water using a 1-inch (25mm) wash brush. Pour Lemon Yellow and New Gamboge tea washes on the main flower center. Add thin washes of red along the sides and Horizon Blue along the top and let all the colors mingle. Use a medium round brush to splatter more color bits and guide the paint. Tilt your board to gently move the paint and water if needed. Use a damp but thirsty brush to carefully mop up puddles to avoid backwashes in overloaded areas. Using a nutmeg grater, grate yellow, orange and magenta watercolor crayons to create more texture. Clean up extra paint along the edges of your board using a sponge.

As the paint washes dry, use a small, damp round brush to lift a few key highlights back to near white in the central

flower and stems. Clean your brush and remove excess water between each lifting stroke.

Let it dry, then add a little light-to-medium value paint splatter of Cobalt Blue and Napthol Red to the upper half of the background using a round brush or even your fingers. Soften any stray spots and splatter with a soft wash brush. Let it dry.

3 Add Darker Colors

Pre-wet background shapes with water, then quickly drop in and mingle darker colors—Rose of Ultramarine, New Gamboge, Cobalt Blue, Sap and Hooker's Green—to define the edges of the flowers and leaves. Connect colors in the negative spaces behind the flowers and stems. Overlap the lower background wash colors into the lighter blue color at the top by blending to clear water as you reach the lighter-value area. Take cues from the initial washes for color choices; either darken and intensify local color or shift the color by glazing analogous or complementary colors over the top. Continue to work around the entire painting. Using ¾-inch (19mm) flat and small round brushes, glaze more color to darken values around petals, stems and leaves. Let it dry.

4 Refine the Flowers

Paint in the dark center of the middle flower with the small jumbo round and no. 8 round brush. This will create contrast next to the light surrounding the petals as your focal point. Pre-wet the center shape leaving the highlighted yellow shapes dry, and paint Quinacridone Burnt Orange overall, then drop in Rose of Ultramarine, Cobalt Blue and Ultramarine Blue along the edges. Soften the edges on the left side of the yellow highlight shape with a slightly damp brush, and dot in some texture to create interest and break up hard edges along the cast shadow. Let the center dry while you move on to other areas.

5 Intensify the Colors

Add thin washes of greens and Cobalt Blue over the back of the right sunflower. Layer a thin wash over the leaves at the bottom center with Cerulean Blue and Hooker's Green Dark. Glaze again over the leaves and petals on the left using Rose of Ultramarine, Permanent Alizarin Crimson, Permanent Rose, Red Hot Momma and Cobalt Blue to define petal edges a bit more in keeping with the other flowers. Let it dry. Remove the masking with a rubber cement pickup or a wad of previously removed masking gum.

6 Final Details

Fill back in the white shapes left from the masking. Select color based on how bright or dull, or how much or little, you want each shape to stand out. Use the colors previously used in the painting. Let it dry as you work around the surface.

GOOD MORNING SUNSHINE | **Jeanne Hyland**
Watercolor on paper; 15" × 22" (38cm × 56cm)

31 Start Bright and Move to Neutral

I love color, so a gray winter scene can be a challenge. Grays can be wonderful and luminous, or they can be dull, uninspiring and boring. When you're faced with a predominantly gray or overcast scene, it can be hard to know where to start. As I moved from the medium of watercolor to oil, I found watercolor enabled me to develop a bright to neutral approach to painting gray scenes. I wanted to translate that to my oil paintings.

The traditional oil method of mixing the right color and putting it down did not work well for me. I found my work looked too predictable, and I missed the sparkle and the unexpected burst of happy accidents that often occurred in watercolor, especially with grays.

With the bright to neutral method, there are no formulas for gray, tube grays or predictable blah colors. Instead the work becomes a kaleidoscope of lively chips and dashes of unique colors that form harmonious and often surprising results. I try to complete all the work wet-into-wet to allow the paint to merge and blend. For me, this has been a major turning point with oils: allowing wet, bright color to blend, to help me create unique and subtle colors. With this method I am always learning about grays and certainly having fun!

REFERENCE PHOTO
The early morning light created harmonious colors in the dusky blue-purple mountain, the soft tree branches and the tawny vegetation on an overcast day. Although the colors are soft, there is drama in the mountain.

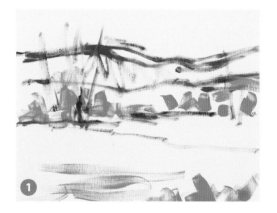

1 Begin With Complementary Colors
Working on an 11" × 14" (28cm × 36cm) canvas panel, start the painting with a strong orange and blue (complementary colors). With a no. 2 flat brush, mix Ultramarine Blue, Cerulean Blue and a few dots of walnut oil to increase the spreadability of the paint. Roughly paint the basic shapes: the mountain, the larger tree trunks, the edge of the tree line, the field and the near shrub cluster. Then use a no. 4 flat brush and a mix of Cadmium Red Medium, Cadmium Orange and a little oil to place some dabs of color in the tree/hill area and the near field.

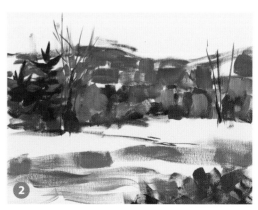

2 Place the Dark Values
With a no. 6 flat, mix a dark green, almost black, color and place it around the canvas for the fir trees, large tree trunks and dabs in the hill area and near shrubs. With the same brush, mix a deep burgundy red color with what remains in the brush and place in the hill area also.

Continue with a no. 6 flat and place a mix of Cerulean plus Ultramarine Blue and a little white in the mountains. Add swipes of this blue mix first to the mountains, then add a little more white and paint some swipes in the hill area and the near field.

3 Begin to Mute Colors

Use the no. 6 flat with the burgundy color and mix with white and yellow on your palette. If the mixture is too pink or red, add more white and yellow. Swipe this mix into the field to make an interesting variety of soft, muted yellows and beiges. Push down to release hints of the burgundy brown color hidden deep in the brush. Now take your brush with blue on it from step 1 and add more white. Place this color in a ragged stripe in the middle of the sky area. Paint the shadow area of the snow in the far field. Add this pale blue color to the top of the mountain and in the near field.

4 Paint the Sky and Hills

Use a new no. 4 flat and mix white with a tiny dot of pale yellow. Place some swipes of this color in the sky. Do not blend or try to feather out the color. Think of slabs of color or a mosaic. It's fine if the large tree branches get covered with some paint. Now wipe off the color on the no. 6 blue brush and mix white and a dot of violet. Finish covering any sky canvas with this light purple mix. Add purple to intensify the white-violet mix and add to the hill/tree area and the field. At this point it's okay to swipe the brush right over an existing color. Don't think about blending—as in soft, blurry edges. Instead, think about layering or modifying color with strokes and dabs.

5 Soften the Edges

Smudge the mountain/sky line with your finger to blend and soften. If you don't want to put your fingers in the paint, use a brush with the paint wiped out to manipulate the existing paint gently back and forth to blur the edge of the mountain. It is all too easy to overblend, so be careful with this step. Step back from the work to see how distance from the art can visually soften brush strokes. Blend a few areas of the sky.

6 Add Details and Fine-Tune the Shapes

For texture or fine detail, an older brush's splayed edge is great for creating tiny branches on the big trees. Dip only the brush tip in the dark mixture and encourage the brush to split open in segments by shoving it into the palette. Paint the trees with the lightly loaded brush, swiping gently down in scooping motions starting from the sky and moving down toward the main trunk. To make the field texture, drag the brush vertically (only a tiny, short motion up) through the swipes of horizontal colors painted in prior steps.

Paint the far snow field with a mix of all the leftover sky whites on the palette. All the tints mixed together will produce a pale silver-blue-gray. Use this mixture to refine the snowy field shapes peeking through the trees. Add more gray-white to the near field in little dots and dashes to look like snow caught in the field stubble. Continue to refine the field, edges of the shrubs and far trees to finish the painting.

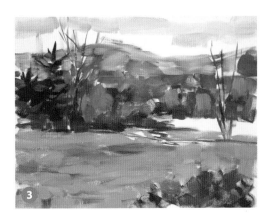

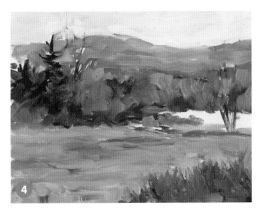

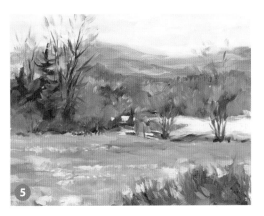

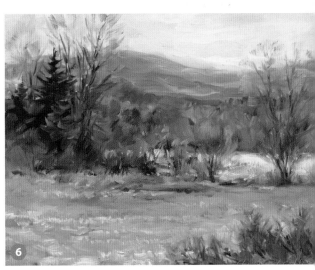

JANUARY FIELDS | **Christine Lashley**
Oil on canvas panel; 11" × 14" (28cm × 36cm)

32 Prepare for the Painting With Preliminary Studies

Preliminary sketches and studies make the creative process flow smoothly for the final painting and encourage a looser and more confident painting. By digging deep into the subject matter and understanding it through and through, the final painting emerges as a synthesis of the creative process.

In the past, I was not a fan of studies. I was eager to get to the painting and be creative. I thought too much preliminary sketching could make a work fussy. I thought by working quickly and painting bigger brushstrokes, I could make a successful painting. However, the results often lacked depth and looked sketchy or unfinished.

When I toured a John Singer Sargent exhibit at the Corcoran in Washington, DC, I became inspired by the large number of sketches and extensive preliminary work exhibited to demonstrate his creative process. Sargent's paintings had always looked so effortless to me. Why would such an accomplished artist need studies? Wasn't that like practice?

I had often heard about working in a series, but I mistakenly thought that meant the same type of subject over and over, painted in slightly different ways. What I now realize is that it's not really about the subject matter when painting in a series. It is about a feeling, experience or memory. When this is explored and an attempt is made to convey this feeling through color, value and imagery, then magic can start to happen on the canvas or paper.

REFERENCE, SKETCHES, STUDIES AND PREPARATION
The first step is to define what memory or idea the art will represent. This photo is from a trip to Provence, France, with my husband. We were jet-lagged but found a charming restaurant.

1 Sketches and Doodles
Start with doodles and sketches. Don't be limited by the horizontal nature of the photo reference. Consider cropping the image differently. Looking at this photo and thinking back to the memory, I realized we were always looking past the dishes and food to the amazing view.

2 Watercolor Studies
Before doing the color studies, I selected an on-location painting I had done of a tropical beach and waves for the color scheme. I prefer to use paintings done on location for color versus the too-dark colors often found in photos. With a no. 6 sable round brush, I created studies to further work on the color scheme of the art. The paper was dry, but some wet color was allowed to merge, such as the sky, foliage and sea areas.

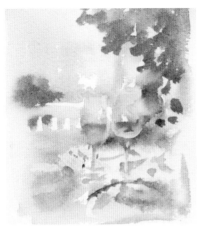

STUDY #1

I filled in the blue sea color with a mix of Peacock Blue and Cobalt. I liked the colors but felt the study started to get too busy with details on the table. It also started to feel overall too dark, and the glasses were too close together. The terrace banister was too even and popped forward.

STUDY #2

Here I liked the interest on the table, but the dark outline on the plates is distracting. I really liked how the glasses sparkled. Everything seemed brighter, and that was good for the mood I wanted to convey.

STUDY #3

Focusing on the idea of more brights, I left most of the table, glasses and plates as white. Merging all the shapes on the table simplifies everything by creating a light table area and darker sea and sky in the background. I chose this as my main sketch moving forward.

3 Final Pen Sketch

I created a final version of the elements on the table after 3 mini watercolor sketches. I decided to add a vase and flowers.

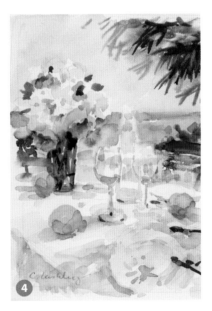

4 Final Watercolor Sketch

Work out color combinations to make sure your colors are harmonious and in balance. The final sketch shows the color scheme, values and elements in place.

5 Begin the Shapes in Oil

With a no. 2 flat brush, mix some Phthalo Green (Blue Shade) and Cerulean Blue. Because much of the drawing and planning has been created already in the sketches, have some fun with your shapes; you should know them by now. As the drawing progresses, rub out any shapes that need correcting with a paper towel moistened with water. Thinned paint dries more quickly than traditional oils, so it makes a great first layer.

6 Vary the Colors for Interest

Subtle shifts of color make a solid area interesting and alive. Premix a variety of pale blues on your palette: Ultramarine Blue plus white, Cerulean Blue plus white, Phthalo Blue Green plus white, Phthalo Blue Green, a small bit of Cadmium Yellow Light plus white (aqua-green color). With a no. 8 flat brush, swipe the colors in random dabs for the sky and ocean. Paint inside the bottle also. Leave some canvas unpainted for now where the foam wave will be. Use mostly Ultramarine mix in the sky and mostly aqua for the ocean. Leave some blank canvas in the upper right for the palm.

7 Finish the Sky and Add Dark Greens

Mix Quinacridone Violet, Ultramarine Blue and white to make a pale purple and apply it to the upper left of the sky. Mix Cadmium Yellow Medium, Cadmium Orange plus lots of white to make a pale cream color for the horizon area, dulling some of the bright blue color to make it appear more distant. Now, define the ocean more using a darker teal color made with Phthalo Blue Green, Cerulean Blue and a little white. For the palm fronds, use a mix of greens. (Dark green: Ultramarine Blue, Phthalo Blue Green, Cadmium Yellow Medium plus a little Permanent Rose; medium green: Cadmium Yellow Medium plus Viridian plus Cerulean; light green: previous medium green mix plus Cadmium Yellow Light and Medium.) Use a medium-green to block in the vase base, flower leaves and the shrubs behind the banister. Add brown to some palm fronds by mixing some Cadmium Red into some of the dark green mix.

8 Add Oranges, Refine Ocean and Finish the Palm Tree

Use Ultramarine Blue to darken the ocean's horizon line. Refine the palm by dragging a brush through all the palm paint layers to craft the final fronds. Add more dark green behind the banister of the terrace to start creating the railing. For the sea foam, take some of the cream color from the horizon and some of the sky purple to make a soft, pale purple-gray. Use the palest blue mix from the sky plus white to block in the white flowers and more of the tablecloth and plates.

For the oranges, use a variety of salmon, orange and yellow colors. Mix an assortment (Cadmium Yellow Medium, Cadmium Orange, plus white and Cadmium Orange, Cadmium Red, plus white) to block in the oranges, orange peels and flowers. Add Burnt Umber to make the yellow more of a tarnished gold color for the shadow side of the sunflowers. For the sunflower centers, use Cadmium Red plus Cadmium Orange. For the very dark center, add some of the dark green tree mixture to make a burgundy color. Paint some of the shrub flowers with the same yellow mix as the sunflowers. Use white plus Cadmium Yellow Light for the sunflower highlights.

9

Refine the Tabletop Elements

Add Quinacridone Violet and Ultramarine Blue to darken the basic table gray. Place this color in the deeper shadows of the table area around the plates, vase, napkin, etc. With a clean brush, mix a large amount of white plus a little Cadmium Yellow Light. Paint the sunlit area of the white flowers and table-cloth. Swipe in some extra flowers with the white to make the bouquet more full. (The wet paints will merge to dull the white.) With the orange mix, dab in swipes to suggest fallen petals or orange peels, and dot in some centers for the white flowers.

10

Modify the Edges and Peach-Orange Colors

Continue to refine the table area and check the values. Soften and lighten the tablecloth fabric folds with some extra white in the lower left of the painting. Using mixed gray colors from the palette, finish the napkin. Add gray to the cutlery to lighten areas and place in some spots of color to suggest a reflective surface. Add some Quinacridone Violet plus white mix to the shadow area of the oranges. Add a ping of white to the glasses on the rim for sparkle.

MEDITERRANEAN TABLE | **Christine Lashley**
Oil on pre-stretched acrylic gesso-primed canvas
30" × 24" (76cm × 61cm)

Christine Lashley | christinelashley.com

Growing up in New England and the Mid-Atlantic area, Christine Lashley was always painting or drawing in the woods and fields nearby. She studied as a teen in Paris at the Parsons Art Institute and the Sorbonne, continuing on to earn her Bachelor of Fine Arts at Washington University in St. Louis. She worked for several years in the fashion industry in Europe, then as a muralist and graphic designer, but turned her interest to fine art soon thereafter.

She has exhibited her work in many cities including Seattle, St. Louis, Boston and Paris. Christine's paintings have been shown in solo and group shows in many areas of the country and continue to win top awards. She works with a variety of mediums, including watercolor, oil and acrylic. Many of her works are held in private and corporate collections such as Sprint/Nextel, HydroGeoLogic and the Archdiocese of Washington, DC. Her work has also been featured in *American Artist Magazine*, *The Washington Post* and *élan* magazine.

Christine has taught art classes for over 10 years and she is a signature member of the Baltimore Watercolor Society, Washington Society of Landscape Painters, and the Potomac Valley Watercolorists, where she served as president. She resides in Reston, Virginia, with her husband and 2 children.

33 Create a New Painting Surface

One way to stay productive in spite of the occasional mental block is to make new painting surfaces for pastels. I usually work on manufactured sanded paper, but I find that these surfaces can be limiting. I love the look and feel of pastels but sometimes wish I had the luxury of putting down a nice, thick, juicy stroke, like you can with oil paint. I have long admired the work of pastelists whose pastel paintings have that look to them. The key is often the surface they are painting on. Most are using pastel boards they have prepared themselves. By stroking soft pastel over the textured surface of the board, you can get this added depth. The texture comes from applying a grit mixture to the board with various directional brushstrokes.

Sometimes I prepare a surface with a particular painting in mind, perhaps leaving the sky area less textured and then building up texture for the land or foreground area. I may also tone the mixture with fluid acrylic paint, adding a few drops at a time. I might tone the whole board this way or apply color to the grit mixture after it is on the board, quickly working it into specific areas with my brush. Another option is to apply the mixture as is, which will dry fairly translucent, then do an underpainting on the board with hard pastels and odorless mineral spirits or watercolor. The reward is in the fun of experimenting, creating a surface that will enhance my pastels and allow me to work with a clearer mind and a fresh approach.

1 Gather Materials
You'll need various sizes of Gator board, gesso for sealing the Gator board, pumice gel as the binder, extra-fine ground pumice powder to mix in with the binder, distilled water, a container with a lid for the grit mixture and various sized brushes.

2 Seal the Boards With Gesso
Apply gesso to the front, back and sides of the Gatorbord. Let dry, then lightly sand with fine sandpaper. This seals your board before you apply the grit mixture.

3 Prepare the Grit Mixture
Pumice gel is an acrylic polymer that already contains finely ground pumice solids. Start with 3 to 4 heaping tablespoons of the gel. Mix in a separate container with a lid. Use plastic wrap or cut a plastic sandwich bag to seal the lid of the container and prevent the lid from sticking. Add your pumice powder 1 teaspoon at a time, stirring slowly to keep dust to a minimum. Add distilled water in small amounts and carefully stir the mixture until it is the consistency of yogurt, as shown here. You can add fluid acrylic in the desired color to your mixture at this time if you prefer. Add several drops at a time and stir well until you get the desired tone.

The recipe for your grit mixture will vary depending on the amount of tooth you desire. For more texture, add more pumice and less water. For less tooth, use less pumice. Try various combinations of binder, grit and water until you find the recipe you prefer.

4 Apply the Grit Mixture

Apply the grit mixture to the prepared board. Using a 1½-inch to 2-inch (38cm to 51cm) flat brush, apply using random, crisscross strokes, covering the board quickly. Let dry, sand lightly with fine-grade sandpaper, then apply a second coat. You can apply more coats, sanding between each one, until you achieve the desired look and feel.

5 Finish the Boards With Brushes

These finished boards have several coats of the grit mixture. The ³/₁₆-inch (5mm) board is toned with Violet Oxide and has a rougher texture with brushstrokes visible. The ½-inch (13mm) board was finished with a slightly smoother surface and very little added tone to the grit mixture. For a more textured board, I apply the grit mixture with a variety of flat brushes, including an old 1-inch (25mm) bristle brush, dabbing and twisting with the end of the brush. Applying the mixture with a wide brush in random strokes results in a brushstroke texture on the finished board. For a smoother board, apply the grit mixture with a small foam roller or lightly stroke a soft brush, such as a hake brush, across the surface in opposing directions after each coat.

Denise LaRue Mahlke | dlaruemahlke.com

There is a quiet thoughtfulness and passionate purpose to the work of artist Denise LaRue Mahlke. Her paintings convey a sense of restfulness and peace that reflects the spiritual connection she feels for the landscape she loves. Denise believes that being an artist is a calling that involves preserving, celebrating and sharing in God's creation.

Denise lives and works in central Texas. She is a signature member of the Pastel Society of America and is also a member of Plein Air Austin and the Central Texas Pastel Society.

Recent exhibits include: Artistic Horizons, PSA 'Pastels Only' show, National Arts Club; Maynard Dixon Country Invitational; Masters in Miniature, C.M. Russell Museum; American Art in Miniature, Gilcrease Museum; Cowgirl Up! Desert Caballeros Western Museum; and Phippen Museum 34th Annual Western Art Show.

Recent honors and awards include first place in landscape in the Art Renewal Center's International 2009/2010 ARC Salon, first in pastels in the 34th Annual Phippen Museum Western Art Show, best small pastel award and the Milford Zornes Best Work on Paper Award at Maynard Dixon Country in 2003 and 2004. Her work has been featured in *American Artist, Pastel Journal, Plein Air Magazine, Southwest Art* and *Western Art Collector*.

34 Copy the Work of an Old Master

The exercise of copying an Old Master is a challenging and fun way to grow in your work. It gets you out of your comfort zone, forcing you to take a closer look at the artist's use of composition, design, value, color, texture and application. It helps you to solve problems you may have with your own work and broadens your understanding and appreciation of the rich legacy left by the artists who came before us.

I love the work of the renowned nineteenth-century Russian landscape painter Isaac Levitan. Levitan was born into a poor Jewish family in Lithuania in 1860. At age 13, he entered the Moscow School of Painting, his tuition fees waived because of extreme poverty. He made rapid progress under the tutelage of Vasily Perov, Aleksei Savrasov and Vasily Polenov. Both Savrasov and Perov revered the Barbizon school of French landscape painters and held them up as examples to the students, and Levitan was particularly drawn to the work of Jean-Baptiste-Camille Corot.

As he grew as an artist, Levitan sought ever simpler motifs in his landscapes, always working directly from nature. Levitan sought to reveal the hidden face of the natural world and to suggest what lay beyond the immediately apparent. His profound love and understanding of his nation's landscape resonates with the viewer of his lyrical, poetic paintings.

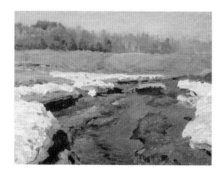

REFERENCE PAINTING
Levitan's 1884 painting Last Snow *is one of my favorites. The challenge was choosing from the many images available of the work. I settled on one in a book and worked with a few online images from my monitor. My favorite reference for the painting is from the Isaak Levitan Exhibit Catalog from the State Tretyakov Gallery, Moscow.*

1 Prepare a Surface

Levitan painted *Last Snow* in oils on canvas, rather small, 10" × 13" (25cm × 33cm), and painted outdoors on location. I chose to do a pastel painting of Levitan's oil and carefully studied the reproductions to get a better idea of the surface he used, the subtleties in his paint color and his brushstrokes.

To gain a better understanding of Levitan's techniques used in this painting, I needed to get as close as possible to reproducing the texture I could clearly see, so I made my own painting surface using ½-inch (13mm) white Gatorbord cut the same size as Levitan's painting. I applied gesso to seal the board, then applied my first coat of pumice mixture. After this dried, I lightly sanded it, then did a drawing on my board, placing the large shapes using a very soft graphite pencil. The softness of the lead easily dissolves or is covered up by soft pastel but was unaffected by the pumice mixture.

I then applied more pumice mixture using a 2-inch (51mm) wide brush, lightly stroking vertically over the whole

board. I let this dry, accelerating the drying time with a hair dryer, then applied another coat horizontally to create a weave effect, not unlike the canvas texture. Once this was dry, I dabbed and brushed an extra-thick coat of translucent pumice mixture to the snow and foreground areas, emulating Levitan's brushstrokes that I could see in the reproduction.

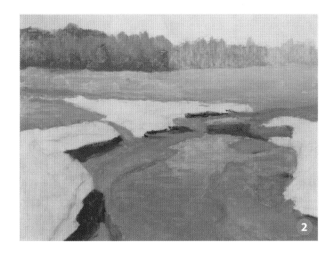

2 Block In Color
Using middle to middle-dark pastels in various earth colors and 2 dark, slightly softer pastels, block in the color of the fields, tree line, water and dark shadows, leaving the board showing for sky and snow at this step of the process. Apply odorless mineral spirits using an old bristle brush to dissolve and spread the pastel over the surface, being careful to keep each shape's color clean.

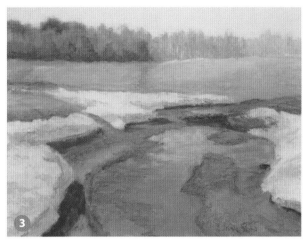

3 Re-Establish Middle and Dark Values
After the underpainting dries, re-establish the middle and dark values. Lay in the sky. Working forward, paint the trees and the sloping plane toward the middle ground. Add more middle-dark values of several colors in the foreground, indicating the muddy banks of the river. Finally, add the cool shadows on the snow banks.

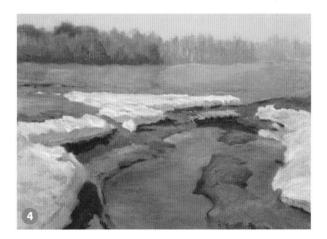

4 Refine the Surface
Continue to work the entire surface of the painting simultaneously, refining and adjusting shapes, values and color. Pay careful attention to the subtle shifts in color temperature in the ground plane and snow banks, using a limited color palette of mostly middle values in Nupastels and Rembrandts. It's best not to use more than 3 colors of similar value in each plane. Using a warm and a cool color of the same value in each area enlivens the work and provides the subtle shifts that Levitan accomplished. Use a softer pastel for the highlights on the snow.

5 Final Details
It can be helpful to use a handheld mirror often during all stages of a painting's development to check perspective and proportion. If something is not right, it will stand out immediately when looking at the mirrored image. Fix anything that does not read correctly. You can see how the texture of the board helps define the look of brushstrokes in the snowbank and on the muddy ground next to the water.

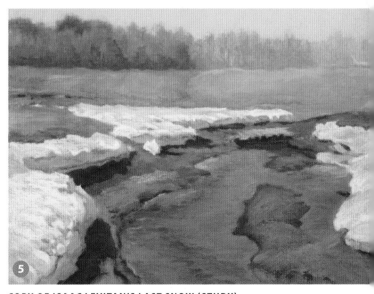

COPY OF ISAAC LEVITAN'S LAST SNOW (STUDY)
Denise LaRue Mahlke
Pastel on prepared Gatorbord; 10" × 13" (25cm × 33cm)

35 Paint Beyond the Boundaries of the Photo

Sometimes when I have nothing specific in mind and I'm waiting for a spark of inspiration, I start looking at photo images from my files. Often one particular element of a photo can be a springboard for an entire painting.

Such was the case with the photograph of an old, weathered sea veteran. The fact that it wasn't a high-quality photo was unimportant, and in fact, the low resolution allowed me all kinds of creative latitude. I knew I could paint a portrait of the boat replete with the weathered textures and all the character of its years of service. I planned to mass on the pigment and let the paint dictate the composition. I knew that the surrounding elements should, like the boat, have character and a timeworn quality. I also knew that, although they would need to be interesting, they would, of necessity, have to play a subordinate role to my main character—the boat.

REFERENCE PHOTO
When you plan to move beyond the boundaries of the photo, you can open yourself up to possibilities by using less-than-perfect photographs, like this one.

1 Tone the Canvas

On a small 9" × 12" (23cm × 30cm) canvas, mix Ultramarine Blue with a little Terra Rosa, and push the mixture around the surface of the canvas with a 1-inch (25mm) synthetic flat brush. Wipe it down, repeat the process, then push and wipe again until you've taken the white of the canvas down about a half value and have a pretty interesting surface. This step accomplishes three things. 1) It gives the canvas a textured and weathered feel, which is in character with the subject. 2) The white of the canvas no longer competes with the lightest values that will eventually be applied. 3) It allows you to see the light passages that will be scrubbed in next.

2 Sketch the Subject and Wash In Color

Since this will be a portrait of an old workhorse boat, it needs to be put in on a supportive stage. With a 1-inch (25mm) flat, make some rough linear indications to place the boat, a seawall and the beginnings of some sort of houses using Ultramarine Blue, Terra Rosa, Cadmium Orange and a bit of Transparent Red Oxide. Mass in some general tones, both warm and cool, with the lightest mass over the boat housing (this will be the main focal point).

It's best not to use a lot of pigment in these washes because you will be working back into them later. There isn't much formation to base the sketch on, so allow the paint to dictate direction. You don't have to worry about going outside the boundaries because there are no boundaries. Simply draw, indicating both positive and negative shapes, and allow the painting to discover itself.

3 Sketch and Block In the Building

Move up to the building on the dock, and continue the same approach. Mass in thin color, continuing to work with the same pigments and brush as in step 2. To create texture, try scratching and scraping, and don't worry too much about covering every little area. As you work, the roof and some door indications will begin to emerge.

4 Paint Negative and Positive Shapes

Use the same colors as before, but also mix Ultramarine Blue, Cadmium Yellow Medium and some touches of Alizarin Crimson to darken the value of the upper dark tree area.

Working with positive and negative shapes, begin to define the building. The shadow under the roof is an example of positive drawing, and the dark trees that surround and define the roof are an example of negative drawing. Look at the rest of the features. Ask yourself which can be created positively and which can be created negatively. Let the previous washes of color direct you. The looseness of those original paint applications will give that building a lot of character. There are plenty of nice lost and found edges that lend an air of mystery to the area. Be careful not to destroy that illusion by overworking it to death. As it currently stands, there's an unfinished quality to the upper half of the painting. If you continue to work on it, it will end up competing with the main subject. You always have to remember what it is that brought you to the dance. In this case, it's that old stalwart ship.

5 Begin the Boat

Move now to the main subject. Use warm and cool colors already on your palette with the addition of Cobalt Blue on the boat hull and more Transparent Oxide Red in the darks to begin to suggest the boat. In addition to the 1-inch (25mm) brush, you may wish to use a ½-inch (13mm) synthetic brush. The colors, although slightly warmer, are in the same family as the buildings in the upper part of the painting. This will add some continuity to the final composition. Allow the original colors that were massed in the boat area to actually extend into the seawall and the area below the boat. That way, when you paint into those color patches surrounding the boat, they will subtly connect the boat to the adjoining areas.

3

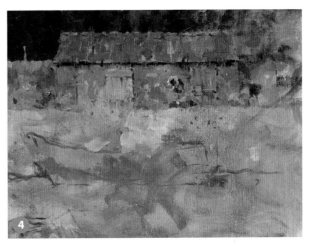

4

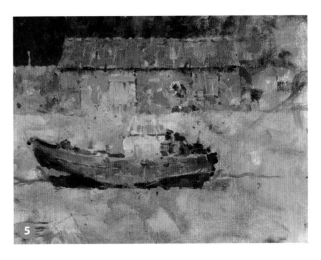

5

91

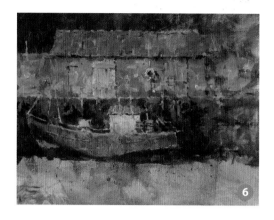

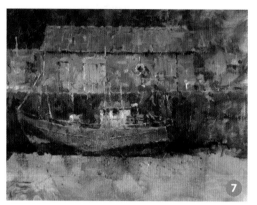

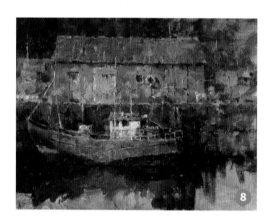

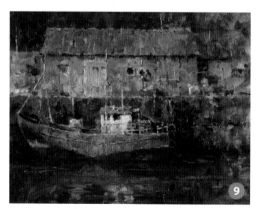

6 Paint the Seawall

Using warm and cool grays already on the palette, mass in the seawall, cutting out the boat negatively. What look like masts and rigging can all be established negatively by painting around those items. Notice how the outline of the hull has some hard edges and some edges that get lost. Pay careful attention to the lost edge between the wheelhouse and the upper part of the hull.

The seawall can be painted mostly with Ultramarine Blue, Terra Rosa and Transparent Oxide Red. In addition to the brushes previously used, add a no. 12 sable round.

Back in step 2, when you scrubbed in that light mass where the wheelhouse was going to be, it wasn't important to worry then about the eventual rendering of the wheelhouse. As a result, some of that light mass extended out into the seawall. If you look at the left of the wheelhouse and above the wheelhouse roof, you can see a faint value and tone, almost like an aura. This creates a subtle visual bond between the boat and the seawall. These little effects are "painting delicacies." Be aware that these subtleties happen only once, any further paint manipulation in these areas will ruin the effect—so don't touch these areas anymore.

7 Redefine the Boat

Now, using some thicker paint color created from the pigments already on your palette, go back to the boat, redefining areas and adding a little faux detail and some rigging. Put a little mossy color on the roof of the building. That small bit of warmth will help relate that area to the warmer foreground colors. Try using your palette knife on the boat as well as the brushes.

8 Add More Details and Water

Further refine the main subject, with a couple more details, some thicker strokes and spicier color. Up on the dock, near the house, add a little more color punch. All the colors you need are on your palette already.

Whenever you're dealing with water reflections, it's a good idea to wait until the objects being reflected are done. Since you don't need to do any more work above the waterline, begin to mass in the reflections, using similar colors but darker values than what you used to paint the objects being reflected.

9 Refine the Reflections

Continue bringing the reflections in a vertical thrust down to the bottom of the canvas. When that's done, take a soft brush like a no. 12 sable and make a few horizontal passes through the reflection mass. Then add a couple of cool, dark horizontal strokes to give surface to the water area.

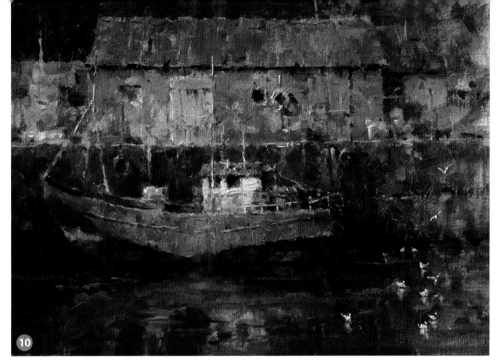

WEATHERED AND WORN | **Eric Michaels**
Oil on canvas; 9" × 12" (23cm × 30cm)

10 Final Details

Add some gulls to give some motion and life to the painting. They also serve as a counterbalance in the composition (the lower right side of the painting seemed a little vacant), and they keep your eye from running off the right side of the canvas. Paint them with a no. 12 sable round and a palette knife, using some of the lightest values on your palette.

I believe that the variety of paint thickness adds much to the scintillating quality of this painting. The transparent, translucent and opaque passages each reflect the light in a different way. In the transparent passages, the light travels through the pigment and bounces off the canvas, causing one particular vibration (much like watercolor). In the opaque passages, the light reflects directly off the pigment and bounces back to the viewer's eye (much like pastels) and presents a completely different vibration. The translucent (semitransparent) passages have qualities that are germane to both the transparent and opaque areas but have a unique vibration of their own (similar to gouache).

Eric Michaels | ericmichaelsfineart.com

Eric Michaels is a signature member of the Oil Painters of America, the National Watercolor Society and the Pastel Society of America. Perhaps the most distinctive feature of Eric Michaels' work is its international flavor. The subject matter spans 4 continents and both hemispheres. Extensive worldwide travel provides him with constant inspiration. Painting in these various locations enables him to achieve an understanding of local light conditions and to participate in the native experience.

Michaels has exhibited at the Royal Watercolour Society in London and has been a regular exhibitor in the Artists of America, the Great American Artists and the "Quest for the West" exhibition at the Eiteljorg Museum. His paintings hang in private, corporate, museum and state collections, including the Albuquerque Museum of Art History, the Booth Western Art Museum, the Americana Museum, the Haggin Museum, the Pearce Museum Western Art Collection, the Institute of American Indian Arts, Phillips Petroleum, IBM, Honeywell. and the State Collection of the Governor's Gallery, Santa Fe, New Mexico.

36 Paint Large Masses and Work Wet-Into-Wet

Watercolor is the perfect medium for "discovered" painting. The vehicle of water gives the medium a capricious quality that forces the artist to give up pre-conceived notions and follow its dictates. I often turn to watercolor when I'm feeling stifled and uninspired. I know that if I accede to its spirit, it will open up possibilities that I could never foresee, as is the case with this painting.

I remembered a trip to Yelapa on the Pacific coast of Mexico. You couldn't drive there, so I took a boat from Puerto Vallarta and spent several days painting in the area. There was a small river that wound through the jungle and emptied into the bay. I painted along that river plain with its sandbars, seagulls and dense, twisted foliage.

I wanted to re-create that experience, but I didn't have a specific plan in mind. So I decided that I would grab a large brush and use a wet-into-wet technique and see what unfolded. The fact that I didn't have any idea of what the painting would look like at completion made the task both daunting and exciting.

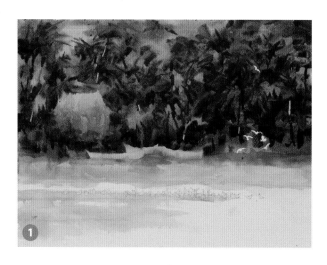

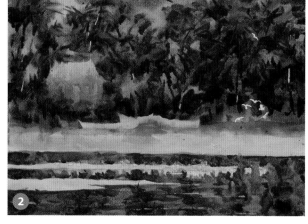

1 Sketch, Apply Frisket and Paint the Upper Half
On watercolor paper, sketch a few rough pencil indications where the shoreline and sandbars will be. Put various dabs of frisket on the area where the upper sandbar will be and stroke in the upper tree mass. Frisket will allow you to swing the brush freely without having to cut around a bunch of little shapes. The forest, house, boats and whatever else will emerge from the wet washes.

Using a big flat brush, wet the upper two-thirds of the painting, and then jump in with some diluted warm tones. Work back in with various combinations of yellows and blues, letting the foliage suggest its own shapes. Add some cooler grays to the lower jungle to keep these areas from jumping out.

While the main wash is drying, continue to cut out palm leaf shapes, and as you see the rough shapes of the hut and the boats emerge, gradually create a variety of edges. Notice that the hut and the boats remain out of focus.

Add some of the local beach color to the sandbars. While the forest area is still wet, scrape some trunk indications out of the foliage, and as the mass comes down to an almost dry stage, stop. When this whole passage is completely dry, rub out the frisket to expose shapes for potential gulls.

2 Lay In the Water
Cutting around the 2 sandbars, handle the water in a similar manner as you did the foliage and with similar color combinations. Keep it out of focus and make the general thrust of the passage vertical with a few small, hard horizontal streaks (white paper), which can be toned down when the passage is dry. These 3 or 4 small, hard streaks give a surface to the water.

3 Remove the Frisket From the Sandbar

When the paper is absolutely dry, remove the frisket on the upper sandbar. All that now remains is the finish work.

4 Final Details

That left side of the beach seems a bit muddy, and the big horizontal shape of the beach running the entire length of the page is awkward. Very gently (without scrubbing) lift the pigment off the beach to about the middle of the left boat, bring some foliage down to the waterline and add some diagonal shadows to connect the water to the upper portion of the painting.

Put some cool blue shading on the undersides of the gulls, some shadows on the sandbar and add a few Cadmium Orange beaks (put a few in the reflections also).

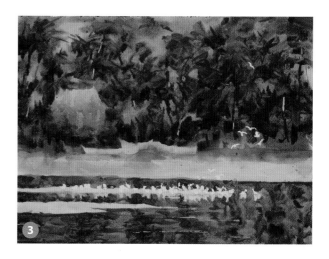

Paint the boats, give the hut some attention and suggest some texture on the sandbars and the beach. With the hard edges of the sandbars and the gulls, the broad, soft masses of the jungle and the water seem to recede a bit and act more like supporting actors to the main characters.

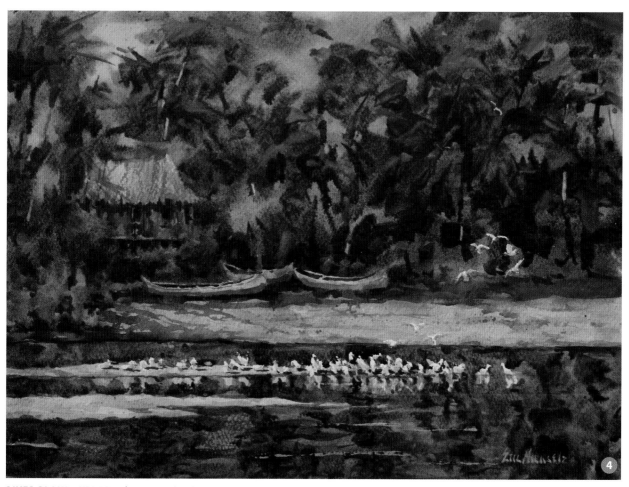

RIVER PLAIN – YELAPA | **Eric Michaels**
Watercolor on Saunders cold-pressed paper; 15" × 20" (38cm × 51cm)

95

37 Put Down the Brush

Using a palette knife allows an artist to break out of the rut of brushstrokes while maintaining clear marks—akin to what the pastelist can achieve with the side of the pastel. These marks are beautiful because of their clear shape and purity of color. The knife can also help you achieve a juicy and painterly style to apply the paint cleanly. When you have to work quickly, such as when the light is fading fast, the knife works extremely well to help you get a lot of paint down on the surface and keep the colors clean with minimal fussing.

The long shadows of the twilight hours are very attractive, and the linear configuration of the scene—horizon, far shore, water and tree configuration—seemed to lend itself beautifully to the kind of action, gesture and texture that a palette knife can bring to the surface of the painting.

THE SET-UP
The Open Box M easel palette is set up close to eye level to facilitate the perception that the painting surface is in the same plane visually as the subject. This allows you to move your eye quickly back and forth from the subject to your canvas.

REFERENCE PHOTO
The photo was taken in the afternoon at Cohasset's Little Harbor, Cohasset, Massachusetts. As the painting progressed, the afternoon light changed and became warmer.

1 Prepare a Canvas
Using a no. 6 filbert brush and a mix of 1 part Ultramarine Blue to 4 to 5 parts Burnt Sienna, block in the major shapes with a major gray tone. Leave the sky and water gray, and vary the values of the paint to represent lighter and darker areas of the composition.

2 Block In the Sky and Water
Using your palette knives, mix a base color for the sky with Titanium White, a small dab of Ultramarine Blue and a hint of Viridian, which will give the sky a brighter look with a light yellow tinge. Lay in the clouds after you've covered the sky with blue, using a bigger knife to draw the creamy paint over the base blue. Don't press and mix, but allow the paint to flow over the sky. Clean your knife between colors to prevent contamination of color.

Mix some of the base sky color with a bit of Magenta or Alizarin Crimson for the darker water areas. Quickly work the water with a smaller knife to establish the various horizontal changes. Don't worry about the edges as you bump up against the painted areas.

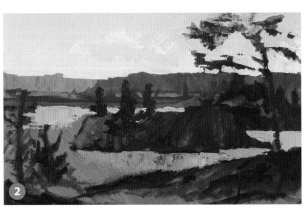

3 Paint the Rock and Trees

Begin laying in the rock and island masses. This process can go very quickly as you freely lay in the shapes. Continue to keep the colors clean and focus on the composition. Back in the studio, you can use your memory and imagination to complete or finish areas that might have been incomplete.

4 Paint the Foliage

Using your knife, mix a good amount of foliage paint with Ultramarine Blue and Cadmium Yellow initially, then vary with yellows, blues and sienna to get the variety of colors needed. Using a bigger knife, lay in the foliage masses by pulling the knife across the area and then lifting the knife off the canvas, giving the surface a kind of stippled effect.

Because of the lowering sun, the colors on the opposite shore and rocks seem very warm against the purples and darker grays. The rock shore on the middle left and the light hitting the cedar trunk on the right are important compositional elements, so accentuate them.

Use the knife to adjust edges on the canvas. Unlike a brush technique, you can still conserve clean edges and color, and vary the effect of the knife by varying the pressure you use as you move the paint around and blend where you want to blend. Work over the surface and make adjustments as needed.

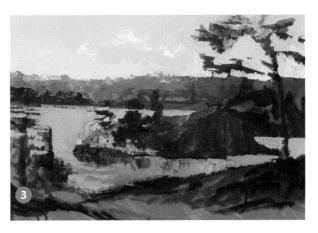

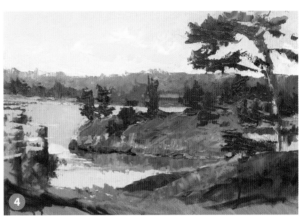

5 Final Details

Use an up-and-down stroke with the knife and various tones of green to get a subtle grass and weed description going without getting too fixated on specific areas or grass stems. Completion of a palette knife painting in the studio deserves time and study. There are effects of the knife work that you may want to preserve, or not. You can go back in and get rid of some of the harder edges using your knife as a sculpting tool. By taking time to study your painting, preserve your fresh clean paint areas and work over areas that need attention, your painting can retain a clean, beautiful style.

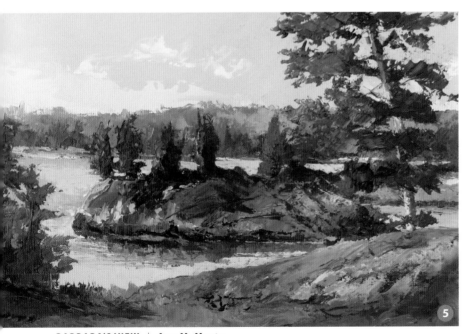

BARBARA'S VIEW | **Ann M. Musto**
Oil on canvas; 12" × 18" (30cm × 46cm)

38 Rescue a Failed Painting With a Palette Knife

Most artists have a collection of failed paintings—paintings that, for one reason or another, didn't quite work out or didn't fulfill the vision the artist had before beginning. If you work in oil or acrylic, and generally paint with a brush, you can rescue a failed brush painting by reworking it with a palette knife. You can change the elements, effects and style to come closer to the concept that you originally had in mind.

In my original painting, *Sugar Hill*, my goal was to show the changing evening light on an early-spring day in the hills where maple syrup is made. The trees have started to warm and glow, especially when the sun is low and coming through an otherwise cold scene. The hills are open and flowing, giving movement to the landscape and moving the viewer up and into the hills. To place the viewer in the scene, I focused on a sugar house, a familiar scene in many parts of New England as well as parts of Canada.

The scene in my orginal is soft because of the brush effect. To add some punch to the design, I used a palette knife to bring in new masses of color to obliterate some areas. I completely reworked this painting and am now much happier with it. This new painting transports me to the sugar bush areas I am so familiar with, and I can almost smell the maple syrup!

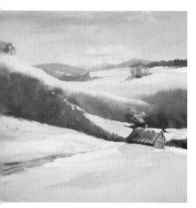

ORIGINAL PAINTING (CROPPED)
The original painting was in a vertical format. To begin the redo, I cropped 6 inches (15cm) of the sky off the top of the painting, changing the design to a square format. Compositionally, I had put the horizon too close to center in the original, so cropping the top solved that problem.

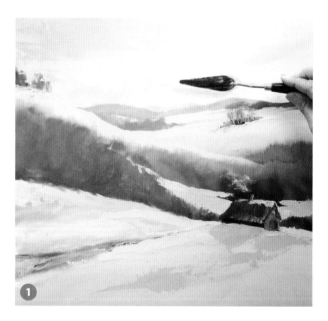

1 Paint the Sky

Right from the start, changes in the composition include rethinking the sky shapes and colors. The original sky appeared too blue and the horizon was a bit messy.

To begin, mix Titanium White with Cerulean Blue for a base sky color. Set some of that color aside to mix with red for a more purple color for clouds. A portion of that purple color can be divided to make a bluer version of the cloud color and a more gray version. Also mix a small amount of white with Cadmium Yellow and Cadmium Red to arrive at the color you want for your horizon. By introducing this warm mixture, the idea of an evening sky and the warmth that would reflect on the snow and trees can be established early.

Using a large palette knife, drag the different colors over the sky to achieve an improved effect. A larger blade knife will create a smoother effect. The resulting smooth and seamless sky will communicate the idea of a quiet atmosphere. Once the sky is completed, clean your knife and apply the cloud colors and shapes, dragging the knife to give the feeling of cloud motion and wind.

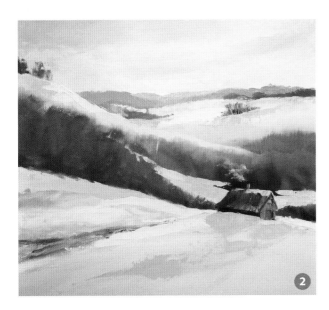

2 Paint the Distant Hills

The original shapes of the hills are pleasing but need more definition. With a small freestyle knife, which is pointed and quite stiff, apply some color to indicate the warmth of the sun on the distant hills and tree masses. Mix a gray with Burnt Sienna, white and Ultramarine Blue in several values. To one of those mixes, add some Magenta to brighten the gray and highlight some of the treetops. To contrast with those trees, define a reflected white snow area in front of the distant hills. Use the knife and a scumbling technique to mix some of these colors right on the canvas.

3 Simplify the Midground

The midground area was too busy in the first composition. By massing those original forest and field shapes into one shape in shadow, you can direct more attention to the tree mass on the right. In step 5, you'll connect the trees through this big field with a suggestion of a road. Using the big knife again, mix a gray-purple snow color, and use it to work down and across the mid-forest and up the ridge to the left to define the difference between the shadow field and the more distant field that reflects the evening sun.

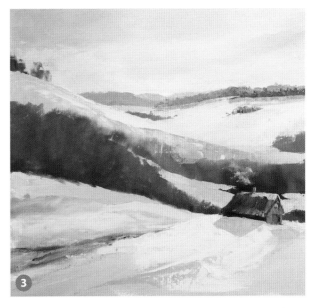

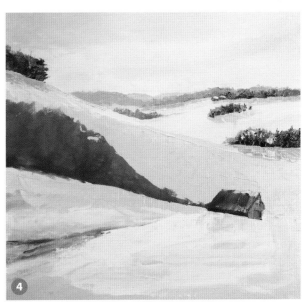

4 Paint the Trees

Now mix some forest colors of Sap Green, Burnt Sienna and Ultramarine Blue so you end up with a variety of colors and values of grays, browns and greens. Use the small knife to apply the paint in small masses, remembering to vary the tone of the paint between darker and lighter values as the trees go up into the air, giving a more atmospheric and airy feel to the trees. A trowel knife with a rounded tip is very useful here to mix on the canvas and soften the edges of the masses. Once in a while, and after careful consideration, use the side of a straight knife to etch tree trunks into the paint and to pull some of the color up into the background, giving the appearance of branches.

5 Finish the Midground and Road

Continue to work other areas of the painting simultaneously with the same paint where the color and value are appropriate. Using a larger knife with a long straight edge, apply the paint and pull it down over the canvas in the foreground snow and under the tree mass on the left. Load the edge of a small trowel knife with paint and pull it across the canvas to describe a road coming across the fields.

Probably the only drawback to painting with a palette knife is that you will use a large amount of paint! Remix colors as needed so you always have a sufficient supply of paint.

6 Begin the Foreground

Using the knife helps develop very painterly masses of color. The knife also keeps the artist from getting very specific—massing in shapes and colors allows you to focus on the big painting idea and the best, most economical way to bring that vision to your canvas.

Mass in the foreground and then develop that area with subtle changes in color and tone. This will allow the paint to describe elevation changes and shadow without attracting too much attention. Using a curved-tipped trowel, lift or scoop the darker shades of blue into the white field to indicate footprints. This is a very important part of the composition—the feeling that someone could come and go to the warm sugar house from different directions.

Define the large forest edge and rework the shape and details of the house with a small-tipped knife. Lay in the shapes of the roof, walls and especially the details of the windows and snow on the roof.

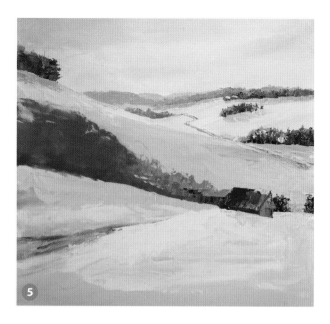

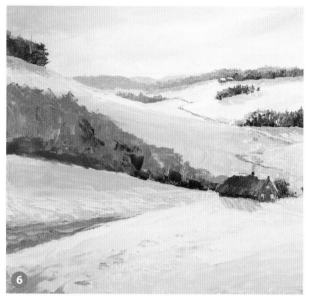

7 Refine the Tree Mass and Add Final Details

Refine the tree mass on the left without getting into too much detail. Using the knife here is a great advantage—you can get mass and form without going after each branch or tree shape. Lay in the general shape of the mass of trees, then pick out areas to highlight. By using the knife to mix and blend on the canvas, you can get a feeling of forest mass, then go back in with the edge of your knife to carve out some branches and tree trunks for specific definition. Crosshatching with the edge of the knife works very well in describing tree branch configuration without getting too specific

Tweaking the painting at this point involves a lot of observation and study. Look at the painting to see what bothers you, and trust your own vision and intuition. You know what it is you want to say, so have confidence in your vision.

The final touches on the reworked painting are made after careful consideration, specifically to depict more light and atmosphere and to lighten any areas of heaviness. The trees in the upper left corner seemed too solid; to portray the idea of the last rays filtering through before darkness fell, areas of blue and soft yellow were placed with the knife edge within the tree mass, giving it a more atmospheric quality. The same technique was used on the edge of the large tree mass on the left so the viewer would feel the airiness of the top branches with the field snow seen through some areas.

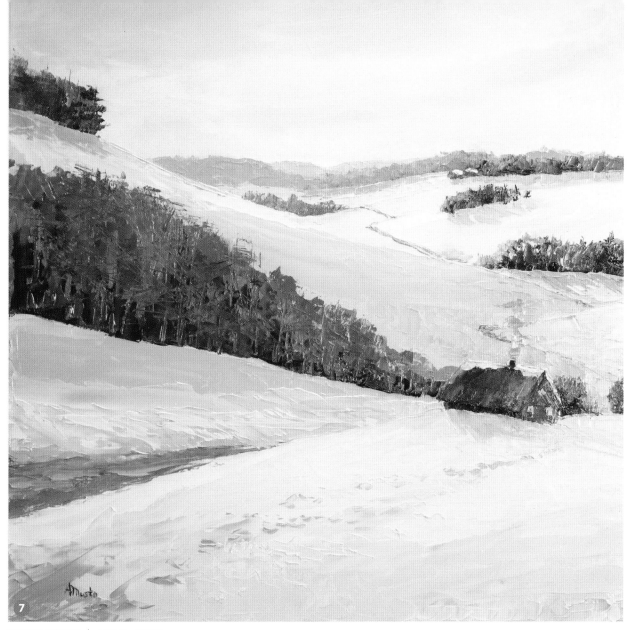

SUGAR HOUSE | **Ann M. Musto**
Oil on canvas; 18" × 18" (46cm × 46cm)

Ann M. Musto | amustoart.com

Ann has worked in both pastel and oils, studying with many contemporary artists in both mediums. Her work has been included in solo, group and juried exhibitions. She is a member of the Pastel Society of America, the Cape Cod Art Association, the Portrait Society of America and other organizations

Ann says, "By creating two-dimensional representational art in both oils and pastel, my work is an attempt to integrate the realities evident both presently and spiritually." She considers herself a colorist and paints both en plein air and in the studio working from life, from plein air color studies and from her gift of imagination.

39 10-Minute Studies

This is one of my favorite exercises, both for myself as a way to get moving and as a subject I teach in workshops. I originally began thinking of a way to loosen up for painting the landscape. I recalled my experiences in life drawing classes, where most sessions began with 30-second gesture drawings. I loved those; in many ways, I thought they were much more fun than longer poses with the figure, and that some of my best work came when I had only 30 seconds to draw and no time to think.

So to translate this to using pastel and painting landscapes from photographs as a class exercise, I came up with the following rules:

1) **Pick a photo.** Pick a photo of a landscape subject. Simpler photos are easier than complex ones, but just about anything will work.

2) **Select 12 pastels.** Pick out 12 sticks of pastels, selecting colors you think you will want when you paint the exercise. It doesn't matter whether they are harder pastels or softer pastels, but each stick should be about 1 inch (3cm) long and have no paper wrappers.

3) **Prepare your surface.** Tape a piece of paper, 7" × 10" (18cm × 25cm), 8" × 10" (20cm × 25cm) or 9" × 12" (23cm × 30cm), to your board. Any color surface will work, but you want something that will accept a lot of layers: Wallis Sanded Paper, Richeson Premium Pastel Surface, Pastelmat, Ampersand Pastelbord, UArt or Colourfix all work well. Clip the photo on the board and lay the 12 pastel sticks you've chosen on a tray or a paper towel beside your board.

4) **Set the timer for 10 minutes.** Using only the sides of the pastels, and with no preliminary drawing, block in your subject. Experiment with the ways you can hold and turn the pastel sticks to create different shapes. Don't give in to the temptation to use the pointy ends of the pastel. If you need a feeling of lines, hold the stick on its side and use an edge to pull down a line. (Square pastel sticks work really well for this.)

As you work, quickly blocking in shapes and colors, you'll learn ways to create the colors you don't have. You'll be tempted to trade some of the colors in your original 12 selections for other, better colors, but don't do it. Layer to make something near the color you want. If you don't need a color you selected, don't use it.

Don't blend with your fingers. You're going for a quick statement here, not a finished painting. Little bits of the surface you're working on showing through are not a problem.

5) **Stop!** When time is up (or before, if you've done all you need to do), put down the pastel in your hand and step away from the painting. Turn the photo facedown or remove it. Look at the study you've just completed and see how it stands on its own. Walk 10 steps back and look at it again. The small imperfections will vanish and you can now see the subject.

6) **Repeat as needed.** I recommend doing this exercise once a week. It's a great way to "keep your hand in," especially when life gets busy and it's hard to find time to paint.

If you find yourself blocked or feeling stuck, or if you want to paint a particular subject and don't quite know how to start, try this exercise. What you learn in the ten-minute study will show you the way to the painting and may give you ideas you'd never have stumbled upon otherwise. Try variations of the subject as well—vertical, horizontal, cropped differently and so on.

This exercise is also a great way to begin a plein air study. When you're painting outdoors and the clouds are moving and the light is changing, getting a fast start in 10 minutes puts you way ahead. Then you can spend another 30 minutes refining the subject and be done before the shadows have moved too much.

REFERENCE PHOTO
This photo was taken in the foothills near the mountains on a warm spring day when the snow was melting.

PASTELS USED
The 12 pastels are all soft, including very dark purple, dark brown, dark green, middle-dark brown, a middle-value orangish brown and yellow-brown, 3 shades of blue, a pink-beige, a pinkish white and true white. Having a strong dark or two, and a white or off-white, will let you create colors by layering that are not included in the limited palette.

THE STUDY
Block the subject in quickly on a 7½" × 10" (19cm × 25cm) surface, making compositional and value changes as you work. Layer the sky using the lightest blue and a layer of white near the horizon, covering it with the blue to create a nice transition. Let bits of surface show through in the foreground's dark snow area to create a sparkly effect.

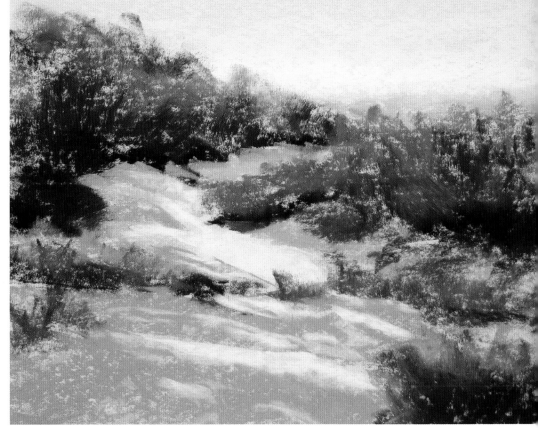

SNOWY ARROYO (10 MINUTES) | **Maggie Price**
Pastel on light gray Pastelmat; 7½" × 10" (19cm × 25cm)

REFERENCE PHOTO

A simple scene, common along the highways in the Southwest, with juniper and piñon trees in the foreground and mountains in the background.

PASTELS USED

Select a variety of blues: 3 values of blue, 1 blue-gray and 1 blue-green; a very dark green and a middle-value green; 2 values of brown; a very dark charcoal-brown; a yellow and a white.

THE STUDY

Even in 10 minutes or less you can simplify and make compositional changes. In the photograph, the closest hill created a line that continued up the hill behind it. Make the closer hill a little taller to break that line. Layer greens and blue-green for the more distant trees, and layer greens, brown and yellow for the closer ones. Holding the pastel sticks at angles but still using the sides, block in quick choppy vertical strokes for the grasses.

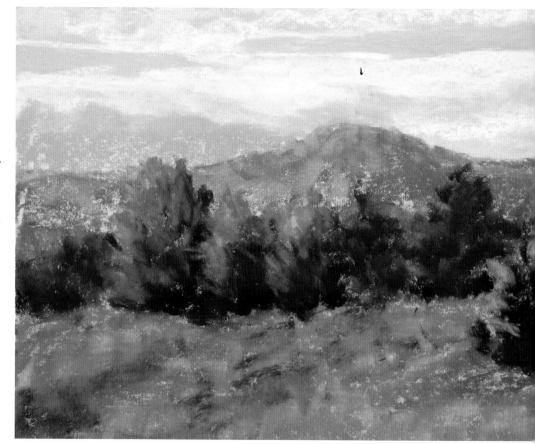

FIELD OF JUNIPERS (9 MINUTES) | **Maggie Price**
Pastel on light gray Pastelmat; 7¾" × 10" (20cm × 25cm)

REFERENCE PHOTO

The photo is of a marshy inlet on the East Coast with some interesting tall trees in the foreground. There's a little hint of blue in the sky, but it's mostly washed out from the camera lightening it too much.

PASTELS USED

Select some soft and medium-soft pastels: a very dark brown; a dark, middle and light green; a light yellow-green; a blue-green; 2 values of blue-gray; a slightly turquoise blue; two values of orange and an off-white.

THE STUDY

To make the distant trees recede even more, paint them with the grays. Skim the white, grays and blues into the sky, leaving the top right corner untouched so you can easily lay in the trees. Paint the marshy grasses using a variety of greens. Pull the tree trunks right up over that, using the dark brown on its side and then the light orange for the highlight side of the trunks. Mingle various greens and oranges for the tree foliage. Note that the water is a little bluer than the sky because it's reflecting from overhead as it moves closer to the viewer.

INLET (10 MINUTES) | **Maggie Price**
Pastel on light gray Pastelmat; 7¾" × 10" (20cm × 25cm)

40 Take a Class, Workshop or Lessons

Over the last two or three years, I've been trying lots of different things to improve my paintings and push myself as an artist. Although I've been painting since I was a teenager, I have periodically found myself at a point where I feel my work is stagnant. I don't want to keep repeating the same things over and over again, and I want to challenge myself with new ways of approaching my art.

I've painted different subjects, moving out of my landscape comfort zone to figures, animals and architecture. After working in pastels exclusively for almost twenty years, I decided to return to working in oils with subjects I've rarely attempted to paint—fruit and flowers. Since my adventure in oils, I feel my pastel paintings have evolved another step. I'm beyond the block now and energized.

If you find yourself blocked or feeling stale in your work, I recommend giving this a try. Change subjects, change mediums or just change the approach to how you work in the medium you love. Classes, workshops and private lessons are readily available almost everywhere. If you live in a remote area, books, DVDs and online demonstrations are always available. You've nothing to lose and much to gain!

TAKE A LESSON

When I read the "Flower Power Hour" demonstration for this book by Cynthia Rowland (pages 112–115), I was struck with the desire to try it. I arranged for a lesson with Cynthia and, with her help, began the painting Sunflowers in Blue Vase. *I could not complete the painting while she was at my side to advise me, but I went back to it the next day. Although I struggled with the fact that the flowers had moved overnight, requiring me to make changes in the composition, I did finish the painting.*

It's not the best painting I've ever done, but it's not bad for a first attempt at portraying an unfamiliar subject with a medium I have not used much for many years. I learned a lot in the process and found there is more similarity between the 2 mediums than I had thought. The experience has inspired me to try other new subjects and to work more in oils. I tackled a fruit still life on my own and enjoyed it immensely.

SUNFLOWERS IN BLUE VASE
Maggie Price
Oil on canvas; 14" × 11" (36cm × 28cm)

SATSUMA ORANGES & BLUE BOWL | **Maggie Price**
Oil on canvas; 8" × 10" (20cm × 25cm)

PICK A NEW SUBJECT
Without the assistance of a teacher, I tried another subject I've rarely painted. I arranged some oranges and a dish next to my easel and jumped right in. While I originally tried these subjects to move forward out of a block, I intend to keep painting more of them because they are fun!

Maggie Price | maggiepriceart.com

Maggie Price has worked in oils, acrylic and watercolor but has focused mainly on the medium of soft pastel since the early 1990s. She was a cofounder and the former editor of *Pastel Journal*, a national magazine for pastel artists (now owned by F+W Media), and has written over 100 articles about pastel art and artists. She serves as contributing editor and is on the editorial advisory boards of *Pastel Journal* and *The Artist's Magazine*.

She is a signature member of the Pastel Society of America, a signature member and distinguished pastelist of the Pastel Society of New Mexico, a signature member of Plein Air Painters of New Mexico, a member of the Master Circle of the International Association of Pastel Societies and a member of the Salmagundi Club of New York City. She is the president and a member of the board of directors of the International Association of Pastel Societies and serves on the board of directors of the New Mexico Art League.

Price is the author of 2 North Light books, *Painting with Pastels* (2007) and *Painting Sunlight & Shadow with Pastels* (2011), and 2 instructional DVDs. Her paintings have been included in a number of books written by others as well, featured in magazines in the United States and Great Britain, and included in numerous juried and solo exhibitions. Price's work is in collections throughout the United States, Great Britain, Europe, Australia and New Zealand. She teaches U.S. and foreign workshops and frequently judges exhibitions.

41 Paint in a Different Size or Format

I usually paint in standard sizes. The paintings are easier to carry wet when on-site, to pack when traveling and to frame in standard-sized frames.

But it's easy to get comfortable or get into a rut when you always do the same thing. So occasionally I choose to paint in a nontraditional size. The painting format need not be extremely elongated vertically or horizontally, just enough so the dimensions feel unfamiliar and fresh.

My studio is filled with lovely props that have the warmth and patina of age. I enjoy arranging them in small vignettes and cropping them as though they are landscapes. The actual process of arranging the elements may take several hours or a few minutes. For this subject I tried about twenty props, replacing and rearranging on a low table in front of the chair rail until I found the right combination.

Designing the painting when working in an unfamiliar size becomes a new exploration of the relationship of the subject to the edges, as though you had rearranged the furniture in the living room. It's exciting, or at least novel. Just putting the board on the easel builds anticipation.

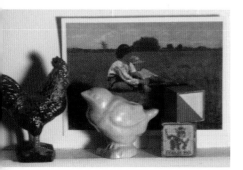

SET-UP
The classic Winslow Homer postcard image serves to carry the feel of landscape to support the nostalgic quality of the props and to give compositional balance. The variety of neutrals in the painting provides rest for the viewer from the high contrast and color of the other elements.

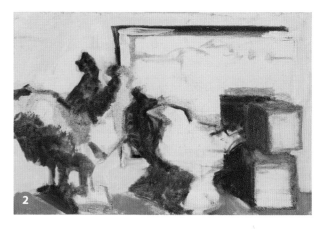

1 Begin With Thumbnail Sketches

Begin by making several thumbnail sketches. They should be quick gesture drawings, drawn in a rectangle proportional to the surface. Indicate the shadows with the broad side of your pencil, looking for connections in shadow shapes and making sure to avoid a static ratio of 50/50 light to dark.

2 Placement of Shapes

Working on an 8" × 12" (20cm × 30cm) gesso-primed board, mix a washy purple-gray from Ultramarine Blue, Scarlet and touch of Yellow Ochre. Use plenty of odorless mineral spirits to keep the mixture loose. Do not use any white in this gray. Draw the shapes with straight lines, and indicate the shadow shapes. Squint while painting to see the shadows accurately. There's no need to differentiate at this point between shadows on the bird or postcard or wall—that will come later. Just concentrate on shapes.

Mix a warmer gray using Burnt Sienna, Ultramarine Blue and a touch of Scarlet for the rooster's shadow. If you need to make any changes, dip the brush in mineral spirits and

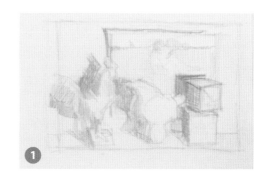

brush away any erroneous lines. Use a paper towel to wipe the board clean in any desired areas. Use a thin Yellow Ochre to indicate the chair rail in the painting. Tint a mixture of white with a tiny bit of Ultramarine Blue, and apply with a no. 10 bright to indicate the edge of the postcard as the lightest light. Make a mixture of white, a small amount of Cadmium Yellow Light and Cadmium Orange, and place a few indications of the warm wall behind.

3 Block In Color

The goal for this stage of the painting is to cover the surface and establish the general color relationships. Add an even mixture of linseed oil and mineral spirits to each color mixture. Continuing with a no. 10 bright brush, mix white, a touch of Yellow Ochre, Ultramarine Blue and Scarlet for the local color of the smaller bird. Use a mixture of Viridian and Ultramarine for lights on the front of the rooster, adding a touch of Scarlet for the shadow area. The rooster's neck is a warm green-gold—a mix of Yellow Ochre, Viridian and a touch of Cadmium Red Light with white. Paint the rooster's legs with Cadmium Orange with some Ultramarine Blue in the light areas, adding Ultramarine Blue for the shadow.

Move around the painting instead of painting one element to its full resolution. The color choices you make are affected by the colors around them. Paint the 2 blocks, noting the lost edges against the shadow they are casting. The top of the upper block is catching a lot of warm bounce from the wall, yet is still in shadow. The front of the upper block is a white tinted with purple.

Paint the front of the lower block with Ultramarine neutralized with Cadmium Orange. Mix lavender from Ultramarine Blue, Scarlet, Viridian and white to paint the top planes of the center bird. Use a blue-purple mix for the bird's shadow extending from below the beak to the ground.

Draw this shadow very carefully as it will convey the base and the volume of the neutral bird. Mix a third purple, warmed very slightly with Yellow Ochre, for the reflected light in the shadow side of the bird. The rooster's head is a mixture of Scarlet and Cadmium Red Light.

When you paint the postcard image, keep each color mixture slightly more neutral than any mixtures in the same family in the foreground. Use Manganese Blue with some Cadmium Orange and white for the sky. The field is a combination of greens mixed from Viridian and Scarlet. Pull some of it to the side and shift it to a little more Viridian; pull some off to the other side and shift it more Scarlet. Make a very neutral yellow-white for the boy's shirt. Lay in the postcard shadow with Ultramarine mixed with Cadmium Red Light. For the wall, mix up a big batch of a peachy yellow and lay it in with big, broad strokes to fill the space.

BIRDS OF A FEATHER | **Jody Regan**
Oil on gesso-primed board; 8" × 12" (20cm × 30cm)

4 Develop the Shadows and Final Details

Mix a purple and pull out small bits of the color and adjust the rooster's shadows. They are generally cooler closer to the body and warmer as the light begins to invade. The legs of the rooster shadow are very diffuse with glowing light. Lay Cadmium Orange thinly over the front leg and Yellow Ochre over the front of the second. The shadows of the birds and the blocks all travel at a diagonal across the warm ledge, then move up the wall.

Check edges throughout the painting to see where they need softening or emphasizing; check planes to make sure the light angles are correct. Step back and squint to see that all is correct, and then the painting is finished.

42 30-Minute Paintings

When you lead a busy life, as most of us do these days, easel time can be elusive. Knowing that time is short imparts an urgency to the painting process that impedes productivity and success. You become locked into negative, circular thinking and ultimately blocked.

Whatever the reason for your creative block, this "short shots" exercise is designed to get you back to your easel with positive results. You will do a series of 30-minute paintings on small panels using a timer and simple still-life elements. Your goal is not to produce finished paintings. Your goal is to launch yourself back into your creative process, to mix color, to think on all the levels that painting requires, to jump back into the intensity that you feel when you are in the groove. Commit yourself to the exercise in half-hour chunks. We can all find half an hour.

1 Set the Stage
The key to the short shots exercise lies in first spending a half-hour of prep time. Set up some interesting, simple still-life props atop a table covered in different solid colored cloths or tissue-paper squares. Overlap the colored pieces using a variety of angles. Then place your still-life elements on the table, looking for interesting intersections of color below. You can place a spacer beneath any prop to enhance the shadow shape, as in the scissors. Set up a lamp to cast well defined shadows. Paint each element separately. Position your easel next to and above the table. Have your timer ready and a stack of small boards on hand.

2 Begin the First Painting
Set the timer for 30 minutes and being painting. Loosely indicate the shadow shapes for the painting, moving them about until you are satisfied. Create an indication of the background colors, then step back to check the design, adjusting as needed.

3 Finish the Painting
Establish your lightest and darkest notes, shadows and highlights, and soften edges as needed. When the timer goes off, stop.

SCISSORS | **Jody Regan**
Oil on canvas; 7" × 5" (18cm × 13cm)

COLORED PENCILS | **Jody Regan**
Oil on canvas; 7" × 5" (18cm × 13cm)

MATCHBOX | **Jody Regan**
Oil on canvas; 7" × 5" (18cm × 13cm)

4 Reflect

Line your paintings up side by side in the order you painted them. Before retouching any of them, look at the difference between the first and the last in your series. Do you see variety in your paint application, confidence, design choices? Put the timer away; you don't need it any longer.

TOY CHAIR | **Jody Regan**
Oil on canvas; 7" × 5" (18cm × 13cm)

Jody Regan | jodyregan.com

Jody Regan is a professional painter, a painting teacher and a math teacher—sometimes all at once. Her path to the present has been nontraditional. Her mother was a prolific and talented artist, and Jody was raised surrounded by art but didn't consider painting as more than a hobby until she ended a long software-engineering career. Painting opened new worlds—the worlds of creating and teaching, which in turn led her to becoming a middle school math teacher as well.

Her paintings are exhibited locally and nationally; many are in private and public collections. She has won drawing and painting awards throughout New England and has had several solo painting exhibitions. She has served as a director of the North River Arts Society in southeastern Massachusetts for over a decade and is an artist member of the Academic Artists Association.

Jody has been teaching oil painting for years and takes great joy in watching her students learn their craft and grow. "Painting has changed my life," she says, "and continues to do so."

43 Flower Power Hour

The artist's block isn't always connected to difficulty in getting started or finding a subject. Sometimes it's the habit of staying in a routine, painting the same way all the time. And sometimes it's a matter of overworking the subject because you can't seem to quit when you should.

I developed this exercise when I found myself overpainting some of my flower still lifes and thus losing the freshness and spontaneity of my strokes. I use this exercise both in practice and as a warm-up on serious painting days. It's also useful in experimenting with unusual color combinations before committing them to large-scale painting projects.

The alarm of a kitchen timer punctuates the hour sufficiently to force concentration on the essentials of each segment and away from the details that I might otherwise be inclined to address.

This one-hour exercise is divided into ten-minute segments: the Block-In, Extremes, Background, Color in Shadow, Color in Light, and Edges and Reflected Lights. Once finished, I set the painting aside for a couple of hours and then allow myself another few minutes to add a final stroke here and there.

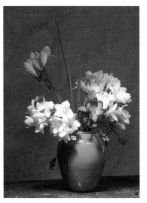

PHOTO OF THE SUBJECT
The set-up has strong light positioned so as to cast an interesting shadow shape on the vase.

PREPARATION
The image size of the painting will be 8" × 6" (20cm × 15cm) on a double-primed linen canvas. The canvas is cut a little larger so it can be mounted on ¼" (6mm) MDF board. Prepare the canvas by taping it to the board before you set the first timer. If you're working from photo references, have them ready. Tone the canvas with Burnt Umber and linseed oil using a paper towel to blend the pigment onto the canvas to achieve a middle tone. Establish a boundary line to ensure that the subject matter resides within the planned compositional space.

1 The Block-In

Using a no. 6 bristle, block in the flowers and vase, mindful of the movement and gesture of the composition. This step determines how the observer's eye will flow through the final painting.

Begin constructing the flowers and the vase by superimposing them on the gesture drawing you have just created. Keep the paint thin and squint to look for the negative and positive shapes. Remember that the negative shapes are generally more important in creating a likeness of your image.

Once you're satisfied with the composition and balance of positive and negative shapes, begin filling in the shadows with Burnt Sienna and Prussian Blue using the same brush. Create the light areas by wiping off pigment with a paper towel. Conceptualize the painting as consisting of three dominant values.

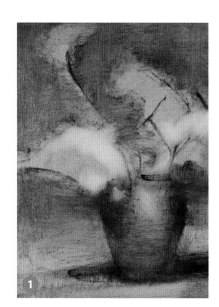

2 The Extremes

The next 10 minutes will establish the extremes on the canvas—the lightest lights, darkest darks and brightest, most intense colors. Don't be concerned with rendering details of the subject. To establish the extremes, simply place the appropriate swatches of color on the canvas with a 3½" (9cm) pointed painting knife. Applying these colors with a painting knife puts thicker paints in the areas of the extremes.

Begin with the brightest, most intense colors—the orange-yellow freesias and the turquoise vase. For the freesias, mix Cadmium Yellow Light, Cadmium Orange and Naples Yellow Light with your painting knife and apply to your canvas. Lay in the bright turquoise of the vase, which is achieved by mixing Turquoise with Naples Yellow. Then add Cadmium Yellow Lemon to the Turquoise to create a bright green citron for the buds in the light. Next lay in your lightest whites using Titanium White with a touch of Cobalt Blue. Finally, apply the swatches of the darkest darks using Prussian Blue, Burnt Sienna and Alizarin Crimson. These occur in 3 areas: where the flowers insert into the vase, where the vase sits on the table and casts a shadow, and the shadow upon the vase that is being cast by the white freesias.

3 Paint the Background

The background in paintings can be challenging, so it's best to get it working early in the process. It's easy to see your subject as three-dimensional because it exists in positive space. But since a background exists largely in negative space, we can fall into a habit of seeing it as two-dimensional, even though it exists in the same three-dimensional space as the subject. At the same time, however, backgrounds need to diminish in color intensity and value to recede.

To establish the color of the background, use the two dominant colors that appear in the set-up. Opposites on the color wheel, like the orange and blue we are using, will create a pleasing chromatic gray that is harmonious with the colors in your set-up. Use a no. 6 bristle brush and place some Cadmium Orange to the center of your palette, then place a swatch of Turquoise next to the orange. Slowly begin to mix the 2 colors, leaning toward the warm side. Add Naples Yellow Light to lighten the mixture as well as some Yellow Ochre.

Since the light is coming from above, paint the lightest part of the background at the bottom. You can alternate the orange and the blue as you darken the value of the colors.

Remember to keep the paint thin. Your thick paint should be kept for the light area on your painting. Don't paint the background color quite up to the edge of the objects. You will decide how to execute the edges in step 6.

4 The Color in Shadow

Since the set-up is in cool light, the shadow colors tend toward the warm side. In the following sequences, use a separate no. 4 bristle brush for each color set. First, add Burnt Umber to the turquoise color and begin with the easiest shadow shape, which is on the vase. Next, paint the shadow side of the focal point—the orange-yellow freesias—with Burnt Umber, Alizarin Crimson, Indian Yellow and a little Cadmium Red Light.

For the shadow side of the white freesias, use Raw Sienna with a little Indian Yellow. Keep the texture of the shadow paint for the freesias thin and thus somewhat translucent, and add a little Burnt Umber to the mixture for the center parts of the flowers. Add Cadmium Yellow and Naples Yellow Light where the light penetrates the petals. Again, think in terms of adding swatches of color rather than the rendering of form. For the shadow side of the leaves, use the original mixture of turquoise and Burnt Umber, adding Cadmium Yellow Deep to make a warm green for the underside shadow of the buds. This color will also work for the long, thin leaves in the back of the set-up.

5 The Color in Light

Start with the vase because it is the single dominant element in the painting. The vase can thus function as the point of reference from which the remainder of the painting's positive elements can be harmoniously developed and completed.

Lay in the top plane of the vase with Turquoise Blue, Naples Yellow Light and white with a no. 4 bristle brush. Remember that light can burn out color, and as light diminishes, color increases, so add more intensity to your blue as you move down the vase. When you paint the highlight, be sure that it accurately reflects the structure of the object's surface, rather than dabbing on a single white highlight point without an appropriate reference. Bring the front plane of the vase forward by adding yellow to your turquoise. As the vase turns back in space, cool the color.

Move on to the focal point and reinforce the bright yellow in the middle of the flowers. Add more intense orange and red to the edges of the petals. Paint the lights of the white freesias. Add a little yellow to the white for the more opaque flowers, such as where one petal is resting on another. To get the white flowers to recede in space, add more blue to the white. Make a bright lime-green citron with the Turquoise, Cadmium Yellow Lemon and white for the tops of

the smaller buds, but cool them down as they move away from the center. Add Naples Yellow Light, Burnt Sienna and Yellow Ochre to the Burnt Umber for the wood in front of the vase as well as some reflection of the vase and flowers in the wood surface.

6 The Edges and Reflected Lights

For the one-hour flower studies, you'll use 3 types of edges: hard, soft and lost. Use a hard edge to draw attention by increasing contrast between 2 values, and use a soft or a lost edge to minimize the contrast. It's important to strike a balance between these types of edges, and one should generally use hard edges sparingly. Create softer edges of the flowers as they meet the background. The edges of the flowers in the back of the set-up are also softened; however, here it was important to conserve their shapes. Bring the color of the background up to the edge of the vase.

Next, add more paint, using Titanium White with a touch of Cadmium Yellow Light to brighten up the insides of the flowers while maintaining the softness of the petal edges. You want to make sure that any hard edges, such as on the white flowers, do not detract from the center of interest, which is, of course, the bright yellow-orange freesias.

The last element to address is the reflected lights. Remember that anything that receives light also reflects it. This means that the tabletop that is receiving light is also reflecting light up onto the bottom of the vase. Take Viridian Green and Cadmium Yellow Light and add them to the turquoise color and lay it on top of the shadow color that is already there. If the timer goes off before completion of the painting, that's fine, but push to work a little faster the next time you do this exercise.

Put the painting away for a couple of hours, then spend another few minutes or so making small adjustments if desired, and then it's done. It's surprising how little painting is required to capture the essence of a vase and flowers.

TENNESSEE CORDIALS | **Cynthia Rowland**
Oil on double-primed linen canvas
8" × 6" (20cm × 15cm)

Cynthia Rowland | cynthiarowlandstudio.com

The ancient adage *Natura Artis Magistra* says it all: "Nature is the teacher of art." Certainly, successful painting demands one's personal abstractions of the physical qualities of form and movement, color and light—and it is the desire to communicate these personal perspectives that underlies Cynthia's principal motivation to paint.

Cynthia Rowland graduated in Fine Arts, College of Arts and Sciences, Texas Tech University. After living in Hawaii and then spending a dozen exhilarating years owning an advertising art business in New York, she returned to New Mexico. With her husband, Mark, she has completed over 40 cast bronze sculptural projects such as the monument *Florida Panthers* at the Orlando Convention Center.

For several years, Cynthia's consuming focus has been oil painting, and she enjoyed the tutelage of Wilson Hurley and David Leffel. She has developed her own style and has been invited to a variety of competitions, exhibitions and galleries. Cynthia's art is represented in both private and museum collections.

Cynthia serves on the board of directors and offers painting workshops at the New Mexico Art League. She is state representative of the Portrait Society of America, and in 2011 received the society's award of excellence for expanding awareness in New Mexico of fine art portraiture.

44 Paint a Single-Color Subject

Combining several objects from my collection with the same dominant color forces me to concentrate on the orchestration of their hues and color temperatures. No color lives in isolation—each color on our canvas is measured relative not only to the colors surrounding it, but to the hues and color temperatures of the same colors elsewhere in the painting.

Blue is considered a cool color on the color wheel, but what is more important to remember is that each individual color will have a cool, warm or neutral feature. The three blues we'll use for this exercise are Ultramarine Blue Deep, Cobalt Blue and Phthalo Blue. Ultramarine Blue is the workhorse of blues: it's a violety blue, transparent, but not as dark in tone as Phthalo Blue and has a wide range of uses. Cobalt is lighter and cooler with medium intensity that is softer than the other two blues. Phthalo Blue is slightly green, very strong and can dominate any mixture. Phthalo produces excellent purples when mixed with Alizarin Crimson.

While painting, the important questions are: What are the values of the blues—which ones are lighter or darker? What are the temperatures of the blues in the set-up—which ones are warmer or cooler? What is the intensity of each blue—which ones are brighter or more dull?

Painting this exercise will help you sharpen your perception of value and temperature, and energize you for future paintings.

1 Arrange the Subject
Begin by arranging the blue and white objects. An exacting composition of the objects is not as important for this exercise as when creating a painting intended for the marketplace. Relaxing this requirement gives you the freedom to concentrate on the interaction of colors and think simply of the sizes of the objects and their relative placement front to back in the set-up.

2 Toning and Blocking
Using a no. 6 bristle brush, tone the canvas with a mixture of Ultramarine Blue and Burnt Sienna. Make sure to keep this mixture transparent and leaning toward warm, which will prevent your painting from feeling too cool.

Using the same mixture of colors and no. 6 bristle, block in the major shapes. Look at masses rather than lines to reflect the dimensionality of the objects in the painting.

3 Form and Value
Using the same no. 6 brush and the mix of Ultramarine Blue and Burnt Sienna, add Alizarin Crimson and begin to mass in the values of the colors. Lean the colors toward the warm for the shadow areas of the background and shelf. For the tissue paper shadows lean toward the cool end of the mixture. Add Alizarin Crimson to the Burnt Sienna to create the undertone of the focal vase. Don't worry about color temperatures of the blues at this point, just be aware of the cool light on the subject and that the shadows are on the warm side.

4 Paint the Background

Still using the no. 6 brush, add Titanium White to the Burnt Sienna and Ultramarine Blue mixture to create a rich chromatic gray. The set-up has 4 values of gray: the background in light, the background in shadow, the cast shadow of the tissue paper and the foreground shadow of the shelf. Pay attention to these values as you lay in the background.

5 Establish the Ranges of Blues

Set out 3 no. 4 bristle brushes, one for each of the 3 main blues. Start with the extremes— lay in the small, dark flask with Ultramarine Blue and a touch of white. The rest of the blues in the painting will be subordinate in intensity to this flask. Use a mix of Phthalo Blue and Alizarin Crimson for the darkest blue on the left side of the same bottle where the color of the tall vase in the background meets the blue of the bottle. For the small ceramic jar, use pure Cobalt and white with a little Naples Yellow on its top plane. For the side plane, switch to a more intense version of the Cobalt, the same value of the Phthalo Blue, which is a little greener, and then Ultramarine Blue as it turns into the shadow. For the figurine and small Chinese jar, lighten the gray mixture, leaning toward the blue. Remember not to make the whites so light that you don't have a value left for the highlights. Continue laying in the major colors of the composition.

6 The Focal Point

The viewer's eye should move toward the duck figurine, so add more Phthalo to the white mixture and place a warm highlight on the duck's breast and head. Using a no. 1 bristle brush, begin to lay in the pattern on the duck's body using pure Ultramarine Blue, but keep it thin. As you work over the painting, remember to compare values and temperatures. In addition, compare your highlights because highlights are not of equal intensity on all surfaces.

7 Final Details

Bring all the objects to a greater state of completion by firming edges, especially those in the light, and saving the hardest edges for the figurine. Use a hard perimeter for the leading edge of the tissue so it comes in front visually, and use softer edges elsewhere so that they rest visually behind the large vase. Know when to stop—if you've done what you set out to do and further strokes aren't necessary for the exercise, then put your brushes down.

STUDY IN BLUE | **Cynthia Rowland**
Oil on canvas; 12" × 16" (30cm × 41cm)

45 Paint Vegetables!

When stymied by the question of what to paint, the answer may be as close as the local farmers' market, grocery store or your own backyard garden. Vegetables, with their wide array of colors, textures and shapes, make for great subject matter. Especially if you normally paint landscapes or figures, this change in subject may be just what you need to get going again.

When selecting vegetables, think about how the various shapes and colors will work together. Do the colors complement each other? Are textures repeated in some of the vegetables? Does the grouping have varying sizes to create interest?

Rather than working from the standard still-life setup on a table, I like to arrange everything on a neutral-colored piece of cloth on the floor, and shoot photos from overhead. I tried different arrangements until I found one that excited me. I took a dozen shots from various angles and directions, ensuring that I would have plenty of photos to choose from.

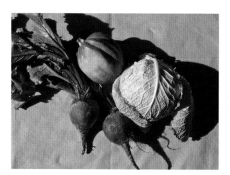

REFERENCE PHOTO
When photographing vegetables to paint, try placing the vegetables in full sunlight so the different shapes will cast interesting shadows. The shadows then become part of the composition. Here, the reds in the beets and leaf veins were complemented by the greens in the beet leaves and the cabbage and squash. The texture of the cabbage was a nice echo of the texture in the beet leaves, and the orange in the squash provided a nice splash of color.

1 Design the Composition
Crop the photo. Having parts of the vegetables run off the edge of the painting creates interesting negative shapes and makes for a stronger composition. The large neutral area on the lower left is a good counterweight to the vegetables and balances the design. Sketch the drawing on a piece of paper that is in proportion to the cropped photo. This cropped image is 3½" × 4" (9cm × 10cm), so the paper is 13" × 16" (33cm × 41cm).

2 Preserve the Shadows
To preserve the shadow areas under the vegetables, lay down a thin wash of acrylic paint in those areas using a ¾-inch (19mm) flat brush and a mix of Pyrrole Orange and a Phthalo blue-green shade to create a soft neutral color. Wet the shadow areas with clear water and then drop the wash in. This will keep the shadow outlines from being washed away during subsequent layers of watercolor washes. Lay in a pale wash of Cadmium Yellow Light on the squash and the cabbage with a 1-inch (25mm) flat brush. While still damp, lift out the major veins on the cabbage using a ¾-inch (19mm) flat. Give the beets a thin wash of Quinacridone Rose and, while damp, lift out the top area of each beet and apply a wash of Golden Green straight from the tube.

3 Lay In the Background and Develop Leaves

Dampen the background sections with clear water, using a 1-inch (25mm) flat brush. Apply a wash mixed from Cadmium Orange and Ultramarine Blue on the damp areas, including over the previously painted shadow areas. After the background has dried, work on the beet leaves. Using a ½-inch (13mm) flat brush, along with a no. 7 round for details, apply layers of greens made from mixes of Permanent Green Light, Magenta and Cadmium Yellow Light. Mix strong darks from Permanent Green Light and Magenta. Paint the beet stalks with Quinacridone Rose, darkened in areas with a mixture of Quinacridone Rose, Ultramarine Blue and a little Magenta. Paint the beets with Quinacridone Rose and Viridian and a highlight of Golden Green.

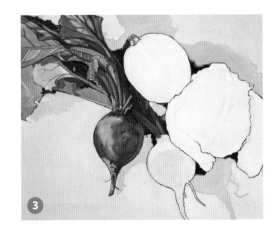

4 Paint the Squash and Cabbage

Wet the acorn squash shape with clear water using a ¾-inch (19cm) flat. Drop in a concentrated mix of Cadmium Orange and Cadmium Yellow Light. While it's still damp, add a mix of Permanent Green Light and Ultramarine Violet on the remaining area of the squash. Working back and forth, add highlights of Golden Green with a ½-inch (13mm) flat, then more Cadmium Orange and more of the Permanent Green Light and Ultramarine Violet mix. Soften the edges using a damp brush to blend areas together. Once the body of the squash is done, add magenta to create the darkest shadows.

Dampen the cabbage shape and paint on a mix of Cadmium Yellow Light and Phthalo Turquoise using a 1-inch (25mm) flat brush. While it's still damp, lift out the major veins of the cabbage with a ¾-inch (19mm) flat. When that's dry, add shadows with a mix of Cadmium Yellow Light, Phthalo Turquoise and Ultramarine Blue.

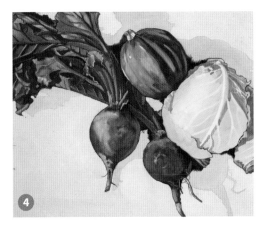

5 Refine the Shapes

Define the cabbage further, layering on a mix of Cadmium Yellow Light and Phthalo Turquoise around the major veins, and then lift out the smaller veins with a ½-inch (13mm) flat. Add shadows along the more prominent veins with a no. 7 round brush and a mix of Phthalo Turquoise, Cadmium Yellow Light and a little Magenta.

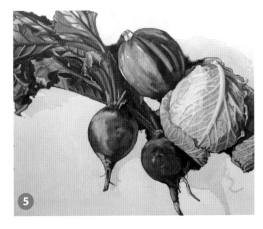

6 Final Details

Lay in the shadows with a mix of Cadmium Orange and Ultramarine Blue using a ½-inch (13mm) flat. The shadows are darker closer to the vegetables and lighten as they recede from the vegetables. Once the shadows are in, the composition pulls together and the painting is done.

AUTUMN STILL LIFE | Peggy Morgan Stenmark
Watercolor on 300-lb. (640gsm) rough watercolor paper
13" × 16" (33cm × 41cm)

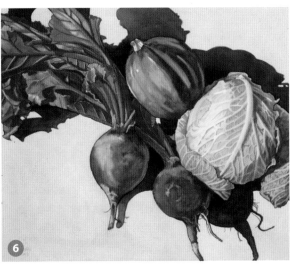

46 Find the Abstract in the Ordinary

Overlooked, everyday items in the world around us can provide inspiration and intriguing subject matter. Trains, rusting old trucks and industrial machinery are just a few of the things that, when viewed more abstractly, supply a wealth of ideas for paintings. Composition is the key to finding the abstract designs that are right in front of us. Training your eye to look for the unusual within the commonplace will open up a new world of painting possibilities.

Things to consider when looking for unique designs are shadow patterns, interesting shapes and unusual colors. I saw this municipal water main outdoors in a park. The patterns created by the play of shadows over the rounded form of the pipe really drew me in. The shapes of the various pipes and pieces had great visual interest as well, and the blue color was an added bonus.

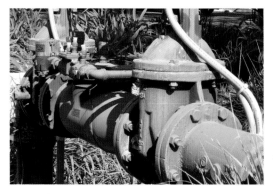

REFERENCE PHOTO
When cropping the reference photo, I worked to find a strong design that looked abstract at first glance, then gradually evolved into something recognizable. Zeroing in on the most intricate part of the water main and letting the pipes run off the page added to the abstraction. By not showing the whole thing, a sense of mystery is created that draws the viewer into the painting.

1 Sketch the Composition
To focus on the water main, leave out the background in the reference photo. It is too busy and takes away from the main thrust of the painting. The watercolor paper is sized proportional to the cropped photo, making it easier to sketch the water main. Because of the complicated nature of this image, after the main shapes are roughed in, set the drawing aside for a day. After looking at it the next day, add and correct any anomalies in the angles and ellipses of the pipes and fittings.

Between steps 1 and 2, a tempera resist technique is applied to the watercolor paper. While this is not required for this exercise, it is an effective technique (see sidebar).

2 Paint the Background
The background for this painting will be a neutral color, giving the impression that the water main is in front of a concrete wall. This will also provide quiet areas for the eye to rest within the composition. First, dampen each background shape with clear water using a 1-inch (25mm) flat brush. Drop a thin wash of a neutral color mixed from Phthalo Turquoise and Cadmium Red Medium into the damp areas using a 1-inch (25mm) brush. This color should be mid-range in value, light enough to contrast with the dark areas of the shadows and dark enough to show off the lightest highlights on the water main. Once the rest of the painting is finished, the value of the background can be re-evaluated and changed if necessary.

3 Lay In the Blues

Mix Phthalo Turquoise, Cadmium Yellow Light and Cobalt Blue to make a very thin wash. Using a 1-inch (25mm) flat, paint the wash on all the blue areas of the water main. Let it dry, then lay in mid-value shadows, using a ¾-inch (19mm) brush and a mixture of Phthalo Turquoise, Cadmium Red Medium and a small amount of Mauve. This preliminary wash will help you keep track of the lights and darks in the composition. The shadows will almost certainly be darkened as the painting develops.

Paint the lower-left area of the picture using a more concentrated mix of the intermediate shadow colors and a ¾-inch (19mm) brush. This gives a baseline for the development of the darker shadow areas in the rest of the picture. Wet the area of the vertical pipe with clear water using a ½-inch (13mm) flat brush, and drop in a mix of Cadmium Red Medium and Phthalo Turquoise on the right side, allowing the colors to mix on the paper.

4 Add Washes

Once the preliminary shadow washes are dry, continue to add more washes, deepening some areas and defining the shapes of the pipes. Use a mixture of Phthalo Turquoise and Cadmium Red Medium, skewed a little to the cool side, with ¾-inch (19mm) and ½-inch (13mm) flat brushes. As each shadow is added, the water main takes on more dimension and life.

What is Tempera Resist?

A resist process involves putting down a substance (called the resist) that protects the paper from absorbing any subsequent layer of paint or dye. Batik dyeing is an example of a resist technique. Wax and frisket are types of resists often used by artists. I use tempera paint as my resist.

The first step is to do a detailed drawing on your painting surface. A resist technique requires careful planning at the beginning stages. You must plan where your black areas are in the composition. When that is done, the tempera paint is applied to the page, covering all the areas that need to be protected from the ink layer.

Once the tempera is dry, the entire page is covered in ink. The ink will only soak into the paper at the uncovered areas. In the rest of the image, it stays on top of the resist. After the ink dries completely, the paper is taken to a sink and the resist is rinsed off.

At this point, you now have a permanent black and white image on the paper. Once the paper is dry, watercolors can be applied without interfering with the ink. With the composition permanently set, the artist is free to concentrate on putting down color.

Also, having the darkest dark (the ink) and the lightest light (the white of the paper) established before starting to paint helps in determining values as the painting progresses.

5 Adjust Shadow Values

The shadows are a key component of this composition, and getting their values right is critical to creating the mass of the pipes. As you lay down each wash, reassess the whole to make sure you balance out the values. It is a bit like a dance, each step determining what the next step will be. The shadows have their own abstract quality, yet they must also work within the context of the total design. Detail work of the shadows is done with a no. 7 round brush. Once the shadows are finished, let the painting dry before moving on to the next step.

6 Begin the Details

Now it is time to work on some details. The flexible white tubing and the 3 white caps are given definition with thin washes of Cadmium Yellow Light and Ultramarine Violet mixed to a cool neutral and applied with a no. 7 round brush. Paint the top half of the water meter with a thin wash of Golden Green using a ½-inch (13mm) flat brush. Before that dries, using the same brush, add a more concentrated mixture of Golden Green and Mauve to the sides, leaving a Golden Green highlight in the center, helping to suggest the round form of the meter. After that has dried, add details with a no. 7 brush. Use a very thin wash of Cadmium Yellow Light and Ultramarine Violet mixed to the cool side on the lower half of the meter with a ½-inch (13mm) brush, and paint the handles on the water main with a preliminary wash of Cadmium Red Medium and a no. 7 round brush.

7 Final Details

Develop the lower half of the meter further, using the ½-inch (13mm) brush and darker washes of the Cadmium Yellow Light and Ultramarine Violet mixture. Leave the highlight areas unwashed. Once the washes are dry, add shadows using a stronger mix of the wash color and a no. 7 round brush. Glaze the small handles with washes of Cadmium Red Medium applied with a no. 7 round brush. Let that dry, then glaze on shadows using a mix of Cadmium Red Medium and Phthalo Turquoise and the same no. 7 brush. Changing the color of the small handles to Cadmium Red Medium introduces the complement of Phthalo Turquoise to the painting and creates a bright spot of interest in the composition. Finally, paint the small label on the large pipe with a no. 7 round brush and the same color mix of Cadmium Yellow Light and Ultramarine Violet as the water meter, which helps to pull the whole piece together and finish it off.

WATER MAIN BLUES | **Peggy Morgan Stenmark**
Watercolor on 300-lb. (640gsm) rough watercolor paper
16¼" × 13¾" (41cm × 35cm)

Peggy Morgan Stenmark | pmorganoriginals.com

Painting full time since 1999, Peggy Morgan Stenmark is a nationally known, award-winning artist. Her work has appeared in numerous juried art shows throughout the country, including the American Watercolor Society's annual show in New York City. Her paintings are included in private collections across the United States and have been featured in both *Watercolor* and *Watercolor Artist* magazines. In 2007, she was chosen as one of "The Ones to Watch" by *Watercolor Artist* magazine.

In her work, Peggy focuses on finding abstract designs within the commonplace things of everyday life, and in the process, she inspires people to see their world with new eyes. She works in watercolor and acrylics, conducting workshops around the West and teaching part time at the Art Students League of Denver. Peggy is a signature member of the National Watercolor Society, the Rocky Mountain National Watermedia Society, the Western Federation of Watercolor Societies and the Colorado Watercolor Society. She makes her home in the foothills of Colorado.

47 Paint Watercolor on a Tinted Surface

The demands of everyday life can interfere with creativity. Deadlines and obligations can create fatigue, so it is important that I keep my creative battery charged.

I recharge my battery by taking time to do things I truly enjoy. This means I take time to play. Play is different from one person to another. Some people need to get away from it all, but for me, grabbing a sketchbook and pen and heading out the door is usually enough. When I sketch for myself, I am not worried about what others might think or if the sketch will work for a finished painting. When I draw with pen and ink, I do not predraw with a pencil. I want to avoid working for exactness. Perfection can feel crippling when I am aiming for creativity and playtime.

I also enjoy working on nontraditional papers. When I work on mulberry paper, I don't always know what the end result will be. I enjoy the feeling of exploring the surfaces. I am more open to change when I don't know what the end result will be.

Watercolor is traditionally applied to a white surface, so tinting the paper before starting the painting moves you out of the comfortable norm right from the start.

ORIGINAL SKETCH
AND REFERENCE PHOTO
I selected a sketch from a recent trip to France. The day was quite cool and overcast. For a few brief moments, the sun broke through the clouds and bathed the tiny village in a warm glow. The scene made my heart skip a beat. I only had enough time to do a quick sketch in my travel journal before the clouds returned and the rain began. The photograph will provide further information.

1 Stain the Mulberry Paper

I like the warm tones and Old World look of mulberry paper stained with tea. The best mulberry paper for tinting is thick enough to withstand being submerged in liquid for a few minutes without coming apart. I begin by making a strong batch of tea, letting it cool and then submerging the paper in it until the color reaches the desired tone. I lay the mulberry paper on paper towels to dry. When dry, I cover the surface with a 50/50 mixture of water and acrylic matte medium. The medium helps the paper become less absorbent. Here, the top paper is left unstained.

2 Sketch a Line Drawing

Refer to the original sketch and photograph as a springboard. Don't worry about creating a duplicate, but use them as a starting point. Change the format to a vertical, including the church tower on the left and using the road as a lead-in to the scene. The mulberry paper is roughly 12" × 10" (30cm × 25cm) inches; draw directly with a waterproof pen.

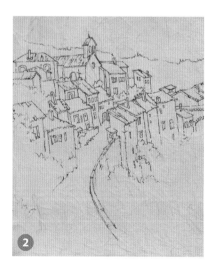

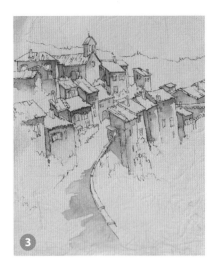 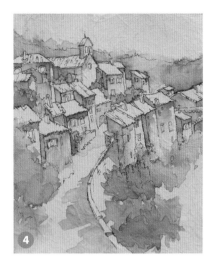 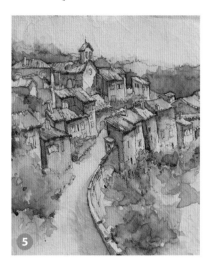

3 First Wash for the Shadows

For the first wash, use Quinacridone Sienna, Burnt Sienna and Cobalt Blue to define the form and cast shadows on the buildings. Since the photo does not have a strong light source, you'll have to make decisions regarding direction of light and shadows.

4 Block In the Foliage

Block in the foliage, mixing greens from a variety of yellows (Quinacridone Gold and Hansa Yellow) and blues (Marine Blue and Ultramarine Blue) into the center of your palette, and allow the colors to mingle on the edges. Each brush load will have a variation of greens. Use more blue in the distant hills and more yellow in the foreground.

5 Paint the Rooftops and Darken the Foliage

Paint the rooftops with Burnt Sienna, Scarlet Lake and Lunar Black. The overhang of the roof tiles is defined with a darker value of the same colors. Allow some of this color to run into the shadows on the buildings. The hills are pushed back farther with a glaze of green. Begin to define the shrubbery in the foreground and around the buildings.

6 Add Permanent White Gouache

First, paint the sky. Mix a gray using Permanent Alizarin Crimson and Viridian. Begin painting the sky with this mixture, and while the paint is still damp, add Permanent White gouache directly on the paper. Use a damp brush to help the 2 paints mix. Next, introduce a small amount of white to the buildings. Paint white directly below the cast shadows on the front of the buildings and soften with a damp brush.

7 Final Details

In the final stage, make adjustments in the values and add final touches. The trees in the distance are not dark enough; darken them using Viridian and a touch of Burnt Sienna. Define and darken the shrubbery with Marine Blue and Burnt Sienna. Before it has a chance to dry, add a touch of Lunar Black to create texture. Paint the shutters and doors with Cobalt Teal Blue. The shadow across the road looks flat, so wet the area with water, drop Quinacridone Sienna in near the wall and pull the color to the left with a damp brush.

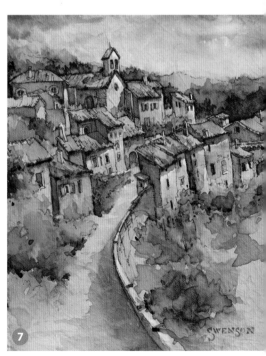

MINERVE, FRANCE | Brenda Swenson
Watercolor on tea-stained mulberry paper
12" × 10" (30cm × 25cm)

125

48 Create a Watercolor-Stained Paper Collage

When I am faced with an artist's block, it usually means I have become bored with what I am doing. I have worked in watercolor for twenty years, and every now and again I need to shake things up to keep it exciting.

To get the creative ball rolling again, I usually change the surface I am painting on or work in a different medium. This creates new and exciting problems to solve and gives me stimulating challenges.

The process of collage is so different from the way I usually work that it requires me to think in a different way. I have to work with general forms and larger shapes. The medium doesn't allow me to fall into my old and familiar way of painting.

1 Stain the Paper

Set aside some time to stain some Japanese paper. While you're at it, you can stain a variety of papers and colors to last you for a while. Stain 1 color at a time by tearing the paper into smaller sizes, roughly 4" × 9" (10cm × 23cm). It is easier to work with smaller pieces, especially with the more fragile papers.

Lay the paper in the center of your palette and use a 1-inch (25cm) flat brush. The Pike Palette works great for staining paper as it has a large flat area and the lid doubles your workspace. If you want a piece of paper to be especially dark, paint both sides; otherwise one side is enough. For light colors, you can mix Permanent White gouache with the paint.

2 Let the Stained Papers Dry

Lay the stained Japanese papers on paper towels to dry.

3 Select Your Colors

Think of the papers as your color palette. It helps if you stain the papers a variety of colors: primaries, secondaries and several neutral shades.

4 Pick a Reference Photo

Select a photo for your collage. This photo of pomegranates is appealing, and it's a nice, simple composition, which should work well for the collage approach.

5 Make a Quick Preliminary Sketch

Draw a quick color sketch to help determine placement and design. You may wish to experiment with more than one sketch until you get a pleasing arrangement of the elements.

6 Sketch the Composition

Draw the image on a piece of 15" × 11" (38cm × 28cm) 300-lb. (640gsm) watercolor paper using waterproof ink. Draw only the major elements to establish placement. Most of the pen lines will disappear under the collage. If you need to establish lines during the process, you can easily redraw them later.

7 Prepare Your Workspace

Begin by laying out your supplies: an assortment of stained papers, dishes of water and matte medium, 2 stiff flat brushes and a watercolor brush.

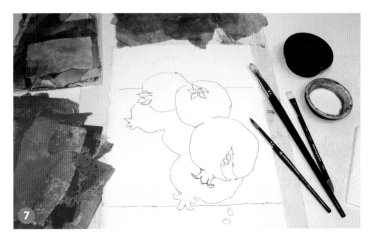

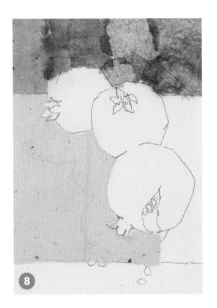
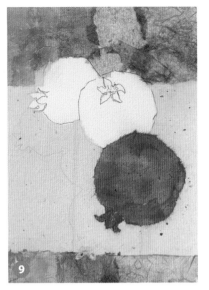
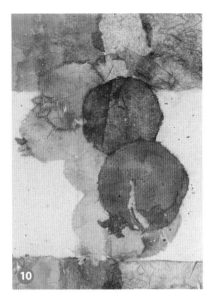

8 Begin the Collage

Begin the collage by blocking in the larger areas. Tear the paper to get the desired shapes. Use a stiff brush to apply matte medium on the watercolor paper and place the stained paper on top and brush more matte medium on top to secure it. Use just enough matte medium to attach the paper to the surface.

9 Outline Complex Shapes Before Tearing

When you need to work around a complicated shape, such as the pomegranate tops, lay the Japanese paper on top and use clear water to draw an outline. The paper will tear in a more controlled manner along the wet line.

10 Continue Blocking In Shapes

At this stage, the collage has a rough, unfinished appearance. Don't worry about details, just get the major shapes blocked in. Before beginning the painting stage, you need to unify the surface of the collage. To do this, make a mixture of matte medium diluted 50 percent with water and paint over the entire surface. Let it dry thoroughly.

It is important to remember that even though you started with a sheet of watercolor paper and watercolor paint, the surface is nothing like a watercolor. The surface of the paper is no longer absorbent since it was sealed with matte medium. It will require less water to be used with the paint.

11 Begin Painting the Details

Begin by painting a wash of Ultramarine Light and Viridian across the top and bottom horizontal bands. If you push the mixture more towards blue than green, it will merge the areas. On the bottom band, suggest a few seed shapes. Next paint a vertical strip of Gamboge starting beneath the top pomegranate. This passage of yellow ties the top and bottom of the collage-painting together.

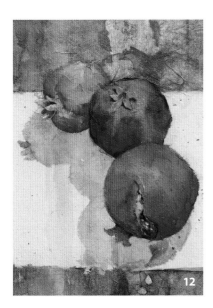

12 | **Paint the Pomegranates**
For the most part, you are painting the shadows of the fruits. Paint the top pomegranate with a mixture of Scarlet Lake and Lunar Black, and the middle pomegranate with Permanent Alizarin Crimson and Lunar Black.

Next move on to the pomegranate in the foreground. To paint the area that is split open, use a mixture of Rose Violet and Ultramarine Light to suggest the seeds. Inside the leathery peel is yellow—use an opaque paint here, a mix of Raw Sienna with a small amount of Permanent White gouache. Also use the mixture on the calyx (floral shaped top) of the 2 other pomegranates. Add a few white accents to the area.

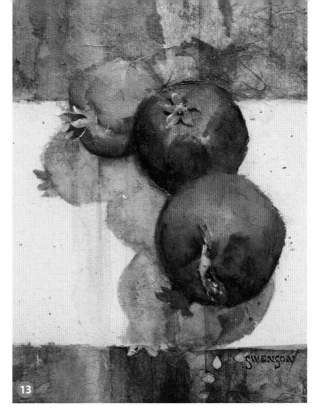

POMEGRANATES | **Brenda Swenson**
Watercolor and collage on watercolor paper
15" × 11" (38cm × 28cm)

13 | **Final Details**
Assess the values and make adjustments. The cast shadow needs to be darker and have more reflected red in it. Paint Permanent Alizarin Crimson directly beneath each pomegranate, and while the paint is still wet, pull the color down the page with a damp brush. Darken the shadows of each pomegranate. Directly beneath the bottom pomegranate, darken the band of color to bring out the negative shape of the seeds and the edge of the shadow.

Brenda Swenson | swensonsart.net

Brenda Swenson is the artist-author of 2 books, *Keeping a Watercolor Sketchbook*, which was an award of excellence finalist, and *Steps to Success in Watercolor*. Her paintings and sketches have been featured in *Splash 11*, *Splash 12*, *Artistic Touch 4*, *Watercolor Artist*, *Watercolor* magazine, *Watercolor Highlights*, *Quarterly Magazine*, *Wheels of Time* and numerous other publications. Brenda has been awarded signature membership in Watercolor West and the National Watercolor Society, and she has won numerous awards for her paintings. An active participant in the arts community, she has served on the board of directors for the National Watercolor Society and Watercolor West. She demonstrates and teaches her painting and sketching techniques to groups nationwide and abroad.

49 Change your Viewpoint and Medium

Until recently, I've always painted in watercolor, so I decided to break out of my routine and try something new—Interactive Acrylics by Atelier. I soon realized that I was handling the new paint the same way I painted in watercolor, but my goal with the new medium was to change.

With the acrylics, I revised my usual technique of starting with darks and continuing toward the lights. The new medium has given me the confidence to change color or value at any time. These acrylics allow you to paint like regular acrylics but also wet-into-wet, ending like oils. If after a few hours you decide to make a change, just mist with water, and you will be able to go in and make a change. But if the paint has dried, say for a week, you can use a product called unlocking medium, and it will allow you to mist and blend with ease, just as if you had done it right off. It's very exciting.

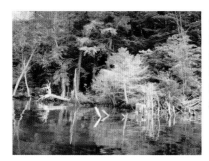

REFERENCE PHOTO
The photo is a scene from early morning on the lake where I spend my summer months in the Adirondack Mountains. My favorite time is early morning just after sunrise when the lake is shrouded in fog. I like to gather my art supplies, sketchbook and camera, climb into my kayak and head out for a morning of exploration. The photo was taken from the kayak, so it's a different point of view than if taken on land.

1 Begin the Composition

Draw a light pencil sketch of the composition on an 8" × 10" (20cm × 25cm) canvas panel. Create some preliminary green mixtures starting with a small amount of Permanent Green Light mixed with some Cobalt Blue with a bit of Sap Green. Darken some of the initial mix with dabs of Ultramarine Blue to vary the greens. For the dead trees, mix a small amount of Titanium White with Cobalt Blue. Use Burnt Sienna for the darker tree trunks and shoreline. To paint the grouping of off-white trees, mix a soft lavender with Titanium White and Dioxazine Purple. Using a ½-inch (13mm) flat nylon brush, paint the shapes in the top third of the painting, holding the brush flat and painting across the canvas, mixing and blending colors together to create depth as you work.

2 Decide What to Eliminate

Replace the X-shape of crossed trees on the left with a grouping of shoreline rocks. Paint the dark shapes in the background tree line with a ½-inch (13cm) sable. This brush can be manipulated to paint in different directions, changing colors as you go, alternating Forest Green with Ultramarine Blue. Don't be afraid to go heavy with your paint, as you can always cover it or change it later. Use Permanent Sap Green with small amounts of Naples Yellow to define the foliage. Paint the sky with Titanium White with Cobalt Blue and a no. 8 round. Add a suggested small sky hole to help define the dark tree shape.

3 Block In the Light

In the foreground lake, the colors of the water are varied. Create a base of Forest Green and small amounts of Carbon Black using a ¾-inch (19mm) brush. Add some Arylamide Yellow Deep, blending here and there, then add a little Titanium White and some Permanent Green Light to the mixture. Vary the color with a little Titanium White and some Permanent Green Light.

4 Making Changes

After the first layer of paint is dry, paint in the tree branches using the same colors as in step 3. Determine where to place the underwater old dead tree shape. For that shape, mix Forest Green with French Ultramarine Blue and apply the paint with horizontal strokes using a ½-inch (13mm) sable brush. Mix the paint as you apply it, back and forth, left to right and right to left, varying the length and width of the strokes to vary the colors, and add mixes of Permanent Green Light, Titanium White and Raw Sienna Dark, Permanent Sap Green and Olive Green. Note how the feeling of water is starting to come together.

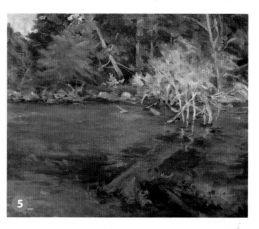

5 Develop the Details

Add some suggestions of tree stumps, mixing Naples Yellow with a touch of Raw Sienna Dark for these. Using the same brush, begin cutting in the negative shapes with a mix of the same Permanent Green Light lightened with some Titanium White. Take your time and step back occasionally to check out what you have painted.

6 Final Details

The composition will be improved if you remove some of the shoreline rocks on the extreme left edge and replace them with greens to correct the strong horizontal line of rocks. By removing some of the rock shapes on the left side of the canvas, you stop the eye from leaving the painting. It allows your eye to travel up and back into the foliage and toward the sky holes, then down the slanted tree trunk shape toward the focal point, the old white dead trees.

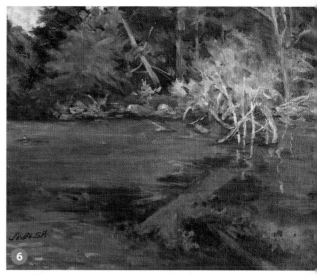

THE STILLNESS OF THE MORNING | Janet Walsh
Acrylic on canvas; 8" × 10" (20cm × 25cm)

50 Paint Your Treasures

Over the years, I have collected many of these old tins as I travel around the country, attracted by the old style designs. My models for this particular painting were collected many years ago when I lived in Manhattan. The Upper West Side had a wonderful street market where I found this treasure, Coleman's Mustard. Its colors, design and shape attracted me, and it was the start of my tin collection.

I found the Tetley Tea tin at the old 14th Street Market. This old metal box with the original paint still bright even had a faint smell of tea. Both of these mar-kets are very large so it did take time to see everything. The Ginger Wafer canister was given to me by a friend, who found it in a shop off Canal Street. The old Orange Blossom talc and the Royal Baking Powder tins I found while at my summer house in Old Forge, New York. Their small size, interesting graphics and condition were a contrast to the other larger pieces.

Putting these treasures together inspired me to move out of my block. You've probably got interesting new subjects around your house as well—you just have to look for them!

1 The Set-Up
Begin by arranging the tins in various combinations, playing with colors, sizes and positions.

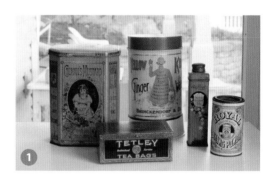

2 Draw and Begin the Block-In
With a pencil, sketch the composition lightly on your canvas board. Mix a small amount of Cadmium Orange with a bit of Arylamide Yellow Deep for the mustard container and paint the sides and top using a no. 12 bright brush. Mix a light blue for the Ginger Wafer tin, using a mix of Cobalt Blue and Titanium White. Paint around the figure and add some darker French Ultramarine Blue to the mixture for a darker value around parts of the figure. Paint the Royal Baking Powder tin with a mix of Naples Yellow Reddish and a no. 8 filbert, and use Titanium White for the background.

3 Finish the Block-In
Begin the Tetley Tea box in the foreground with French Ultramarine Blue. Suggest some green foliage in the background with Permanent Green Light, Naples Yellow and Cerulean Blue, painting around all the contours of the box shapes down to a line representing the table. Work your way around by painting the figures on the mustard and ginger tins, painting the tin tops with Burnt Sienna mixed with Titanium White for highlights. On the vertical talc tin on the right, paint a darker orange using the same mix as the mustard tin. Work on the small round baking powder tin using a ½-inch (13mm) brush. Mix a combination of Aryl-amide Yellow Deep and Cerulean Blue for the container.

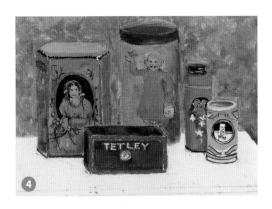

4 Develop the Details

Develop the young girl and foliage on the mustard tin with a black fine-point permanent marker. Suggest the dark orange rim of the Tetley Tea tin with dark orange, and outline the very edge with gold.

Paint the screw top of the orange talc tin with a red-brown mix, adding some Cerulean Blue for highlights. Change the light blue label to a light yellow-green using Sap Green with a little Naples Yellow. Add a thin white line using an opaque white paint marker for the trim line and to suggest the label's stars and flowers.

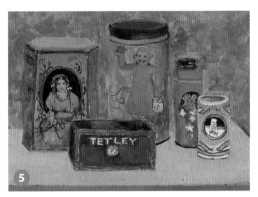

5 Finish the Tea Container

Paint the baking powder container with Naples Yellow Reddish using a no. 2 bright brush. Use Cerulean Blue for the ribbon shapes.

Add the lettering to the tea box using opaque white. Then add the red outline around the letters using a fine-tipped opaque red pen marker. When this is dry, use a gold paint marker for the lettering and decoration around the tin.

6 Final Details

Revise the colors of background and the foreground to simplify the painting. Paint the background using a no. 16 bright brush. Start on the left side using Permanent Green Light, some Titanium White and some Cobalt Blue, blending into a mixture of Cobalt Blue and some Arylamide Yellow Deep on the right. Adjust the foreground with Cerulean Blue mixed with Titanium White and bits of Cadmium Orange. Drag this mixture down in a vertical manner to give the appearance of reflections.

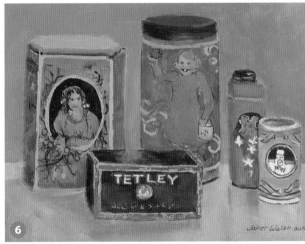

TREASURES | **Janet Walsh**
Atelier Interactive Acrylics on canvas board;
8" × 10" (20cm × 25cm)

Janet Walsh | janetwalshwatercolors.com

Janet studied at both the School of Visual Arts and the Art Students League in New York City. She has taught watercolor workshops throughout the United States, France, England, Ireland and Spain. Besides teaching and painting, Janet juries and judges many regional and national art shows. She is a member and president emeritus of the American Watercolor Society.

She is the author of *Watercolor Made Easy* and has 6 instructional watercolor CDs on her painting approaches and techniques. Janet has written articles for *Watercolor* magazine and was selected as one of the America's top 20 watercolor instructors by *American Artist* magazine. Janet has received many awards and honors for her work. She also participated in the International Watercolor Masters Exhibition in 2008 and 2009 in Nanjing, China, and in the first Shanghai Zhujiajiao International Watercolour Biennial Exhibition in 2009. Her works are in museum, corporate and private collections, both national and international.

51 Take a Detail From Oil for a Painting in Pastel

It is essential to keep one's work fresh, innovative, challenging and full of verve. If you are constantly repeating a subject or motif—as in my case, flowers—you have to be on the alert to not fall into the trap of stylization and of repeating past solutions. Nothing is worse than realizing that you have painted this picture before and that you are only repeating yourself over and over again without any creative spark.

To jog myself into new creative territory, I'm going to use a portion of an oil painting I've already done as the inspirational source for creating a new work in pastel. The new work will interpret one medium, oil on canvas, into a new medium, pastel on paper, and explore a new composition that I found in the existing oil painting.

The goal is to not just copy one medium and composition into another medium, but to use the painting's cropped image as a kick start to finding a new, fresh image.

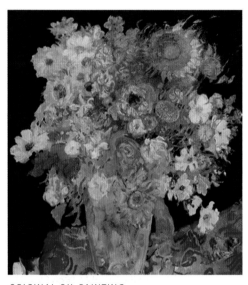

ORIGINAL OIL PAINTING

STILL LIFE ON RUG | **Jimmy Wright**
Oil on canvas; 60" × 55" (152cm × 140cm)

CROPPED IMAGE
Selecting just a portion of the original painting isolated a new potential subject; rotating it moves it further away from the original painting.

THE SET-UP
I work while standing at an easel, so for my reference, I cropped and rotated the painting image on an iPad, which is mounted on a light stand placed to the side of the easel.

Tape all 4 sides of the paper to the drawing board with masking tape so the paper will dry flat.

1 Sketch and Block In the Subject

Sketch the image on a 29" × 41" (74cm × 104cm) sheet of hot press using a combination of gesture and contour drawing techniques. With rapid strokes using a dark gray pastel, fill in the black background. The edge of the bouquet is not drawn as a rigid outline. The meeting of black against color is defined as the place where the gesture of the bouquet ends.

As you draw, look for ways to add movement to the composition. Apply broad strokes of dusty red, gray-green and violet-gray pastel to signify the red flower shapes. Leave the white of the paper exposed in areas of the lightest color. Use Burnt Sienna to signify movement and punctuation of space.

When the sketch is complete, spray with a coating of Spectra-Fix fixative and allow it to dry before continuing.

2 Apply Pastel Ground

Mix 2 teaspoons of pastel ground diluted with 4 to 6 teaspoons of distilled water in a container large enough to accommodate a 3-inch (8cm) foam brush. Apply an even coat of the mixture over the entire surface to the edges of the tape. This gives a lightly pumiced surface to the paper. If you like a toothier (a more heavily pumiced) surface, increase the amount of pastel ground.

To apply the ground, follow the general composition by blocking in separate colors and shapes. Begin with the lighter values, and brush over the darkest areas last to not muddy the colors. You may want to wash out your brush as you move from color to color. Be careful to not load the foam brush with water when you dip into the ground. To remove ridges of ground or textures, quickly smooth out the entire paper surface with the foam brush. The application of the ground should be done very quickly so no areas start to dry before you have covered the entire paper surface. Let the paper dry.

3 Block in the Next Layer

Block in basic colors and shapes while searching for rhythms in the overall composition. Block in the black background with a large stick of black and a Diane Townsend black Terrage pastel.

Develop the flowers with light to medium rose reds; light, medium and pure yellow; yellow-gray, deep red-purple and white. Use Viridian, Cadmium and Olive Greens for the foliage.

At this stage, you may be satisfied to continue developing the composition to a finished pastel by focusing the forms and defined details. That is a valid path to take. However, the goal is to give yourself a creative jolt. You may feel that you're wandering off into the wilderness for what seems like 40 years searching for a fresh new image using the compositional division of black played against a landscape like a mass of flowers. But the next stage will help you step into the unknown.

4 Cover the Surface with Rubbing Alcohol

Using a 1-inch (25mm) soft-bristle flat brush, saturate and brush out the color with rubbing alcohol. This creates a matte surface that you will then highlight with a new application of pastel forms and higher-keyed color. The objective is to enliven the surface. Flashes of color break through the gray. The bright colors are quickly covered with warm to cool grays to unify the mass, variations of warm gray over warm colors and cool gray over cool colors. The large mass of cool rose located in the left center is brushed over all the areas of warm rose surrounding the single white flower near the center. All yellow flowers are brushed over, mixing the dark ochre over the more intense yellows. Make sure all white areas are covered with a light application of alcohol tinted with pastel from the neighboring forms.

When that stage is done, apply a light coat of fixative and let it dry.

5 Explore Variations of Shapes

At this stage, the pastel work has become fully independent of the original oil painting. This is a stage of search, destroy and invent. It's time to explore the edge and overall shape of the form against the black.

Move some of the existing flowers to new locations and add new flowers. Over the large rose mass in the left center, draw a spent sunflower in sienna with expressive orange petals. Below that add another sunflower with pale yellow and white petals. Add a loose warm gray over the yellows on the right side. Add a lavender-gray over the yellow on the left side. The only form that survives intact in the finished pastel will be the gestural sunflower in the middle-left area of the composition.

Throughout these stages, work with the intent to crop the image on all 4 sides to create a tight composition. This is a very crucial stage in the creative process. You can easily melt down and quit in frustration at this point because there are so many issues to resolve at the same time.

To ease your anxiety, create a page of thumbnail sketches in soft pencil on paper. This can be done at any stage of a pastel. Move the forms around. Work in rapid succession. Let the variations flow.

6 More Compositional Changes

Use an angled palette knife to scrape away areas of the composition before adding fresh pastel.

The contour of the dense dark ground against the mass of organic forms remains the same. Use a dark blue over the black background as a complementary color to intensify the yellow forms. The red form adds vitality to the overall gray tones of the vegetation. There is a sense of the in and out of space between the leaves and stems.

It's a good idea to take a break at this point and come back the next day. Brush away the red poppy in the center, the larger yellow form and the 2 sunflowers on the lower left. Use the palette knife to remove excess pastel buildup.

7 Final Details

Use your hand to blend a large sunflower head in the left center from the middle yellow sunflower and the red flower. With muted oranges and a dark warm gray define the large sunflower head. A bit of purple in the form will accent the orange tones. The writhing sunflower petals below in orange remain with their color intensified with Cadmium Yellow, orange and lavender. Wipe out the white petal flower and redraw it farther left of center. By drawing over the background with black Townsend Terrages pastels, the petals gain a transparent and fragile physicality that is more convincing and flowerlike.

Add the petunia forms in the lower right and edge of the upper right using purple and rose. Both flowers have fading white to gray line accents. Break up the symmetry of the right-top sunflower by varying the edge of the form to help move the viewer's eye to the right and clockwise around the painting.

Edit the contour line of the black against the flower form, covering the dark blue background entirely with a Townsend Terrages black pastel. The black background on the left side dramatizes the sense of organic forms on the edge of darkness, a mass of flowers seen against the black depth of night.

Throughout the composition, highlight petals with more intense variations of existing colors with a soft pastel. The orange details become almost red. The yellow details have

GATHERING ON BLACK | **Jimmy Wright**
Pastel on paper; 26" × 30½" (66cm × 77cm)

highlights of the most intense yellow that you own. The rose on the petunia has a few red highlights. The added intensity of a few details lifts the forms, giving the mass of flowers a greater sense of dimension.

Give the finished pastel several coats of fixative, allowing each coat to dry between applications.

Jimmy Wright | jimmywrightartist.com

Jimmy Wright is a Kentucky native. He earned a BFA from the School of the Art Institute of Chicago and an MFA from Southern Illinois University, Carbondale. He continued his studies traveling in Europe, Asia, the Middle East and Africa before settling in New York City.

His work has been exhibited at the Metropolitan Museum of Art, New York, and a survey exhibition at the Springfield Art Museum, Missouri, covering 20 years of work. His work is in the collection of the Art Institute of Chicago, the Metropolitan Museum of Art, New York, and other public collections. DC Moore Gallery, New York, and Corbett vs. Dempsey, Chicago, have presented several solo exhibitions of his work and represent the artist.

He serves on the boards of the Pastel Society of America and the International Association of Pastel Societies and is on the editorial boards of *Pastel Journal* and *The Artist's Magazine*.

Wright has lectured on art at numerous educational institutions teaches pastel at Ox-Bow School of Art, Michigan, and the Pastel Society of America School for Pastels at the National Arts Club, New York.

52 Create a New Pastel Painting Over an Old One

When experiencing a creative block, it can be helpful to bring out all the unfinished and unsuccessful pastels from storage for closer scrutiny. There is no need to sit and become down while you analyze them for their shortcomings. Choose one that you are comfortable with completely reworking in a fresh, adventuresome way.

One advantage of working on a heavyweight paper primed with pastel ground or sanded paper is that when a pastel painting is unsuccessful, you can remove the image with rubbing alcohol, creating a fresh surface tinted with traces of pentimento.

Select a few passages in the painting that have an interesting color or shape. If you have a landscape, it might be the sky, a stand of trees or the texture of a field. In a still life, it may be the fold of the tablecloth, a single flower or group of items. If it is a figure pastel, you may remove everything in the background. Or you may do the opposite by removing the figure and preserving the setting. The selected isolated passages of form will become the start for a new pastel painting. You will have turned a failure into a new opportunity.

1 Remove the Old Painting
Tape the old pastel to the drawing board on all 4 sides of the sheet to allow it to dry flat. With a 2-inch (51mm) disposable foam brush apply rubbing alcohol on the surface rapidly, letting the pastel colors mix together. Pick up the excess pastel and drips with a paper towel or tissue. There is no need to rub or scrub the surface, as the pastel buildup will dissolve instantly in the rubbing alcohol.

Select favorite passages of the old pastel to leave untouched as inspiration or incorporation into the new work. The pastel left behind on the surface will dry with a flat, lusterless surface.

The tint of the surface color will depend upon the mix of pastel from the old painting. The dark gray ground takes on the color of an old-fashioned blackboard as the alcohol dissolves the pastel. Allow the surface to dry before continuing.

2 Draw the New Composition
Using a Townsend Terrages white pastel, draw freely upon the surface using gesture and contour lines to define new shapes.

3 Develop the Drawing
As form and placement develop in the drawing, add a full range of Townsend Terrages grays from dark to light. Be careful to select grays that match the color temperature of the ground.

4 Edit With Rubbing Alcohol

Edit the shape of forms and placement of lines by using a ½-inch (13mm) flat bristle brush dipped in rubbing alcohol. Be bold and playful with a black pastel. Enjoy the sense of freedom as you play over what was the surface of the failed pastel. Layer the lines of varying values of gray over each other to create density of form and a sense of placement in space.

5 Paint the Background

To further define the space and the forms from the overall gray ground, select a medium warm violet. The violet is the complementary color of the small amount of pale yellow remaining from the original pastel. While drawing the violet negative space, edit the shape of the forms. Use the violet to thin too-thick lines and remove unwanted shapes.

6 Change to a Vertical Format

To freshen the eye, rotate the painting from horizontal to vertical. With the foam brush and rubbing alcohol, edit the composition to eliminate ambiguous areas of the composition. Use this exercise to hone your critical skills of evaluating the formal aspects of your own work. You must be fearless when evaluating your own work.

7 Finish the New Painting

Draw with a full range of pastel textures from very soft to crunchy firm. By working with a limited palette, a selection of black, white, warm grays and violet, you can concentrate on composition, inventive form and draughtsmanship.

At this final stage of the new pastel drawing over an old pastel painting, begin to use fixative between layers to build the luminosity of the pastel application. Using a drawing style of direct application of line to define form, the goal is to retain spontaneity and verve with the pastel application.

Select a medium red-violet for the form in the lower half of the composition. The variety in the violet adds complexity to the limited color palette. By drawing some positive shapes with the same violet used in the background, you establish a play between figure and ground shapes.

This play of positive and negative shapes is a keystone to Modernist painting. For further study on using a limited color palette to create interplay of positive and negative shapes and the application of drawing technique to a painting medium, take a look at Picasso's *Guernica* painted in 1937.

SUNFLOWER STUDY IN BLACK, WHITE, GRAY AND LAVENDER | **Jimmy Wright**
Pastel on paper; 41" × 29" (104cm × 74cm)

139

Conclusion

As you've read and worked through the exercises and discussions in this book, you've probably noticed some common themes.

Everyone has blocks. It doesn't matter whether you are a beginner or whether you've been painting for many years, it's not always a smooth ride.

There are many kinds of blocks. There are times when you don't know how to get started, don't know what to paint, are afraid you can't produce the level of work you want or are just uninspired. Blocks may not always be easily recognizable, but when you find yourself stuck in any way, try one or more of the exercises in this book to help you move on.

Blocks can be useful. Pushing yourself to try new things, moving in different directions, picking up a new medium and pursuing other ideas we've presented can not only break you through a block but can help you grow in ways you might not have anticipated. Instead of being frustrated by a block, you may find yourself welcoming the challenge to do something new and different.

So when you run into a block, remember it is just a plateau on your artistic journey. Cross it and move onward and upward.

DEDICATION

This book is dedicated to my husband and fellow artist, Bill Canright, whose beautiful paintings and demonstrations appear on pages 24–29.

Acknowledgments

It's always impressive to realize how many artists are willing to share information with others. Rather than being competitive or guarding the secrets of their success, again and again they generously teach classes and workshops, give lessons and tell writers what and how they do what they do.

When I embarked upon this project, it was intimidating at first to tackle the task of finding 25 artists who would give their time and energy to talking about and demonstrating how they break through their blocks. But it turned out to be surprisingly easy. The response was positive, and the artists provided images and information to bring these 52 exercises to publication. I want to thank each of the contributing artists in this book once again, and I know the readers will appreciate their efforts as much as I do.

I'd also like to thank the great people at North Light Books and F+W Media, with special thanks to Jamie Markle, Pam Wissman, my editor Sarah Laichas and designer Julie Barnett. It's a pleasure to work with you all.

Santorini Sentry | **Maggie Price**
Pastel on Pastelmat; 16" × 20" (41m × 51cm)

Recently, when I found myself uninspired by my usual landscape subjects, I decided to try something radically different. I combined working on a surface I'd tried only once before with underpainting with pastel and alcohol, a solvent I rarely use with pastel. In addition, I chose an entirely new subject, a cat. The result was challenging but educational, and it's motivated me to try other new subjects.

Index

About the Author

Maggie Price has worked in oils, acrylic and watercolor, but has focused mainly on the medium of soft pastel since the early 1990s. She was a cofounder and the former editor of *Pastel Journal*, a national magazine for pastel artists (now owned by F+W Media), and has written over 100 articles about pastel art and artists. She serves as contributing editor and is on the editorial advisory boards of *Pastel Journal* and *The Artist's Magazine.*

She is a signature member of the Pastel Society of America, a signature member and distinguished pastelist of the Pastel Society of New Mexico, a signature member of Plein Air Painters of New Mexico, a member of the Master Circle of the International Association of Pastel Societies and a member of the Salmagundi Club of New York City. She is the president and a member of the board of directors of the International Association of Pastel Societies and serves on the board of directors of the New Mexico Art League.

Price is the author of two North Light books, *Painting with Pastels* (2007) and *Painting Sunlight & Shadow with Pastels* (2011), and two instructional DVDs. Her paintings have been included in a number of books written by others, featured in magazines in the United States and Great Britain, and included in numerous juried and solo exhibitions. Price's work is in collections throughout the United States, Great Britain, Europe, Australia and New Zealand. She teaches U.S. and foreign workshops and frequently judges exhibitions. Visit her website at maggiepriceart.com.

Other fine North Light Books are available from your favorite bookstore, art supply store or online supplier. Visit our website at fwmedia.com.

17 16 15 14 13 5 4 3 2 1

DISTRIBUTED IN CANADA BY FRASER DIRECT
100 Armstrong Avenue
Georgetown, ON, Canada L7G 5S4
Tel: (905) 877 4411

DISTRIBUTED IN THE U.K. AND EUROPE
BY F&W MEDIA INTERNATIONAL LTD
Brunel House, Forde Close, Newton Abbot, TQ12 4PU, UK
Tel: (+44) 1626 323200, Fax: (+44) 1626 323319
Email: enquiries@fwmedia.com

DISTRIBUTED IN AUSTRALIA BY CAPRICORN LINK
P.O. Box 704, S. Windsor NSW, 2756 Australia
Tel: (02) 4560 1600, Fax: (02) 4577 5288
Email: books@capricornlink.com.au

Edited by **Sarah Laichas**
Designed by **Julie Barnett**
Production coordinated by **Mark Griffin**

Metric Conversion Chart

TO CONVERT	TO	MULTIPLY BY
inches	centimeters	2.54
centimeters	inches	0.4
feet	centimeters	30.5
centimeters	feet	0.03
yards	meters	0.9
meters	yards	1.1

Ideas. Instruction. Inspiration.